Dalí and Surrealism

Dalí and Surrealism

DAWN ADES

ICON EDITIONS

HARPER & ROW, PUBLISHERS, New York

Cambridge, Philadelphia, San Francisco,

London, Mexico City, São Paulo, Sydney

1817

709.04
A d 35d

Acknowledgments

I would like to thank Professor Arthur Terry, of Essex University, for his generosity in providing material for the chapters on Dalí's early writing and relations with the Catalan avant-garde; also Maite Hutchinson and Monserrat Guinjoan for their help with translations from the Catalan.

Works by Salvador Dali
© Salvador Dali/S.P.A.D.E.M. 1982

Contents

Preface

After Picasso, Salvador Dalí is probably the most universally famous, which is not to say the most highly regarded, twentieth-century painter. Not least among the reasons for this is his talent, extraneous to his abilities as a painter, for publicity. He has been frequently identified with Surrealism, and has to a large extent even determined its popular image, yet he was eventually rejected by the movement itself and his most celebrated painting, at least in England, *Christ of St John of the Cross*, is fundamentally opposed to Surrealism in spirit. One reason for his popularity is the widely held opinion that he is an extraordinarily gifted painter technically, a brilliant draughtsman. But this was not the reason for his initial success within the Surrealist group, and Dalí himself is less than flattering about his own talents. Perhaps a comparatively commonplace academic technique borrowed from despised nineteenth-century masters is now unfamiliar enough to be dazzling. It is seldom recognized that Dalí further twists it into an almost grotesque baroque mannerism, or manufactures it into a flat photographic realism. For Dalí, though, it is always the idea that is most important: the medium for its expression – and he is as fluent in words as he is in paint – is a matter of relative indifference for him. He considers his technique to be no more than a vehicle for conveying the disturbing imagery of his work, which, based initially (in the late twenties) on psychiatry textbooks and the comparatively new science of psycho-analysis, opened up new subject-matter for painting.

Not being qualified to undertake fully the type of psychological/sociological analysis that Dalí's work seems to beg, I have attempted in Chapter Three to suggest some lines along which such an analysis could proceed. This book aims to place Dalí's work in context within the main streams of twentieth-century art and in relation to the historical and social upheavals of the period. In order to disentangle his crucial formative influences and his most important artistic relationships, this book dwells at some length on his relationship with Surrealism, at the expense of a more detailed discussion of his later work. It is hoped that the illustrations will provide a balance, and that the most important questions have at least been raised if not answered.

Some of the material in the book is based on long conversations with Dalí at his home at Port Lligat.

6

Chronology

1904 11 May: birth of Salvador Dalí at Figueras, Spain.

1918 Exhibits at an exhibition of local artists at the Municipal Theatre, Figueras.

1921 Enters the School of Fine Arts, Madrid; lives at University Residence where meets Lorca and Buñuel.

1923 Suspended for a year from the School of Fine Arts for subversive behaviour.

1925 First exhibition at Dalmau Gallery, Barcelona, 14–27 November: includes a 1917 *Landscape*, Cubist paintings of 1924, *Venus and Sailor* (1925), *Portrait of my Father* (1925) and *Girl Seated Seen from the Rear* (1925).

1926 First visit to Paris; permanently expelled from Academy of Fine Arts; 31 December–14 January 1927, second one-man exhibition at Dalmau Gallery: includes *Composition with Three Figures (Neo-Cubist Academy), Girl Sewing, Landscape at Penya-Segats, Harlequin.*

1927 Military service; designs sets and costumes for first performance of Lorca's drama *Mariana Pineda* in Barcelona; first texts for *L'Amic de les Arts*.

1928 Publishes *Catalan Anti-Artistic Manifesto.*

1929 Joins Buñuel early in the year in Paris to make *Un Chien Andalou*; Gala and Paul Eluard, the Magrittes, and his new dealer Camille Goemans visit him at Cadaqués in the summer, and he officially joins Surrealist movement; first one-man Paris exhibition at Goemans Gallery in November: drawings and 11 paintings, 9 completed since the summer including *Dismal Sport, Accommodations of Desire, Illumined Pleasures, Face of the Great Masturbator* (sic), *Man with Unhealthy Complexion Listening to the Sound of the Sea* and *Portrait of Eluard*. Rejoins Gala in Paris to begin their lifelong companionship.

1930 Enters financial arrangement with the Vicomte de Noailles which enables him to buy tiny fisherman's house at Port Lligat, near Cadaqués, in which, much extended, he still lives. Contract with Pierre Colle Gallery, Paris. Represented with 8 paintings and 2 drawings at first Surrealist exhibition in the USA at the Wadsworth Atheneum, Hartford, Connecticut. First showing of *L'Age d'or*. Lecture 'Moral Position of Surrealism' at Ateneo, Barcelona.

1931 First one-man exhibition at Pierre Colle Gallery, includes *Invisible Man, Invisible Sleeper, Horse, Lion, William Tell* and *The Persistence of Memory*.

1932 Included in Julien Levy's exhibition *Surrealism* in New York, immediate success. Second one-man exhibition at Pierre Colle's.

1933 A group of 12 collectors and friends ('the Zodiac') arrange to give Dalí regular 'salary' in exchange for the right to choose either one large painting or a small painting and two drawings in rotation over the year, one each month. Dalí shows 8 works at Exhibition of Surrealist Objects, at Pierre Colle, and in June one-man exhibition includes several works on theme of Millet's *Angelus*. First one-man show at Julien Levy Gallery, New York.

1934 At Carnegie Institute, Pittsburgh, shows *Enigmatic Elements in a Landscape* and receives 'Honourable mention'. First one-man exhibition in London, at Zwemmer Gallery, arouses much interest. November, first trip to USA, one-man exhibitions at Levy Gallery and Wadsworth Atheneum.

1935 January, gives lecture on Surrealism at Museum of Modern Art, New York. Enters agreement with English collector, writer and Surrealist sympathizer Edward James, by which James purchases his most important works – the arrangement lasts until 1939.

1936 At the International Exhibition of Surrealism in London gives lecture encased in diving suit and helmet which sticks and nearly suffocates him. Exhibition at Levy's, New York, much publicity, appears on cover of *Time*.

1937 Visits Hollywood. Spends several months at Edward James' house in Italy to avoid Spanish Civil War.

1938 Visits Freud in London. Works in Monte Carlo on ballets *Mad Tristan* and *Bacchanale*.

1939 In New York, latest exhibition at Levy's excites much attention. Works on *Dream of Venus* for New York World's Fair. Moves to Arcachon on outbreak of War.

1940 Visited by Chanel and Duchamp. After fall of France in June flees to USA via Spain, where visits father for first time since rupture nearly ten years before. Settles at Caresse Crosby's house at Hampton, Virginia.

1941 Exhibition at Levy Gallery. Attacked by Breton in *Artistic Genesis and Perspective of Surrealism*, and by Calas in the New York magazine *View*. Finishes writing *The Secret Life of Salvador Dalí*. In November, Retrospective Exhibition at Museum of Modern Art, New York. Makes first jewels in collaboration with the Duke of Verdura.

1943 Exhibits a number of portraits of American celebrities at Knoedler Gallery, New York; paints murals for Helena Rubinstein's apartment. During these years in the USA designs numerous advertisements.

1945 Exhibits recent works at Bignou Gallery, New York, to coincide with which publishes *Dalí News*.

1947 Second exhibition at Bignou's, and second issue of *Dalí News*.

1948 Returns to Europe. From now on Dalí regularly spends part of the winter in New York, and divides the rest of the year between Port Lligat and Paris. Rupture with Surrealists complete, but never joins another movement.

1949 Audience with the Pope to whom he gives small version of *Madonna of Port Lligat*.

1951 Dalí and Gala attend the Besteigui Ball in Venice dressed by Dior as 7-metre-tall giants.

1952 Dalí lectures throughout the USA on 'nuclear mysticism'. Controversy in Britain over acquisition by Glasgow Arts Museum of *Christ of St John of the Cross*.

1954 Travelling retrospective exhibition in Rome, Venice and Milan.

1955 Lecture at the Sorbonne: 'Phenomenological aspects of the paranoiac–critical method', on Vermeer's *Lacemaker* and rhinoceros.

1957 Designs night-club for Acapulco, which will move and breathe, but is never realized. Walt Disney visits him at Cadaqués; they plan a film on *Don Quixote* which is never made.

1958 At the Paris Fair Dalí has a loaf of bread 12 metres long baked, to use at a lecture at the Théâtre de l'Etoile. Marries Gala in religious ceremony in Spain. Exhibits atomic 'anti-matter' paintings at Carstairs Gallery, New York.

1959 Lectures in Paris and at the Planetarium in London. Presents his Ovocipede, a vehicle consisting of a transparent plastic ball.

1960 Exhibition of Dalí's first 'historical picture', *The Discovery of America by Christopher Columbus* (or *Dream of Christopher Columbus*), commissioned by Huntington Hartford for Gallery of Modern Art in New York. Protest by Surrealists against his participation in Surrealist Exhibition at d'Arcy Galleries, New York. ('We don't EAR it that way.')

1962 Dalí's painting *Battle of Tetuan* exhibited in Barcelona beside Fortuny's of same subject.

1964 Dalí awarded one of highest decorations in Spain, Grand Cross of Isabella the Catholic. Retrospective exhibition in Japan.

1965 Special exhibition at Knoedler Gallery, New York, of the painting Dalí described as his best so far: *Gala looking at Dalí in a state of anti-gravitation in his work 'Pop-Op-yes-yes-Pompier' in which can be seen the two anguishing figures of Millet's Angelus in a state of atavistic hibernation standing out against a sky which explodes suddenly into a gigantic Maltese Cross just at the heart of Perpignan station towards which the whole universe starts to converge*.

1967 Dalí organizes exhibition 'Homage to Meissonier' at the Hotel Meurice in Paris, where he shows latest painting *Tunny Fishing*.

1968 During May *événements* in Paris, distributes tract 'My cultural revolution' to striking Sorbonne students.

1970 Exhibits *Hallucinogenic Toreador* at Knoedler's, New York. Creation of Dalí Museum in Figueras announced.

1971 Inauguration of Dalí Museum in Cleveland, founded by Reynolds Morse, a major Dalí collector. Dalí designs chess set for American Chess Foundation, using moulds of fingers and teeth for pieces, and dedicates it to Duchamp.

1972 Exhibition of holograms at Knoedler's, New York.

1974 Inauguration of Teatro Museo Dalí in Figueras.

1977 Exhibition of latest work at André-François Petit Gallery in Paris, includes *Gare de Perpignan* (Perpignan Station).

1978 Elected to Beaux-Arts Academy.

1979 December Retrospective Exhibition at the Pompidou Centre, Paris, with special installation 'La Kermesse héroïque'.

Early years

Early influences; Madrid School of Fine Arts; Cubism and Purism; first one-man exhibitions.

Salvador Dalí y Domenech was born on 11 May 1904, at Figueras in the north-eastern Spanish province of Catalonia. His childhood and adolescence have remained vivid and peculiarly important to him; anecdotes from this period, real and imaginary, are at the basis of many of his most persistent images, and his relationship with his family was crucial to the formation of his artistic personality. His sister, three years younger than himself, described their childhood as exceptionally rich and harmonious, a point of view glimpsed only occasionally in Dalí's own accounts.

Summers and free days were spent at the family's holiday house on a beach near the fishing village of Cadaqués. Dalí has remained faithful to this habit all his life, buying, shortly after he met his future wife Gala, a shack just above the sea in the tiny fishing village of Port Lligat, round a point in the bay to the north of Cadaqués. He and Gala transformed this into their permanent home, a place of retreat where they spend nearly every summer. Dalí has always loved passionately the landscapes of his childhood – the great plain of Ampurdán, in which Figueras lies, and the Catalonian coast with its olive groves and sharp, barren rocks. These ancient, melancholy landscapes enter his paintings not just as backdrops, but as presences.

Historically, Catalonia is more than a province of Spain. Now, the French–Spanish border cuts across the old territory of Catalonia, which had its own language and its own system of government from the early Middle Ages. After the Treaty of Corbeil in 1249 it retained the counties of Cerdagne and Roussillon, now part of France, and Perpignan, the capital of Roussillon, was an important Catalan city which has always held a special fascination for Dalí, not least as the departure point of the train for Paris. Catalonia's economic strength lay, however, in Barcelona, the centre of the greatest mercantile expansion in the Western Mediterranean from the twelfth century. It lost its independence to Castile only in 1714, after siding with Austria in the Austro-Spanish War. A strong separatist movement has persisted throughout the nineteenth century and up to the present day, when a measure of independence has been restored with the re-establishment of the old parliament.

Helped by its geographical position, Barcelona has always been more outward looking, more culturally progressive as well as economically and industrially stronger than Madrid; it was more cosmopolitan too, so it was natural for Dalí to look to Paris from there, as Picasso had done before him. Traditionally resistant to the centralizing policy of the Bourbons and each successive regime, Catalonia has been the natural home of Republicanism in Spain, and from the middle of the nineteenth century a centre of Anarchism.

Although his Catalan background is so important to Dalí, it has not, except perhaps in a negative sense, determined his political outlook in the way that it did that of his fellow Catalan and Surrealist Miró, whose paintings from very early on have contained references to Catalan separatism and who actively worked towards it. Dalí's more wayward allegiances have perhaps to be understood in the context of his family. His father was an atheist and Republican, an eminent notary in Figueras, and a powerful character; his mother, whom he adored, was a pious Catholic. The family was intellectually and politically progressive, and Dalí himself was an Anarchist for most of his youth. Because of the support his father gave to political activists after the dictator Primo de Rivera seized power in 1923 his family was harassed, and during the Spanish Civil War their house was sacked by the Franco rebels. Yet Dalí subsequently declared himself a monarchist, and a Catholic, and vocally espoused tradition against the radical beliefs of his youth and of his contemporaries. His reaction against and rejection of his father fed this change. Paradoxically, too, although he has remained so close to his Catalan roots, he has frequently expressed a sympathy for the Spain of Philip II, preferring his grim and gloomy Palace of the Escorial to the glassy elegance of Versailles, and perceiving in his own character a violence, and extremism, that he identifies with Spain.

In all accounts of his childhood, Dalí is revealed to have been highly excitable, and morbidly sensitive, rather than abnormally heartless, as George Orwell once suggested. Dalí offers as one of the chief clues to his personality, the death from gastro-enteritis, just over nine months before his own birth, of an adored elder brother, at the age of two. This other Salvador, after whom the younger son was named, had shown signs of a remarkably precocious intelligence, and a 'majestic' portrait of him lived permanently in his parents' bedroom beside a reproduction of Velázquez' *Christ on the Cross*. Although indulged and spoiled, the second Salvador felt none the less a substitute. 'He was the wisely loved; I was but loved too well', Dalí said in *The Unspeakable Confessions of Salvador Dalí*, and jealousy combined with a morbid self-identification with his dead brother to make Dalí an ambitious, attention-seeking and exhibitionist child: 'At the age of six I wanted to be a cook. At seven I wanted to be Napoleon. And my ambition has been growing ever since.'

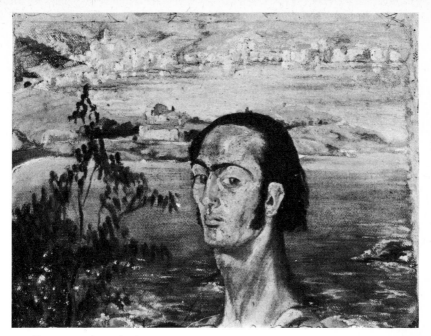

1 *Self-portrait with Raphaelesque Neck, c.* 1920–21

At the age of seven he was sent by his father to the State school in Figueras, where, in his embroidered sailor's suit and with perfumed hair, he formed a strange contrast to the poorest children in the town. After a year there he had learned nothing but a habit of reverie, and his father removed him to the local private school run by the Christian Brothers to join the other middle-class children. From this period he has retained three clear visual memories, all of which surface in some form in later paintings: two cypress trees that were visible through the classroom window, a reproduction of Millet's *The Angelus,* which could be seen lit up on the wall of the corridor leading to the classroom, and a 'big yellow-enamel Christ nailed to a black cross', whose feet the children touched as they crossed themselves on leaving the classroom.

Dalí's early enthusiasm for painting and drawing met with no opposition from his family, although his father insisted that he acquire his baccalaureate before pursuing his chosen profession, and nourished hopes that his son would follow a secure, academic, official career. Dalí also received encouragement from a friend of his father's, the Impressionist painter Ramón Pitchot, who knew Picasso and had shared the summer the Cubist painter had spent at Cadaqués in 1910. Dalí frequently stayed with Pitchot's gifted artistic and musical family, and during a visit when he was about nine painted a still life of cherries on the back of an old door, using only vermilion, carmine and white.

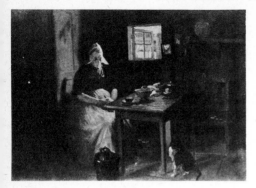 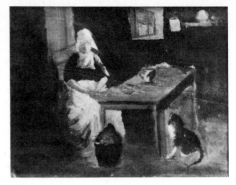

2, 3 Manuel Benedito y Vives (1875–?), *Dutch Interior* and Dalí's copy, 1915 (*right*)

When it was pointed out that he had forgotten the stalks, Dalí glued real cherry stems to the door. He was fascinated by Pitchot's paintings hanging in the dining room, of which he wondered most at the pointilliste ones, with their 'systematic juxtaposition of orange and violet', a colour scheme characteristic of such early works by Dalí as his *Portrait of the Cellist Ricardo Pitchot* (1920), or his *Self-Portrait*, though not applied systematically. At Pitchot's suggestion he was at the age of twelve enrolled in the drawing class of Nuñez an academic artist and winner of the Prix de Rome in engraving, to whom, Dalí later said, he owed a good deal.

Dalí painted abundantly, and at the end of every summer gave his work to his uncles. Many of the early pictures depict either the local landscape, or the tranquillity of Spanish domestic life, interior scenes with female relations sewing quietly by the window (*Grandmother Ana sewing at Cadaqués*, 1916–17). Some of these are not unlike the genre scenes of the Spanish painter Urgell, to whom Dalí has acknowledged his debt. One of Dalí's first attempts at oil painting was the copy he made of Manuel Benedito's *Dutch Interior*, which had been reproduced in the review *Museum* in 1912, and which explicitly demonstrates the link between the traditional Dutch genre scene and the domestic interior settings Dalí was beginning to study from the works of his older compatriots.

An early interest in chiaroscuro was probably also linked to his experiments in Nuñez' drawing class. One day the class had to draw a beggar with a curly white beard. Dalí's first sketches were criticized for being too heavy and dark, and he was advised to press more lightly and leave more white space. But he persisted until his drawing was nothing but a shapeless black mass, which he then smeared with Indian ink. When it was dry he scratched it with a penknife through to layers of white paper, and spread saliva on other parts to make

them grey; the effect was now one of lightness and depth. 'On my own,' he remarked, 'I had rediscovered the engraving methods of that magician of painting named Mariano Fortuny, one of the most famous of Spanish colourists.' Fortuny's exotic scenes and opulent interiors (*Spanish Marriage*, 1870) have a jewelled intensity of colour against a sombre ground similar to that of the late nineteenth-century French Symbolist Gustave Moreau. It is interesting that, having under the influence of Pitchot and others turned to Post-Impressionism and subsequently followed through the various phases of European modernism until he joined the Surrealists, Dalí was to return in the thirties to his early tastes for nineteenth-century academic painting.

Dalí's very early paintings are as uncertain in date as those of his student period, but he would seem to have been in his early teens when he began to experiment with thickly applied layers of colour, built up so that the canvas surface was almost in relief. 'My research led on to making canvases covered with a thick layer of matter that caught the light, creating relief and presence. That was when I decided to stick stones on to my pictures, then painting over them' (*Vieillard crépusculaire* – Old Man in Twilight, 1918–19). In one such painting of a dazzling sunset, which Salvador Dalí senior hung in the dining-room, the clouds were made of stones of various sizes. Stones would periodically drop off and hit the sideboard, and he would observe, 'Nothing but stones falling from our child's sky.'

4 Mariano Fortuny, *Spanish Marriage*, 1870

When Dalí was about fifteen he collaborated with friends on a review called *Studium*. Printed on rough unbleached paper, it was decorative in design, and contained a section by Dalí entitled 'The Great Masters of Painting', where he first expressed his enthusiasm for Velázquez, and wrote also on Goya, El Greco, Dürer, Leonardo and Michelangelo (in his opinion academic and grandiose). One year he was given the job of making one of the carts for the traditional Epiphany procession, the Cabalgata de los Reyes (the procession of the Kings), one of the main Christmas festivities in Spain. He designed a carriage so high that the branches of the trees along the route had to be cut; it was mounted by gigantic dragons with phosphorescent eyes. Such huge and grotesque carnival figures, a traditional part of Catalan festivals, were also to inspire Miró, much later, in his creation of satirical figures for the Catalan street theatre group La Claca in their anti-Franco productions during the seventies. Another incident from Dalí's early student life which earned him a certain notoriety in Figueras was on the occasion of a postponed and disputed celebration of the Armistice at the end of the First World War. Dalí was invited to speak to a meeting of Anarchist students, but, armed with a carefully prepared speech, when he faced the large audience from the intimidating platform of the Republican Hall in Figueras, he found that he could not remember a single word of it. Instead, he shouted 'Long live Germany! Long live Russia!' The leader of the Anarchists, above the resulting tumult, explained that what Dalí meant was that there had been neither winners nor losers during the war but that its real result was the Russian Revolution, now spreading to Germany.

In 1921 Dalí went to Madrid for the entrance examination to the Fine Arts Academy, accompanied by his father and sister. The candidates had six days in which to complete a drawing of a cast of Jacopo Sansovino's *Bacchus*. During the course of the first day, Dalí's father discovered that Dalí's drawing was smaller than the required proportions. Highly suggestible, Dalí erased his first attempt. Not until the sixth day did he succeed in completing a drawing to his satisfaction, but now it was even smaller than the first one. It was, however, so competent that the jury passed it. So in September 1921 Dalí moved into the University Residence in Madrid. If he was to learn very little from his tutors in the Academy, he was to make some very important friendships among the most advanced group of student writers and artists in the Residence, most notably with the poet Federico García Lorca, and the future film maker Luis Buñuel. This group, which also included Pepin Bello, Pedro Garcias, Eugenio Montes and R. Barrades, was a 'strident and revolutionary' group, as Dalí described it, who had inherited from the previous generation the 'Ultra-ist' tradition, a paradoxical movement closely related to Dada.

It is not easy to trace the development of Dalí's work for the next few years. Not all the works are dated, and while he is assimilating the successive stages of

European modernism, the chronology of his own work does not necessarily reflect that of the artists or movements he is studying. He seems to have taken the apprentice's licence to experiment to an extreme degree, in the sense that he painted in a number of different styles in the course of one year; this seems to have become by 1925 almost deliberate, and he claims that he used to work simultaneously in two different styles.

Dalí has said that he felt himself far in advance of most of his fellow students when he entered the Academy, for they were just in the process of discovering the Impressionism with which he had long been familiar, and which, he noted scornfully, they interpreted as an invitation to slapdash freedom. Dalí later claimed that what he wanted of the Academy was instruction in the formal discipline of oil painting and academic art. This claim is not very convincing, for his paintings during this period show him experimenting with one after another of the most advanced styles from Paris, starting with a kind of Post-Impressionism using a very heightened palette reminiscent of the Divisionist-influenced Fauvism of Matisse and Derain of 1905, probably, indeed, in advance of his fellow students but by no means academic. His claim may not be entirely due to a persistent tendency in his memoirs to displace later enthusiasms to an earlier period, however, for at later stages of his career as an art student he does reveal a sympathy for a return to classical ideals, for that 'rappel à l'ordre', in Cocteau's phrase, which he would have come across in the review *L'Esprit Nouveau*. This review, published in Paris between 1920 and 1925, was an important influence on him, as was the Italian review *Valori Plastici* (1918–21); these were probably among the art magazines to which he subscribed or which his assiduous father regularly sent him. Barcelona was, of course, distinctly progressive by comparison with Madrid, and, notably through the Dalmau Gallery, in close contact with the Parisian avant-garde. Although Dalí was obviously far too young to have known the Cubist exhibition held there before the war, he must have known their post-war exhibitions. In 1920 they held an exhibition of French twentieth-century art, a very mixed show of ex-Fauves, Cubists and post-Cubists, which did not, however, include any works by Picasso and Braque of the pre-war period of high Cubism. He does not seem to have witnessed at the time the big exhibition Dalmau put on in 1922, of Picabia's Dada and machine works, which had a catalogue preface by the leader of the Paris Dadaists and the future leader of the Surrealists, André Breton, who delivered at the same time a lecture at the Ateneo in Barcelona, 'Caractères de l'évolution moderne et ce qui en participe'.

But even if he did not actually attend these events, they certainly helped to create an active avant-garde in Catalonia which he was shortly to join. Landscapes, still lives, and portraits of his friends and family were still his favourite subjects, and when he was working at his studio at home in Figueras

he often painted local gipsies who would come to pose for him. The most unusual works of this period, however, which date from 1922 to 1923, are a series of Indian ink and wash drawings which are a curious mixture of a deliberate naivety and childishness and a sophisticated introduction of dislocated space and abandonment of perspective. Some of these (*Madrid Slum* for example) have a clear Futurist influence, with the houses leaning in at dramatic angles. It could also be Futurism which had suggested to Dalí the juxtaposition of scenes taking place simultaneously at different times and places, though there is also a curious and perhaps fortuitous echo of the fantasy paintings of Chagall, or even early Kandinsky. The most ambitious of this group, though still on a small scale, is the watercolour *The First Days of Spring*, in which the figure of the artist himself, a portfolio or sketch-book under his arm, his head framed by a gigantic leaf, is at the centre of a set of different scenes, of mingled memories, dreams and events occurring simultaneously.

In about 1923 Dalí adopted a Divisionist technique, though he by no means used it exclusively, and sometimes mingled it with other techniques. *Bathers of Llané* (the beach at Cadaqués where the Dalís' summer house stood) is one of the most successful of these; but while the technique and some of the motifs, like the curved white sails reflected in the water, are adapted from Seurat, the simplified curvilinear forms of the bathers, with faces often featureless or with eyes and nose barely indicated, suggest that Dalí had also been looking at André Derain's post-Cubist, Cézannist and primitivist bather scenes or nudes, and some landscapes, or townscapes, of Cadaqués of the same period, show a similar flattening and geometrical tendency. The influence of Derain appears sporadically, and perhaps helped to push Dalí in the same year towards the use of the muted palette of the Cubists, with the predominance of ochre, green and grey.

Dalí seems, therefore, to have been picking up a post-Cubist flattening and simplifying style from lesser Cubists before he actually came into contact with the true Cubism of Picasso and Braque; but when exactly this happened is not easy to determine. He himself gives 1920 as the date of the Cubist *Self-Portrait*, but he also says that he only began to paint Cubist pictures after he had settled at the University Residence in Madrid. A date of 1926 has also been suggested for the *Self-Portrait*, but it would seem, with its shattered surfaces and fragmented planes, closest in style to the *Portrait of King Alphonsus* done soon after the King's visit to the Academy in 1922. Although from the evidence of these works his application of Cubist technique is rather rudimentary, in that he does not really attempt to analyse form, it is none the less clear that he had grasped the fact that Cubism in spite of its apparent illegibility remained an art of realism. He had acquired a monograph on Braque, which he took into the Academy and showed to the students, to whom it was quite new. A professor of anatomy borrowed the book, and on returning it the following day spoke

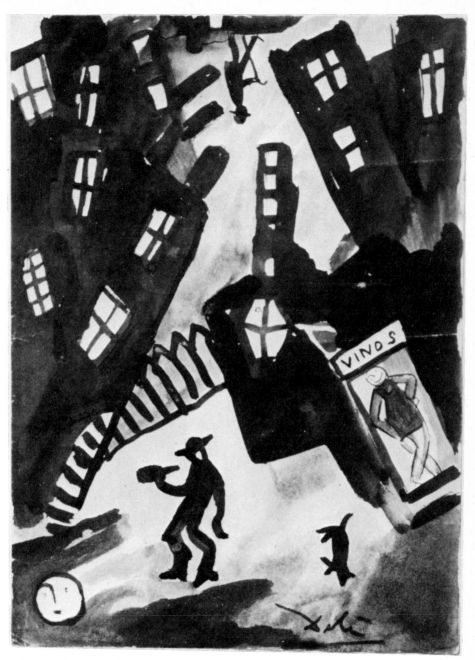

5 *Madrid Slum,* 1922

to Dalí about examples of non-figurative and geometrical art in the past. Dalí replied that this was not the point, for there was in Cubism a very manifest representational element.

In the *Portrait of King Alphonsus*, or in his own *Self-Portrait*, the heads are still readily visible within a forest of diamond-shaped abstract marks, and the model for these is clearly Picasso's 1910 Cubist portraits of Kahnweiler or Vollard, although Dalí's are little more than pastiches. Paintings of *c.* 1923, however, look rather to the clear, stylized and volumetric Cubism of Derain's 1910 paintings. Dalí continued to show an active interest in Cubism and post-Cubist developments until 1927, though after 1925 Picasso's works of the mid-twenties were the dominant influence.

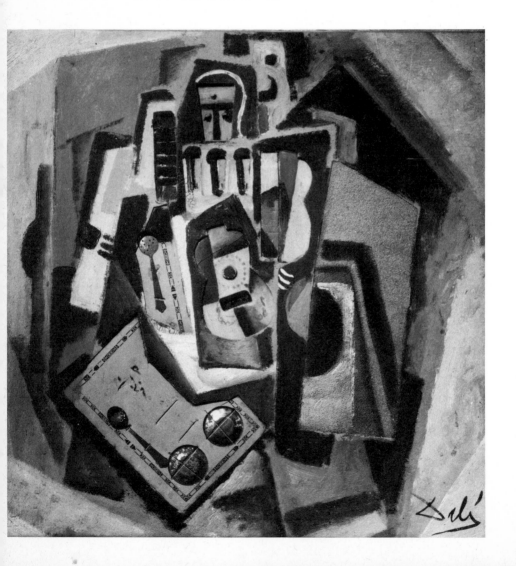

7 Cubist *Self-portrait*, 1926?

6 (opposite) *Pierrot and Guitar*, 1924

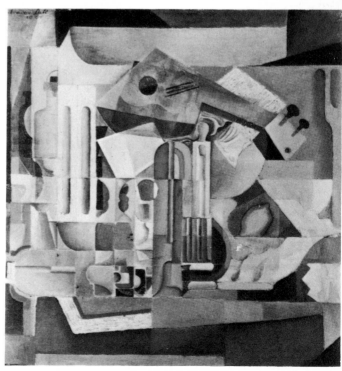

8 *Purist Still Life*, 1924

Dalí's extreme and vocal opposition to abstract art dates from a later period, and although he was never attracted by the various branches of pure abstraction, he did in 1924 turn to Purism, the movement founded by Ozenfant and Jeanneret (Le Corbusier) in 1918, based on the principle of the marriage of the object and pure geometric form. He was, characteristically, drawn as much by the ideas as by the art itself, and long after he had abandoned the style he was still, in the articles he wrote in 1927, expressing an attitude to the modern world not far from that of the founders of Purism. The most important artists for him were Picasso and Juan Gris, who dominate the pages of *L'Esprit Nouveau*, the Purists' principal mouthpiece. The subjects of Purist painting as defined by Ozenfant and Jeanneret were machine-made objects of geometric shapes. In Dalí's big *Purist Still Life* there are a number of completely abstract forms mingled with partly recognizable objects, but Dalí seems uneasy in attempting to maintain a balance between abstraction and figuration; as a result the ideal clarity of the Purist picture is not achieved. The contours and identity of some objects are difficult to determine – the fluted shape in the centre, for example, which obviously derives from the particular type of glass vessel so often present in Purist paintings and especially in Gris's works, is meant to relate to the long-necked glass decanter, but Dalí's attempt to depict objects clearly in combined plan, section and elevation is not altogether successful. Other Purist still lives of this year concentrate more simply on the objects, and are perhaps closer to the Metaphysical paintings of Carrà and De Chirico, which were amply reproduced in *Valori Plastici*.

In 1923 Dalí was suspended from the Academy for a year, accused of insubordination. He had walked out of an assembly of professors and students gathered to hear the announcement of the appointment of a new professor, when, instead of the candidate popular among the students, someone Dalí considered incompetent was appointed. A number of students followed him out, making him appear to the authorities to be the ring-leader. His rustication caused Dalí no concern at all; his progress in painting owed little or nothing to his training at the Academy, although his anxious father watched his son's chances of an official career slipping away. Like most of his friends Dalí was an Anarchist, and on returning home he was arrested and imprisoned for a month first in Figueras and then in Gerona, having been implicated in the burning of the Spanish flag after rioting at the Art School in Figueras during a popular uprising against the extra-legal dictatorship of Primo de Rivera, who had seized power in 1923. He returned to the University Residence in 1924, and it was during this period, until his final expulsion in 1926, that he began to live the life of a dandy. When he was still at school in Figueras he had begun to affect an exaggerated bohemian dress and wore his hair long. Now in Madrid he began to dress with great care and expense, and he experimented with using glue on his hair rather than brilliantine. In *The Secret Life* he gives a long and

lurid account of his discovery of cocktails. This life-style contrasted with the extreme asceticism of his holidays in Figueras and Cadaqués, though nothing seems to have interfered with his obsession for work.

The poet Rafael Alberti, another member of the Lorca group, gave the following description (probably in 1925 or 1926) of the young Catalan and his studio-cell in the Residence: 'Dalí seemed to me in those days timid and taciturn. I was told he worked all day sometimes forgetting to eat or arriving in the Refectory when the meal was over. When I went into his room, a simple cell like that of Federico, I could hardly get in because I didn't know where to put my feet: the floor was covered with drawings. Dalí had a formidable vocation, and at that time, in spite of his youth, he was an astonishing draughtsman. He drew as he wished, from nature or from his imagination. His line was classical and pure. His perfect stroke, which recalled the Picasso of the hellenistic period, was no less admirable; outlines jumbled with rough marks, blots and splashes of ink, lightly heightened with watercolour, already heralded the great Surrealist Dalí, of the first Paris years.

'With a serious air characteristically Catalan, but hiding a rare humour, which not a feature of his face betrayed, Dalí never failed to explain what was happening in each picture, revealing thus his incontestable literary talent.

'"That, there, is a beast gomitting" [i.e. vomiting, the transcription of *v* into *g* to give an idea of Dalí's strong Catalan accent]. It was a dog vomiting which looked rather like a bundle of tow. "That there is two policemen [*guardia civil*] making love with their moustaches and all the rest." Indeed you could see two tufts of hair armed with tricorns entangled on something that could be a bed. "That, there, is a 'putrefied' [*putrefact*, the name Lorca, Dalí and their group gave to conformist philistines] sitting at a table in a café."'

By the time Dalí was expelled from the Academy, in 1926, he had not only had works shown in student and other mixed exhibitions but, in November 1925, had held his first one-man show at the Dalmau Gallery in Barcelona. With the exception of one early landscape, all the works shown date from 1924 and 1925, the former being largely Cubist or Purist, the latter falling into two categories: a new, atmospheric realism, with mainly single figure studies and portraits, with a few landscapes, and, secondly, canvases showing the first signs of the neo-classical Cubism that was to dominate his work the following year.

One of the drawings exhibited was the fine pencil portrait of his father and sister. The source for this detailed and realistic drawing would seem to lie in the kind of portrait drawings Picasso began to make in 1915, when Cubism was still in full swing. In the first issue of *L'Esprit Nouveau* Picasso's 1919 portrait of Serge Diaghilev and Alfred Seligsberg was reproduced, and Dalí follows the compositional arrangement of the two figures closely, although his drawing is softer and more academic, without quite the force of Picasso's

10

9

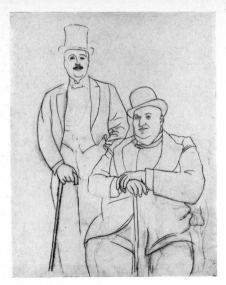

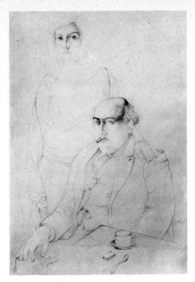

9 Pablo Picasso, *Serge Diaghilev and Alfred Seligsberg*, 1919

10 *Portraits of the Artist's Father and Sister*, 1925

heavily exaggerated purely linear contour, while the heads of the sitters are completed in a more traditional way. Both Picasso and Dalí are looking back to nineteenth-century French bourgeois portraiture, to Ingres and David. That this was conscious on Dalí's part too is clear from the catalogue to his exhibition. First, Dalí included a comment by Elie Faure: 'A great painter only has the right to take up tradition again after he has gone through the revolution, which is only the search for his own reality.' This ambiguously audacious sentence was followed by three of Ingres's maxims:

'Drawing is the probity of art.'

'He who will not look to any other mind than his own will soon find himself reduced to the most miserable of all imitations, that is to say, to his own works.'

'Beautiful forms are straight planes with curves. Beautiful forms are those which have the firmness of plenitude where details do not compromise the large masses.'

In choosing these maxims arguing for tradition and classical form, Dalí was probably motivated partly by a desire to shock his contemporaries in Spain who were still in the full flood of a Post-Impressionist rejection of academic rules and traditions, and emphasis on the uniqueness of each painter's vision. However, they also correspond closely to the direction Dalí's paintings were already beginning to take, with the introduction of mythological subject-matter and the use in certain works of a more classical contour line.

11 *Venus and Sailor*, 1925

12 *Portrait of my Father*, 1925

11 The large composition *Venus and Sailor*, painted in memory of the Catalan poet Salvat-Papasseit, who had recently died, brings the mythological Mediterranean and modern worlds together in an ironic embrace. The monumental Venus, with her angular classical drapery, not unlike one of Picasso's *Three Women at a Spring* (1921), is clasped by a sailor, flattened and ghostly, defined almost by his absence, a Cubist wraith in profile, whose hand alone clasping a pipe has any substance. Of the same year is the little painting *Venus and Cupids*, set in the bay of Cadaqués. To underline the mythological subject-matter, Dalí has floated a cupid in the sky with a Baroque swathe of pink drapery. The flattened and emphatic planes of the bodies, however, as in

12 his *Portrait of my Father*, mark it as unmistakably post-Cubist, while the child with the shell on the right again strongly evokes Picasso.

24

The Dalmau exhibition received favourable critical attention. *Gaseta de les Arts* of December 1925 noted that the exhibition revealed an artist of great gifts, and singled out for special praise a portrait of a girl looking out at a landscape through a window. The anonymous reviewer in *La Publicitat* of November 1925, remembering the promise Dalí had shown in a mixed student exhibition in Barcelona in 1922, praises the young painter's increased self-confidence, but notes a fundamental contradiction between the Dalí who sympathized with *L'Esprit Nouveau*, and a Romantic whom the former does not fully succeed in strangling. *Venus and Sailor* is essentially, the reviewer suggests, a Romantic work, and he notes that often the brushwork within a single painting varies considerably, backgrounds or a figure's clothes being painted more thickly and with greater freedom than the figure itself. It is true that in certain works of this period – *Girl Standing at the Window*, for example – the paint is laid on with an ardour that the formality of the composition and the aimed-for Ingresque cool and sheer linearity belie. The awkward conjunction of the girl's foot and the wall also suggest an uneasiness within the controlled discipline of drawing.

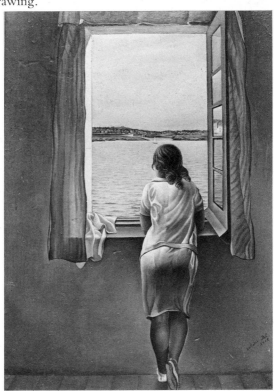

13 *Girl Standing at the Window*, 1925

14 *Old Man in Twilight*, 1918–19

15 *Portrait of the Cellist
Ricardo Pitchot*, 1920

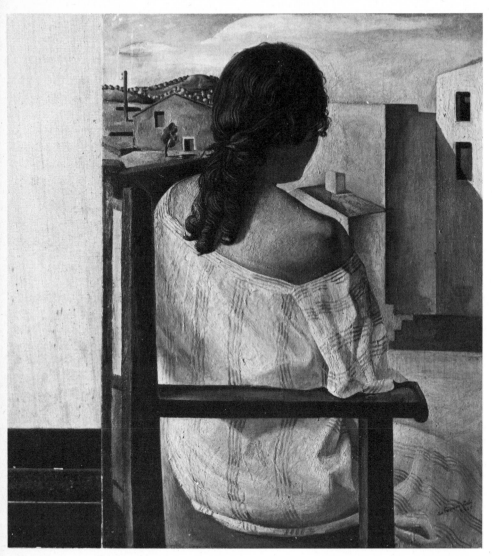

17 *Girl Seated Seen From the Rear,* 1925

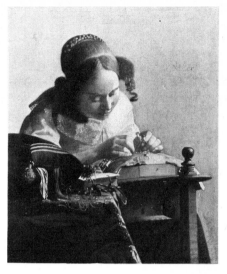

18 Jan Vermeer, *The Lacemaker*, 1665–8

The quiet domestic scenes of his sister seated by a window, or sewing, probably already relate to his interest in Vermeer of Delft, whose *Lacemaker* has obsessed Dalí all his life, appearing first in *Un Chien Andalou* in 1928, and most recently in the still unfinished film *The Prodigious Adventure of the Lacemaker and the Rhinoceros*. An undated painting of Dalí's, known as *Woman at the Window at Figueras*, which must belong to this or the following year, in fact depicts a girl making lace. There is also a curious affinity between these paintings and such German artists of the nineteenth century as Overbeck, or Philip Otto Runge, in whom neo-classicism gives way to a cool and decorative Romanticism, and a further striking parallel can be drawn between Dalí and the *Neue Sachlichkeit* artists like Georg Schrimpf. Dalí shared this leaning towards a 'New Objectivity' with other contemporary Catalan painters. Given the range and sophistication of Dalí's sources at this time, it is not surprising that he took a high hand during his Academy examination in the summer of 1926. When asked by the jury examining the Theory of Fine Arts to choose a subject, he replied, 'No. Given that none of the professors at the School of San Fernando has the competence to judge me, I withdraw.' This, combined with similar 'breaches of discipline', led to his final expulsion from the School. The report of his progress shows a patchy record: he received the congratulations of the jury in the examinations in the history of antique and of modern art, was absent for several juries, passed drawing from the model and anatomy, but failed colour and composition, stone engraving, and drawing from the model in movement. The expulsion could hardly, however, affect Dalí's already launched career.

19 *Grandmother Ana sewing at Cadaqués*, 1916–17

21 (opposite) *Bathers of the Costa Brava*, 1921

20 *Woman at the Window at Figueras,* c. 1926

Sometime in the spring of 1926, Dalí paid his first visit to Paris, where he went to see Picasso, who had seen the 1925 Dalmau exhibition and had admired particularly *Girl Seated Seen From the Rear*. Picasso spent two hours silently showing Dalí the contents of his studio. On the same trip, Dalí visited Holland to see the works of Vermeer.

The canvases of monumental bathers of 1926, like *Figures Lying on a Beach*, or *Woman Lying Down*, are very clearly indebted to Picasso, a debt Dalí comments on in a spirit of self-parody in the drawing *Picasso's Influence*.

Dalí's second exhibition at the Dalmau Gallery, from December 1926 to January 1927, included not only works which continued the realism of the previous year, but also Cubist and 'neo-Cubist' works, such as *Composition with Three Figures, Neo-Cubist Academy*. The pull towards a Romantic symbolism, which was unmistakable in the Caspar David Friedrich motif of the open window in the canvases of the previous year like *Girl Standing at the Window*, becomes even more noticeable in the heightened realism of, say, the *Landscape at Penya-Segats*. Here, the tiny figure is dwarfed by the dramatic bulk of the rocks half-lit by the evening sun, a light favoured by the Swiss painter Böcklin, whose mythological landscapes and islands with cypresses were also a major inspiration to De Chirico. A more explicitly mystical painting is the *Basket of Bread*, which was also exhibited, in which a faint luminosity seems to be shed by the objects themselves; the combination of dramatic lighting against an almost black ground and a detailed illusionism suggest that Dalí was looking at the still lives of Velázquez' contemporary, Zurbarán.

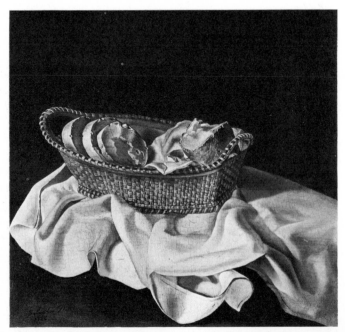

22 Basket of Bread, 1926

Critical reaction to this exhibition was more varied than to that of 1925, although it was clear to the critics that he was one of the most interesting of the young Catalan painters. Sebastià Gasch, who was within a year or so to become a close ally of Dalí's, wrote a long and considered account of the exhibition in *L'Amic de les Arts* early in 1927. In his opinion the paintings were too constructed, but the coldness, lack of sensibility and any indication of an inner life that had marked, in his view, Dalí's earlier work, were now somewhat diminished. His hypertrophied intelligence had disappeared, and, in consequence, his 'sensibility could sing out fully' – a view Gasch was radically to revise later.

It was probably this exhibition that the Catalan poet J. V. Foix described in 'Presentations: Salvador Dalí':

At the entrance to the exhibition room Dalí was stroking a huge, many-coloured bird which perched on his left shoulder.
– Surrealism?
– No, no.
– Cubism?
– No, not that: painting, painting, if you don't mind.
And he showed me the windows of the wonderful palace he had built at Dalmau's. I felt very acutely that I was present at the exact moment of birth of a painter. The vivisection hall showed, stripped to the bone, unlimited physiological landscapes: splendid groves of bleeding trees cast their shade over the brief lakes where the fish strive from morning to night to escape

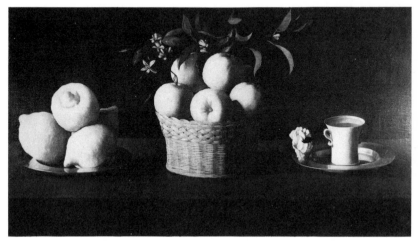

23 Francisco de Zurbarán, *Still Life with Lemons, Oranges and a Rose*, 1633

their shadows. And in the depths of the pupils of the painter, the harlequin and the tailor's dummy, black stars fled across a silver sky. I was thinking of staying there, when, from the depths of each canvas, on the stroke of seven, there emerged the celebrated phantoms.

It is a fine sight: they subtly cover you with their veils and confer on you their immateriality. If many of the citizens of Barcelona knew this, the sight of the phantoms which every evening fill the rooms of the Galeries Dalmau would be for them the entry to the 'other' world.

It is probably not fortuitous that there is a delicate echo here of the catalogue preface by Breton to the first exhibition of Surrealist painting which had been held in Paris in 1925, in which the titles of the works are woven into a fantastic narrative. So, here, Foix incorporates in his text the 'harlequin' and the 'tailor's dummy', both titles of works exhibited; the *Tailor's Dummy* in particular, its curvilinear negative–positive silhouette recalling Picasso's *Three Dancers*, and with a fish placed in its upper thigh, seems already to hover on the edge of Surrealism, as Foix divined.

Foix is not only the best and best-known Catalan poet of his generation, but the one who has been most consistently interested in the visual arts. Although he stayed clear of manifestos and public demonstrations, he belonged to the group of young writers in Barcelona who were in the avant-garde of Catalan cultural activity and who collaborated on the review published in Sitges, *L'Amic de les Arts*. Drawings by Dalí were reproduced to accompany Foix's texts in *L'Amic de les Arts*, and from 1927 Dalí himself was a regular contributor. Most interestingly, though, Foix was, already before the founding of Surrealism in 1924, writing in a manner that could be described as 'surrealist'. The passage quoted above belongs to a poetic or 'marvellous' – in the Surrealist sense of the evocation of another world – strain in his writing with which Dalí was familiar. This sheds light on the way Dalí was not struck with Surrealism with the sudden force of a revelation as, say, Tanguy was, and also on the way in which he was to bring an entirely new kind of visual Surrealism to the movement rather than following orthodox Surrealist practices like automatism; when, eventually, he separated himself from the Surrealist movement in Paris he replaced the accepted 'surrealist ancestors' with others of Spanish and Catalan origin, like Gaudí, and Ramon Lull, a thirteenth-century Catalan mystic who was also a favourite quarry and inspiration for Foix.

By far the most important friend and influence for Dalí at this time, though, was the Andalusian poet Federico García Lorca. Their friendship lasted until Lorca's death during the Spanish Civil War in 1936 at the hands of a Falangist firing squad, although without the intensity of their early relationship. Lorca was a vivid and powerful personality, and eventually the more timid but

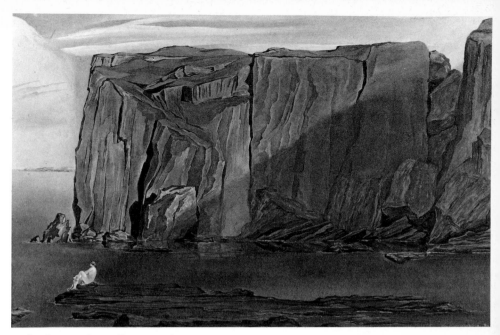

24 *Landscape at Penya-Segats*, 1926

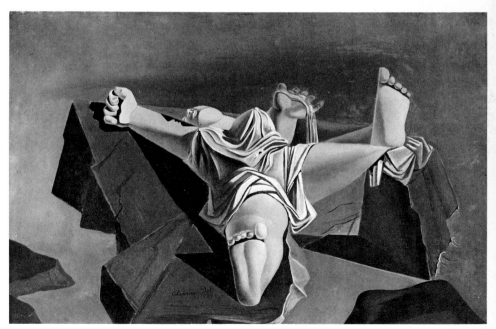

25 *Woman Lying Down*, 1926

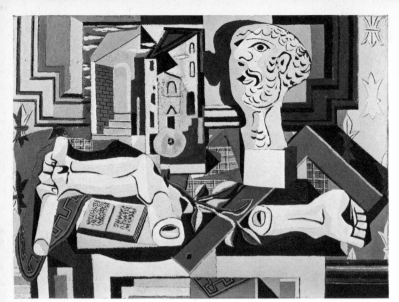

26 Pablo Picasso, *Studio with Plaster Head*, 1925

fanatical Dalí felt the need to shake himself free. But in 1925 and 1926 Lorca was a constant visitor at the Dalís' family house. Enthralled not only by the adolescent painter, but also by the 'baroque body and grey soul' of the olive trees at Cadaqués and by the severe clarity of the Catalan landscape, 'eternal and actual, but perfect', as he wrote in a letter, he published the first of his Odes, 'To Salvador Dalí', in the *Revista de Occidente* in April 1926. The poem also reveals the source of some of the extravagant language in the texts Dalí began to write the following year. Lorca's ode makes characteristic use of unusual, lyrical and sometimes untranslatable adjectives: '¡O Salvador Dalí, de vóz aceitunada!', which means literally 'O Salvador Dalí of the olive-coloured voice', or 'Canto tu corazón astronómico y tierno de baraja francesa y sin ninguna herida,': 'I sing your astronomical and tender heart like a french deck of cards and without a wound.'

During his visits Lorca made contact with the Catalan intelligentsia in Barcelona, and, having already given two readings of his first lyrical drama, *Mariana Pineda,* at the Dalís' house, arranged a production of it in Barcelona in 1927, when an exhibition of his drawings was also held. Dalí designed the scenery, which was to be very simple, largely black and white with a faded air like an old engraving, with colour limited to the costumes, and without, as Lorca said, a 'single folkloric note'.

At the beginning of 1927 Picasso's influence on Dalí was still strong; the effect of paintings like his *Studio with Plaster Head* of 1925 is immediately visible in *Peix i balcon* (Fish and Balcony, Still Life by Moonlight), in that a Cubist structure is infiltrated by new Expressionist and Surrealist elements.

36

The setting of the still life before the open window, though, becomes heavily theatrical, and the red patch in the centre echoes Picasso's use of distinct areas of red. But whereas the Cubist structure or framework in Picasso controls the isolated fragments, in Dalí's painting the objects spill out over the edge of their Cubist stage. The combination, too, of the moon and guitar is just out of key with its other Cubist associations, and hints at a more romantic Spanish setting. The moon is a recurrent image in Lorca's poetry ('Romance de la luna,

27 *Fish and Balcony, Still Life by Moonlight*, 1927

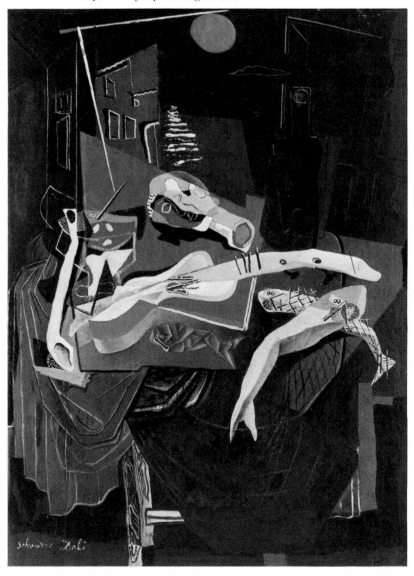

luna', for example) and the 'Ode to Salvador Dalí' contains the lines: 'The horizon innocent of wounded flies/joins the vitrified masses of fish and moon.' The lyricism of this picture, which still marks his affinity with Lorca, was soon to be rejected by Dalí, and his changing attitude is revealed in his letters to the poet. In the autumn of 1927 Dalí wrote ecstatically to Lorca to describe pictures which are not only the most radical departure in his work so far, but which already announce the Surrealist works to come:

> Federico, I am painting pictures which make me die for joy, I am creating with an absolute naturalness, without the slightest aesthetic concern, I am making things that inspire me with a very profound emotion and I am trying to paint them honestly. . . .
> At the moment, I am painting a very beautiful woman, smiling, tickled by multicoloured feathers, supported by a little burning marble dice, the side of the marble in turn is held up by a tiny plume of smoke, which trails peacefully, in the sky there are clouds with little parrots' heads, and sand from the beach.

30 This painting could be the lost *Honey is Sweeter than Blood*, on which Lorca asked Dalí to inscribe his name 'so that it might amount to something in the world'. This is a work which certainly contains the germs of the obsessive images that were to dominate the Surrealist pictures of 1929. Lorca wanted to call it the 'Wood with Objects', but the title Dalí chose was a phrase of Lydia

28 *Self-portrait dedicated to Federico García Lorca*, undated
29 Cartoon of Lorca and Dalí which appeared in *La Noche* on the opening of
Mariana Pineda at the Goya Theatre in Barcelona in 1927

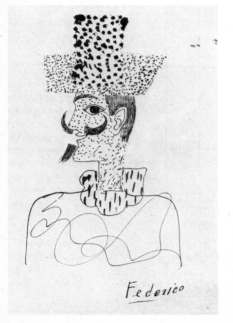

30 *Honey is Sweeter than Blood*, also known as *Blood is Sweeter than Honey*, c. 1927

Nogues, 'La ben plantada', one of the most extraordinary characters of Cadaqués, a peasant woman whose sons were fishermen, and who nourished an obsessive delusion which could almost be the model for the paranoiac–critical method Dalí developed in the thirties. The writer Eugenio d'Ors had as a student stayed at her house in Cadaqués, and she had ever since nourished a passion for him though she never saw him nor corresponded with him. However, she read each of his books and articles and interpreted them as hidden messages to herself. She was to prove a source of great support for Dalí later when he was banished from his father's house, and it was from her that he bought the fishing shack at Port Lligat. Dalí called her in *The Secret Life* 'godmother to my madness'.

By the spring of 1928 Dalí's new ideas had crystallized in such a way that he began to distance himself deliberately from Lorca – probably for personal reasons as well. After the publication of Lorca's *Romancero gitano*, Dalí wrote him a long letter criticizing its folkloric side and the fact that it was still deeply embedded in an outworn poetic tradition and was, therefore, out of touch with the present.

Dalí and the Catalan avant-garde

The Catalan Anti-Artistic Manifesto *and the* L'Amic de les Arts *group; Dalí's early writings on painting, photography and film; Luis Buñuel and the making of* Un Chien Andalou; *Surrealism in Spain and its influence on Dalí.*

In 1927 Dalí began to take an active role in the literary and artistic avant-garde in Catalonia. His two one-man exhibitions at the Dalmau Gallery in 1925 and 1926–7 had already won him attention from the critics; for the next two years he exhibited regularly in mixed exhibitions and at the Barcelona Autumn Salon, the Saló de Tardor, but his main forum was the plethora of Spanish and Catalan reviews that flourished during this period. Through 1927 and 1928 he published on average one article in every monthly issue of *L'Amic de les Arts* alone, and sometimes more. This was to set a pattern he continued after he joined the Surrealist movement in 1929, and he has, throughout his career, written almost as much as he has painted.

Although the change in his paintings noted in the previous chapter, about which he wrote to Lorca in the autumn of 1927, can at least partly be ascribed to a new Surrealist influence, the texts he was writing at this time reveal him to be only gradually giving his allegiance to Surrealism. He tends to maintain a distinct and independent if eclectic position for himself, often provocative and aggressive, which sometimes seems to have most in common with Dada.

As well as contributing articles and illustrations to the Catalan reviews, Dalí was illustrating at this time books and poems by Catalan writers, such as
31 *L'oncle Vicents,* by Puig Pujades, written at Figueras in 1924 and published in
32 Barcelona in 1926, and Buendía's *Naufragio en 3 cuerdas de guitarra* (Shipwreck in 3 Guitar Strings) of 1928, which was dedicated to Dalí, Gasch and Montanyà. But although his main platform was *L'Amic de les Arts,* a valuable organ of publicity, his growing reputation was not restricted to Catalonia. In February 1928 a new review was founded from Lorca's home country, Granada, in southern Spain, called *Gallo,* in which Lorca played a major role. Although he and Dalí appear to have become less close by this time, especially as far as their attitudes to art were concerned, Lorca none the less gave Dalí a prominent place in the new review. The first issue contained a Spanish translation of his first and most highly coloured text 'Sant Sebastià', originally published in *L'Amic de les Arts* in July 1927. 'Sant Sebastià' is interesting

31 Illustration from J. Puig Pujades, *L'oncle Vicents*, 1926
32 Illustration from Rogelio Buendía, *Naufragio en 3 cuerdas de guitarra*, 1928

because it introduces a concept of irony that Dalí refers to several times during these years, and which he derived from an article by Alberto Savinio, De Chirico's musician–writer–painter brother, in *Valori Plastici* in 1919. There Savinio had discussed a fragment of the pre-Socratic Greek philosopher Heraclitus' writings about irony, by which he meant the way nature hides herself the better to be revealed, and Dalí is obviously probing this idea as the possible basis of a new aesthetic.

The second issue of *Gallo*, in April 1928, opened with a translation of the *Catalan Anti-Artistic Manifesto*, also sometimes known as the *Groc Manifest* or *Yellow Manifesto*. It was written in Barcelona in March 1928, and signed jointly by Dalí, Lluis Montanyà and Sebastià Gasch, Catalan writers regularly contributing to *L'Amic de les Arts*. The *Anti-Artistic Manifesto* was primarily an attack on contemporary Catalan culture and its lack of modernity, and, *Gallo* claimed, 'launched the most interesting faction of Catalan youth today'. It contains a strong dose of Futurism, echoes of Dada and the short-lived Spanish movement Ultraism, and of *L'Esprit Nouveau*. The machine, it argues, has revolutionized the world but most writers and artists have failed to respond to the new sensibility; automobile and aeronautic shows are more dynamic and alive than exhibitions of landscape painting, and what is or should be in a state of formation is a 'post-machinist state of mind'. In place of decorative, lyrical,

traditional or folkloric art, there are the cinema, boxing, jazz, electric light, the gramophone, the camera. The Manifesto expressed the ideas of the small group of artists and writers gathered round *L'Amic de les Arts* and *Gallo*, but, hardly surprisingly, upset most of the Catalan intellectuals, artists and writers; one critic described it as 'Futurist crap'. In May 1928 Dalí published what is effectively another Manifesto, based on the same ideas: 'Per al "Meeting" de Sitges', in which he condemns everything local, regional, folkloric, including the Catalan national dance the Sardana, in favour of the new, finishing with 'let us proclaim ourselves anti-artists out of respect for art'.

Although there are similarities with the Paris-based *L'Esprit Nouveau*, closer to home Foix was expressing the same ideas and was almost certainly a profound influence on him. He was fascinated by sport, jazz and the objects of the new machine world, as was the *Anti-Artistic Manifesto*, but also, woven into his writings is an element of fantasy, or the marvellous, linked to a cold and objective rather than subjective vision which finds close parallels with Dalí. At the end of 'Presentations: Salvador Dalí' (*c.* 1927) Foix wrote: 'As I left the gallery, the Paseo de Gracia, deserted, without trees or lampposts, was an immense avenue lined with hundreds of Shell petrol pumps, their luminous heads softly reflected on the asphalt.'

Closing the *Anti-Artistic Manifesto* is a list of 'great artists of today', with whom the authors claim an affinity, which covers, as they say, 'the most diverse tendencies and categories: Picasso, Gris, Ozenfant, Chirico, Joan Miró, Lipchitz, Brancusi, Arp, Le Corbusier, Reverdy, Tzara, Eluard, Aragon, Desnos, Cocteau, Stravinsky, Maritain, Raynal, Zervos, Breton, etc. etc. . . .'. Surrealist writers and painters are present there in unlikely contiguity with, for example, Ozenfant and Jeanneret, who were proposing a modernism alien to Surrealism.

Dalí pursued his ideas about the modern world and its objects in other texts of the period, like 'Poesia de l'útil standarditzat' (Poetry of Standardized Utility), in which he praises the 'sensible and primary logic' of *L'Esprit Nouveau* and Le Corbusier. But the language in which he expresses his enthusiasm for simple machine objects is hardly that of Le Corbusier or of Ozenfant. The tone of a phrase like 'the tender joy of the black and vermilion numbers of the electric counting machine' recalls Satie's deliberately inappropriate proto-Dada musical titles ('Unappetizing Choral') though, as so often with Dalí, the sentimental element outweighs the humorous. 'Telephone,' Dalí exclaims in the same text, 'wash basin, white refrigerators painted with ripolin [an enamel paint], bidet, little gramophone . . . objects of authentic and purest poetry.' His attitude to the modern world is perhaps less like Le Corbusier's than like Apollinaire's, whose enthusiasm was mingled with iconoclasm in a spirit not unlike Dalí's 'anti-artistic world of commercial bill-boards!'

The disturbing incongruity between Dalí's lurid and excitable prose and the functional machine world he is praising is interesting and symptomatic. His enthusiasm for these man-made objects springs from what he describes as his anti-artistic viewpoint, or rather from his horror of the illegibility, confusion and visual inefficacy of the conventional 'artistic'. The objects of the modern world are by contrast clear, clean and pure. Dalí's 'hygienic soul', as Lorca described it, already shuns the emotional. At the beginning of 'Poesia de l'útil standarditzat' he quotes Le Corbusier, who wrote: 'strongest of all is the poetry of facts. Objects which signify something and which are disposed with tact and talent create a poetic fact.' But Le Corbusier's belief in the 'miraculous modern industrial world', as Dalí put it, still depends on the beauty of functional mechanics, while for Dalí the functional – which is not at all the same as the factual – is already being subsumed in the poetic. The seeds are there of the contortions to which he was later to submit the simple mechanical objects which never lost their fascination for him. The telephone, for example, is the central character in such paintings as *The Enigma of Hitler* of 1937 or *Beach with Telephone* of 1938, where the mouthpiece is suspended alone over a deserted landscape. And it is transformed, in the work he made for the patron of his early Surrealist days, Edward James, *Lobster Telephone*, with the substitution of a lobster for the mouthpiece.

The incongruity of his language is only sporadic, however, for in the long and serious text 'Nous límits de la pintura' (New Limits of Painting), published in February and April 1928, there is a sober discussion of *L'Esprit Nouveau* and the possibility of reaching through its ideas a genuinely popular art. The main burden, though, of 'New Limits of Painting' is a detailed account of Surrealist artists which shows him to be familiar both with their work and with Breton's latest writings. He is obviously near now to identifying himself with Surrealism, and attacks other critics, like Rafael Benet, an artist who also wrote for *Gaseta de les Arts*, for not understanding it properly.

By 1928 there was in fact a good deal of informed discussion in Spain about Surrealism, and close contact with the Surrealists themselves. Recent contacts had included the lecture the Surrealist poet Aragon gave in Madrid in 1925 (though there is no evidence that Dalí attended), and translations of French Surrealist poetry appeared regularly in the reviews, which also carried articles on Surrealism. These varied in tone from the explanatory to the critical. *L'Amic de les Arts*, which published several enthusiastic articles on Miró, nevertheless maintained an independent attitude to Surrealism. Lluis Montanyà, for example, Dalí's co-signatory on the *Anti-Artistic Manifesto*, wrote a 'Panorama' on Surrealism for *L'Amic de les Arts* in June 1928, which points out that realizations of Surrealist theory in terms of literary or artistic works worthy of attention are very thin on the ground, and also questions

33 Artur
Carbonell,
Christmas Eve, 1928

35 (opposite, left)
Yves Tanguy, *He
Did What he
Wanted*, 1927

36 (opposite, right)
Giorgio de Chirico,
*Melancholy of an
Autumn Afternoon*,
1915

34 *Apparatus and Hand*, 1927

whether the uncontrolled subconscious does not give birth anyway to monstrous, hybrid fruits. He quotes, interestingly, the caption to one of Goya's *Caprichos*, the great set of engravings of 1796 inspired by the Enlightenment: 'The sleep of reason produces monsters.'

It would now be interesting to look more closely at the Surrealist influence already noted in Dalí's 1927 painting, and at the nature of the reservations he still felt about fully committing himself to Surrealism. There were, I think, theoretical, not simply practical and geographical, reasons for these reservations. *Honey is Sweeter than Blood* and *Apparatus and Hand* were sent in to the Barcelona Autumn Salon, where they received a good deal of attention and were widely reproduced in the reviews. The influence of Tanguy is paramount (it is visible also in the works of Dalí's contemporary Carbonell), although there are also elements from Miró and Ernst. Tanguy's *Il faisait ce qu'il voulait* (He Did What he Wanted), has the same kind of figures scattered ambiguously through earth and sky and Dalí borrows the ghostly configurations in the sky, which in Tanguy's case are actually scratched through the paint. The central geometrical figure derives from a mixture of Tanguy and De Chirico, in such canvases as *Melancholy of an Autumn Afternoon*. But there are also striking contrasts between Dalí and Tanguy in terms of style. Tanguy's paintings have a rudimentary naivety and immediacy: a self-taught painter, he uses the simplest, almost childlike means to present his enigmatic images. Dalí, on the other hand, also makes sporadic

34

33
35

36

45

use of an almost academic realism, so that in *Apparatus and Hand*, for example, the torso on the left forms a strange contrast to its own ghostly repeats on the right of the central figure, which are rough and sketchy. In the context of his Cubist and neo-Cubist works during the preceding year, this torso is like an almost deliberate affront to modernism. It is not really surprising that these paintings should have had a largely hostile reception. They puzzled the critics, who appear to have found them incomprehensible, as well presumably as finding images like the rotting donkey distasteful. There is little light to be thrown on them, either, by the ideas expressed in the *Anti-Artistic Manifesto* and related texts of the following spring, which have already been examined, except in so far as the paintings too may be seen as 'anti-artistic' and deliberately removed from any aesthetic questions.

There are, however, some texts from the autumn of 1927 which are more or less directly related to these paintings, and which introduce an important dimension of Dalí's thought at the time missing from the more manifesto-like texts discussed above. In October 1927 he published in *L'Amic de les Arts* 'My Pictures at the Autumn Salon', in direct response to the adverse criticism. He was, he explains, trying to paint in the most normal and natural manner possible. His paintings are, he says, perfectly comprehensible to children, or to the fishermen of Cadaqués, who are able to look with 'pure' eyes. They are incomprehensible only to people with aesthetic preconceptions, who can understand the complexities and richness of contemporary 'artistic' painting, but have lost the ability to look at nature simply. Dalí goes on to admit the 'intervention of what we would call the poetic transposition of the purest subconscious and the freest instinct', recognizing in fact that he is appealing to the concept that lies at the very heart of Surrealism, the unconscious. However, he then goes to great pains to isolate what he sees as a crucial difference between himself and the Surrealists:

A living eye, the most anodyne and insignificant vegetable, a fly, are organisms infinitely more complicated, more mysterious, more un-expected, than any of my simple and primary organisms, which are described moreover with a clarity more precise than nature can offer us, always at the mercy of the slightest accident. To know how to look at an object, an animal, through mental eyes is to see with the greatest objective reality. But people only see stereotyped images of things, pure shadows empty of any expression, pure phantoms of things, and they find vulgar and normal everything they are in the habit of seeing every day, however marvellous and miraculous it may be. As I wrote recently, talking of photography: *To look is to invent.*

All this seems to me more than enough to show the distance which separates me from Surrealism. . .

37 *Untitled*, 1927

The other text Dalí is referring to here is 'La fotografia, pura creació de l'esperit' (Photography, Pure Creation of the Mind), published in September 1927. In this, Dalí praises both Henri Rousseau, who knew, he says, how to *look* better than the Impressionists, and Vermeer, but the main argument concerns photography, and its capacity for objective vision: 'Photographic fantasy; more agile and faster in discoveries than the murky subconscious processes!' By 'subconscious processes' he is clearly referring to Surrealist automatism and specifically to automatic drawing. He is, then, explaining the distance he sees between himself and the Surrealists as deriving from his preference for a kind of mental fantasy or reverie based on the objects of the external world rather than on the inner revelations of automatic drawing, and for which he sees photography as the best medium.

Dalí had, in fact, experimented at about this time with automatic drawing, as the unexpected example that surfaced in the 1980 Dalí exhibition at the Pompidou Centre in Paris revealed. The fact that there are few if any other examples of this suggests that he did not at the time find it a satisfactory method, as his writings of the period confirm. Much later, in 1974, he

37

47

maintained that this drawing was not Surrealist in a strict sense; only its calligraphy was Surrealist, and what distinguished it from Surrealist automatism was the drawing's 'desire to inform'. This distinction is one that is very much in line with his views at the time of making the drawing, though one might be justified in wondering how far it is verified by it. Dalí does, though, emphasize the drawing's importance because, he says, it prefigures the iconography of his future work; his cosmogony is already present there: 'the finger/phallic form/flies/viscous forms like jelly fish/biological elements/all sorts of soft and pliant elements.' It is certainly true that such shapes are visible and do correspond to the organic and lumpy forms in the 1927–8 paintings. It is hard to know what he can mean by 'Surrealist calligraphy', which would imply a fixed formal device of a type alien to Surrealism. There is a certain degree of resemblance between the short repeated strokes, furry hatchings, swarming fly-like marks, truncations and cramped fussy lines like unravelled knitting, so characteristic of Dalí's own 'calligraphy', and Masson's automatic ink drawings, which Dalí would have known from *La Révolution Surréaliste*. He seems, then, at this point, to have been opposed theoretically to automatism, though flirting briefly with its techniques, and to have been wary of the subconscious, while at the same time to have been attracted to that freedom of the imagination so valued by the Surrealists. For Dalí, though, it was to be an imaginative freedom based objectively on the poetry of facts rather than on a subjective inner world.

38

The emphasis Dalí places, in such texts as 'My Pictures at the Autumn Salon' and in those on film and photography, on objective vision and on the potential fantasy in objects themselves, placed him in a position that he saw to begin with as being at something of a tangent to Surrealism. And the more his paintings showed the influence of Surrealist painters like Tanguy, Miró, Arp, Ernst, Masson, the more tentative he felt them to be compared with his ideas about the camera. In December 1927, Dalí dedicated to Buñuel, a friend since his student days in Madrid, the text 'Film-art, fil antiartístique'. The film can, he wrote, realize images of a kind that painting is powerless to render; at the same time, it can itself provoke a new way of seeing. He attacks the dominance in the cinema of anecdote or of grandiose artistic emotion, the tendency to utilize cinema as a means to 'illustrate' the artistic imagination; he does not accept the attempts of Man Ray and of Léger to make a new type of film (although he admits theirs as by far the most interesting) because they make the mistake of starting from the world of invented forms, rather than from ordinary objects. 'The world of the cinema and of painting are very different; precisely, the possibilities of photography and the cinema reside in that unlimited fantasy which is born of things themselves.' The huge eye of a cow, he wrote in 'Photography, Pure Creation of the Mind' could contain a 'very white and miniature post-machinist landscape', and in 'Film-art, . . .', he suggested, 'a piece of sugar can become on the screen larger than an infinite perspective of gigantic buildings.'

For Dalí, the film was the medium he now urgently wanted to explore. When Buñuel, who was in Paris and had been working as Jean Epstein's assistant filming *The Fall of the House of Usher*, wrote to tell Dalí of a scenario he had written, Dalí replied that he too had just written a scenario which would 'revolutionize contemporary cinema'. Buñuel's script, involving the animation of various sections of a newspaper, was in Dalí's opinion mediocre and was abandoned. Buñuel spent part of the winter of 1928–9 with Dalí at Figueras and Cadaqués, and wrote to their mutual friend Pepín Bello: 'Dalí and I are closer than ever. We have worked in intimate collaboration on a formidable scenario, with no precedent in the history of the cinema.' Buñuel returned to Paris, with the completed scenario, to cast the film, and in March 1929 Dalí followed, and was closely involved in the shooting, which took place in Paris and Le Havre and was completed in six days. The film was called *Un Chien Andalou* (An Andalusian Dog), and was short, savage, and quite unprecedented.

Although, as Buñuel said, '*Un Chien Andalou* would not have existed if the movement called Surrealist had not existed' – and it is Surrealist in its psychic automatism, its 'ideology', its anti-artistic motivation, its aggression to the spectator – Surrealism had so far produced nothing like it on the screen, although some early theoretical texts on the cinema had discussed its capacity

to transform objects in terms very similar to Dalí's. Aragon, for example, had written in 'On Decor' in 1918: 'Children — poets without being artists — sometimes fix their attention on an object to the point where their concentration makes it grow larger, grow so much that it completely occupies their visual field, assumes a mysterious aspect and loses all relation to its purpose. . . . Likewise on the screen objects that were a few moments ago sticks of furniture or books of cloakroom tickets are transformed to the point where they take on menacing or enigmatic meanings. . . .' But so far the interest had largely been theoretical and passive rather than active. Dalí, Buñuel and the Paris Surrealists shared their admiration for the American cinema, and particularly for the comics, but whereas the Paris Surrealists went for Charlie Chaplin, Buñuel preferred Buster Keaton. Chaplin, in his opinion, had sold out to the intellectuals and no longer made the majority of the public, or children, laugh. In his review of Buster Keaton's *College* (*Cahiers d'Art*, no. 10, 1927) Buñuel describes the use of montage as 'the golden key of the film', and it is clear from *Un Chien Andalou* that his interest in the montage techniques of Keaton's films was an active and fruitful one, and he uses them for both macabre and comic effects.

Dalí and Buñuel worked closely together throughout the planning and the filming of *Un Chien Andalou*, and there was clearly a remarkable conjunction in their ideas. They unanimously rejected, to begin with, most avant-garde cinema of the time, which was more or less abstract, playing with light and shadow, photographic effects, invented forms and so on. Dalí wrote of their intention to revolt and provoke, to make a film that 'would carry each member of the audience back to the secret depths of adolescence, to the sources of dreams, destiny, and the secret of life and death, a work that would scratch away at all received ideas . . .'. Buñuel, in his 'Notes on the Making of *Un Chien Andalou*', describes the film as a 'violent reaction against what was at that time called "avantgarde cine", which was directed exclusively to the artistic sensibility', and continued: 'In *Un Chien Andalou* the cinema maker takes his place for the first time on a purely POETICAL-MORAL plane. . . In the working out of the plot every idea of a rational, aesthetic or other preoccupation with technical matters was rejected as irrelevant. The result is a film deliberately anti-plastic, anti-artistic, considered by traditional canons. The plot is the result of a CONSCIOUS *psychic automatism*, and, to that extent, it does not attempt to recount a dream, although it profits by a mechanism analogous to that of dreams. The sources from which the film draws inspiration are those of poetry, freed from the ballast of reason and tradition. Its aim is to provoke in the spectator instinctive reactions of attraction and repulsion. . . .'

The film lasts only seventeen minutes; it was originally silent, with records of an Argentine tango and Wagner's *Tristan und Isolde* played during the first

performance. Both Buñuel and Dalí make appearances in the film. Buñuel is seen in the opening sequence testing out a razor on his thumb-nail before the notorious sequence of the slitting of the girl's eye, for which they used an ox's³⁹ eye. This scene harks back to a menacing passage in Dalí's 'Nadal a Bruselles' (Christmas in Brussels), one of the 'Dues Proses' dedicated to Lluis Montanyà with the inscription 'Honey is sweeter than blood': 'A hair in the middle of the eye. I leave my handkerchief so that Anna can pull it out. A wide open eye with a hair across it. Afterwards Anna will bring some jam and some more wood. It is not yet six o'clock. A hair in the eye; in the depths of the eye there is the little face of an animal looking at us. The little animals, the females of the little animals, we mustn't blow the fire, you could get a spark in your eye.' Dalí appears fleetingly in a later scene dressed up as a priest.[40]

At the heart of the direct vitality of the shocking and poetic images in *Un Chien Andalou* is, as Buñuel said, the use of montage. The rapid montage sequences in the film achieve just that effect of a reverie rooted in the world of objects, one image leading to another, which Dalí had discussed earlier and had explored in his writings, but for which painting, as he said, was unsuited. The element of transformation in such sequences is paradoxical, for each separate image remains at the same time absolute, not a simile. Dalí is obviously aiming at this in such passages as the following from 'Dues Proses': 'It was a very large cow . . . no, it was a telephonist . . . no, it was a bone that was begging in the Jewish Quarter . . .' and: 'One morning I painted with ripolin a new-born baby which I then left to dry on the tennis court. After two days I found it bristling with ants which made it move with the anaesthetized and silent rhythm of sea-urchins. Then I realized that the new-born baby was no other than the pink breast of my mistress, frenetically eaten by the shining metallic thickness of gramophone needles.' Film can render such sequences of shifting images, as in the following early passage from *Un Chien Andalou*:

Large close-up of the hand full of ants.

The shot of the crawling ants dissolves into a close-up of a woman's armpit.

The woman is sun-bathing in a field; . . .

Dissolve from the armpit hairs to close-up of a sea-urchin's spines as it lies on the sand.

Dissolve to a head seen directly from above as though through the iris of an eye. The iris opens slowly to reveal an extremely masculine-looking young woman, dressed like a man and with a man's haircut. This young androgyne is holding a stick with which she moves a hand, severed and bleeding, lying on the ground. . . . Cut to the androgyne, seen further from above. Iris out to show her surrounded by a milling crowd. . .

39, 40, 41 Two stills and a
photograph of the set
from the film *Un Chien
Andalou*, 1929. Dalí
features as one of the
priests pulling the pianos
and rotting donkeys
(*centre*)

Buñuel has described the process of working on the scenario with Dalí: 'both took their point of view from a dream image, which, in its turn, probed others by the same process until the whole took form as a continuity. It should be noted that when an image or an idea appeared the collaborators discarded it immediately if it was derived from remembrance, or from their cultural pattern or if, simply, it had a conscious association with another earlier idea. They accepted only those representations as valid which, though they moved them profoundly, had no possible explanation.' 'NOTHING, in the film,' he goes on, 'SYMBOLIZES ANYTHING.' That is, he might have added, consciously, for he then admits that 'The only method of investigation of the symbols would be, perhaps, psycho-analysis.' But even psycho-analysis could not fully elucidate *Un Chien Andalou*. Its savage poetry, its confrontation between the rational and the irrational, could never be reduced to rational prose.

Like Surrealism, it constitutes an attack on the spectator, 'to the degree that he belongs to a society with which Surrealism is at war.' Jean Vigo discusses this aspect of *Un Chien Andalou*, in one of the best and subtlest accounts of it, *Towards a Social Cinema*. Our cowardly acceptance, he argues, of so many of the horrors that we as a species commit, is still dearly put to the test as the razor in the opening sequences slices the woman's eye in half. From that moment it is impossible not to be gripped. In one sequence the man, Pierre Batcheff, tries desperately to reach the girl who is cowering in a corner of the room. Searching for something to help him, he picks up two rope ends to which various objects are attached: including two recumbent priests and a grand piano filled with donkey carcasses, whose slimy dripping putrefaction was simulated by pouring pots of glue over the heads. This is grotesque comic relief, but also stands for the whole dead weight of a decaying society chaining the free expression of the man's desire. As Jean Vigo put it:

A cork, here is a weighty argument.
A melon – the disinherited middle classes.
Two priests – alas for Christ!
Two grand pianos, stuffed with corpses and excrement – our pathetic sentimentality! Finally, the donkey in close-up. We were expecting it.

In a slow flashback Batcheff murders the youth he was and thus the man he could have become; the film ends with a shot of 'a man and a young woman in a desert. They are buried up to their chests in sand, blinded, in rags, being eaten alive by the sun and by swarms of insects', an image of useless regret for a betrayed future ironically subtitled IN THE SPRING.

Some images in the film relate closely to the obsessional themes that already have begun to appear in Dalí's paintings: eroticism, death and decay. The putrefying donkey first appeared in *Honey is Sweeter than Blood* and

41

30

53

subsequently, among others, in *Senicitas* and *L'Ane pourri*. In the film, elements associated with decay, like swarming ants, are transposed to the humans – a close-up of Batcheff's hand, trapped in a door, shows ants

apparently crawling out of a hole in his palm. A later painting, *Dream* (1931), combines this with another sequence in the film where Batcheff, to terrorize the girl, wipes his hand across his face, apparently removing the mouth and leaving smooth flesh, which then bristles with her own underarm hair. In another 1931 painting, *The Persistence of Memory*, the ants swarm on the case of a watch like a biological *memento mori*. These images of decay have, as Dalí has frequently recalled, sources in his childhood. In '. . . L'alliberament dels dits . . .' (The Liberation of the Fingers), published in *L'Amic de les Arts* in March 1929, Dalí described seeing a lizard decomposed and eaten by ants when he was three or four years old. Another incident that profoundly affected him as a child is recounted in *The Secret Life*. His cousin gave him a wounded bat, which he adored, and left overnight in a little pail in the washhouse. 'Next morning a frightful spectacle awaited me. When I reached the back of the washhouse I found the glass overturned, and the bat, though still half alive, bristling with frenzied ants.' At that moment he saw a young woman he much admired at the gate, and suddenly committed an act incomprehensible to himself: picking up the bat, instead of kissing it as he thought he would do, he bit it violently, and then overcome with horror threw it away.

42 *Dream*, 1931

Dalí's enthusiasm for photography and film continued to find expression in the texts he wrote at the end of 1928 and beginning of 1929 for Catalan reviews, such as 'Realidad y Sobrerrealidad' (Reality and Surreality) and 'La Dada Fotogràfica' (Photographic Fact). Where these differ, though, from the earlier texts is that he now sees the camera's objective vision, its capacity to reveal the marvel of ordinary objects, as being quite compatible with Surrealism. In 'Photographic Fact' he wrote: 'Photographic data . . . is still and ESSENTIALLY THE SAFEST POETIC MEDIUM and the most agile process for catching the most delicate osmoses which exist between reality and super-reality.

'The mere fact of photographic transposition means a total invention: the capture of a SECRET REALITY. Nothing proves the truth of super-realism so much as photography. The Zeiss lens has unexpected faculties of surprise!'

Perhaps the distance he had previously kept between himself and Surrealism (in 'My Pictures at the Autumn Salon', for example) had been a result of seeing Surrealism as inflexibly wedded to the principle of automatism; now, he clearly saw that it was more flexible and could extend to include his own ideas. It is very possible that Buñuel, who had already been in contact with the Surrealists in Paris, had helped Dalí to greater understanding of the movement, and certainly working on *Un Chien Andalou* had given him greater confidence. The year 1928 had in fact marked something of a change in Surrealism too, a greater richness and a sense of new directions; during this year Breton had published a series of collected articles as a book, *Le Surréalisme et la peinture*, the most important statement so far about the relationship between painting and Surrealism, which showed how far Breton was from preserving a dogged rigidity over the principle of automatism, and also *Nadja*, an extraordinary study of his relationship with a young and beautiful but mentally disturbed girl. The book 'you love so much', Buñuel once remarked to Dalí of *Nadja*.

Dalí did not, however, commit himself to Surrealism until the summer of 1929, and his painting meanwhile shows him still working under the dominating influence of the first generation of Surrealist artists: Tanguy, Arp, Miró, Ernst, Masson. In spite of his enthusiasm for photography – an enthusiasm he shared with the most innovative of the European reviews, notably, apart from *La Révolution Surréaliste*, *Documents* and the Belgian review *Variétés*, and with Breton who illustrated *Nadja* with Boiffard's photographs of Paris – he did not practise it himself. His articles were often illustrated with photographs – 'La Dada Fotogràfica', for example, had photographs of a detail of the Catalan Romanesque cross of Vilabertrán, a studio portrait of the film star Wallace Beery, and a racing motorbike – but he never seems to have contemplated abandoning painting in its favour.

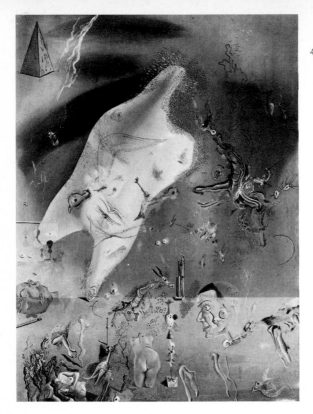

Although he had explicitly compared painting unfavourably with photography for the expression of certain kinds of images or sequences of images, he is none the less in several 1928 paintings trying to transmit precisely that process of transformation which can be achieved on the cinema screen by dissolve or montage. In *Senicitas*, for example, the large central torso is shown bristling with black or with mixed red and yellow strokes which in one place obviously represent underarm hair, but elsewhere simply look like bristles. This is an attempt to realize on canvas the kind of chain of images already described from 'Dues Proses' or *Un Chien Andalou*, where for example a woman's armpit hairs dissolve to sea-urchin spines.

Clustered more thickly in the lower part of *Senicitas* are scattered fragments of more carefully realized objects which suggest a state of delirium. Dalí is now mixing techniques of representation in his paintings, so that some images are half-realized and ghostly, others vividly palpable. In this he follows De Chirico and Max Ernst, who used both illusionistic modelling and a very rudimentary drawing in *Pieta, or Revolution by Night*. This type of naive drawing, of which there are several examples in *La Révolution Surréaliste*,

stemmed from the idea that the contents of a dream should be noted down immediately and as fast as possible in order to avoid the distorting influence of memory and the intervention of learned drawing skills. The thin composite creature in the lower centre of *Senicitas* descends both from the Surrealist *cadavre exquis* (the child's game of head, body and legs) and from the strange personages and creatures that people such canvases by Miró as *Harlequin's Carnival*. This creature, and the roughly outlined heads and arms, form a very strange contrast with the livid upright torso in the lower centre below the horizon line, which is painted with all the unreal illusionism of the academic nude. The Miróesque genitalia, phallic fingers and the dominant lumpen, biomorphic torso in *Senicitas* obviously do relate to Arp and to Miró, but he makes a much more convincing use of this organic morphology in other canvases, also of 1928, like *Bathers*, *Bather*, or *Unassuaged Desires*. In *Bather* Dalí 44
expressively exaggerates the body in the way Miró does in *Figure Throwing a Stone at a Bird* (1926). The theme of masturbation which runs through the 1929 paintings surfaces here clearly for the first time. The tiny round head with schematic features tops a hermaphroditic body with a swollen arm merging into a sex organ which is also shown displaced into the palm of the other hand. In *Bathers* the torso becomes a single gigantic digit, a metamorphosis which relates to several other paintings of this time. *L'Oiseau Blessé* (The Wounded 45
Bird, 1926) floats the phallic finger on an abstract sanded ground, and in *Anthropomorphic Beach* its ambiguous sexual connotations are emphasized. In 'The Liberation of the Fingers', which Dalí illustrated with photographs of

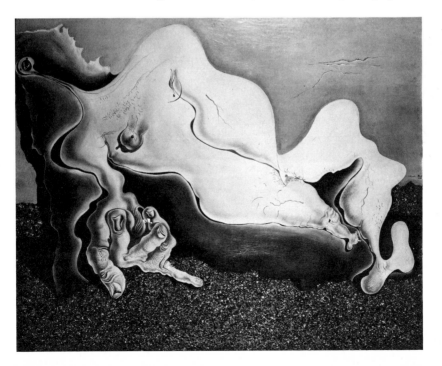

45 *The Wounded Bird*, 1926

fingers, he tells an anecdote related to this image. He had met, during his military service, a man with whom, although uncultivated and ill-read, he came to a close understanding 'on the most inaccessible things'. Dalí showed him Surrealist texts and they seem to have practised automatic writing. Dalí was impressed by his free imagination; one day, he announced suddenly, while they were sitting in a café, 'There is a flying phallus', and proceeded to draw it on the marble café table. Only later, Dalí added, did he come across Freud's allusion to the winged phallus of ancient civilizations.

44 The soft and ambiguous forms in, for example, *Bather* also draw upon the kind of morphology Arp had developed in the twenties, in which one configuration could mean more than one thing: a shape could suggest both a bird and a moustache, but also be independent of both, thus challenging conventional designations. Dalí was intrigued intellectually by this, as much as he was plastically, and refers more than once in 'New Limits of Painting' to
47 Breton's passages in *Le Surréalisme et la peinture* on Arp's relief *Mountain, Table, Anchors, Navel*: 'The word table was a begging word: it wanted people to take a meal, to rest their elbows or not, to write. The word mountain was a begging word: it wanted people to gaze in contemplation, to climb or not, to breathe . . . In *reality*, if we know by now what we mean by that, a nose is not only perfectly at ease by the side of an armchair, it even takes the exact shape of the armchair. What difference is there *basically* between a pair of dancers and
46 the dome of a beehive?' In the cork relief *Torso* (Feminine Nude), or the large,
48 strange and bare canvas *Sun*, Dalí is trying out with varying success a morphology based on Arp.

Sometime at the end of 1927 Dalí had begun to incorporate sand of various textures into his paintings, influenced by Masson's extension of automatic techniques on to canvas, when he freely poured sand on to a sticky surface, but his controlled use of it recalls rather Picasso's incorporation of sand in late Cubist paintings.

49 In *L'Ane pourri* (The Putrefied Donkey, 1928) he incorporates stones and sand of different textures into a highly organized canvas surface, where they form a striking contrast with the painted areas. The paint has a smooth, hard and brilliant finish, almost perfectly even, with barely a visible brushstroke. An analysis of a fragment of paint has revealed that Dalí was already, by this time, experimenting with different resins, as he was to describe much later in *50 Secrets magiques* (written in 1947 but not published until 1974). The pink tones of this painting come from the mixture of 'dragon's blood', a bright red gum or resin obtained from the fruit of a palm, and zinc oxide, a white pigment. The pigment is so completely ground in that no grains are visible, and Dalí is

49 *The Putrefied Donkey*, 1928

50 *Bird*, 1929

effectively painting in enamel, without any use of oil. Such enamel dries swiftly to a glass-like hardness, which could well have helped Dalí to develop the miniaturist technique that begins to mark his paintings.

Tentative though the paintings of 1928 are in contrast to *Un Chien Andalou*, and highly varied and eclectic in style, they are none the less beginning to reveal the iconography and obsessive themes of his subsequent work. His increased closeness to the Surrealists is manifested, too, in a marked tendency to draw upon literature, and specifically upon Surrealist poetry. At least one painting from 1928, *The Spectral Cow*, is based on an account of a dream in Breton's *Clair de Terre* (1923), as well as being modelled very closely on Ernst's *La Belle Saison*. In the dream in *Clair de Terre*, two birds fly over a beach where Breton is swimming, and as he and the rest of the company carry guns, someone fires, and one of the birds is wounded. They fall some distance out to sea, and as the waves gradually bring them closer, 'I observed that these animals were not birds, as I first thought, but sorts of cows, or horses. The unwounded animal supported the other with great tenderness. As they reached our feet, the latter died.'

Both the bird and ghostly cow are present on the beach in *The Spectral Cow*, and there are echoes of this dream in *The Wounded Bird*. Breton's dream feeds directly into Dalí's recurrent image of the decaying donkey, where it is stripped of its romantic associations while retaining the grotesque, but it also probably fascinated Dalí because it involved the same kind of transformation for which he was still seeking a pictorial equivalent, and which could so successfully be captured on the screen. Not until he developed his 'paranoiac–critical method' the following year did he approach a solution.

61

51 Max Ernst, *La Belle Saison*, 1925

52 *The Spectral Cow*, 1928

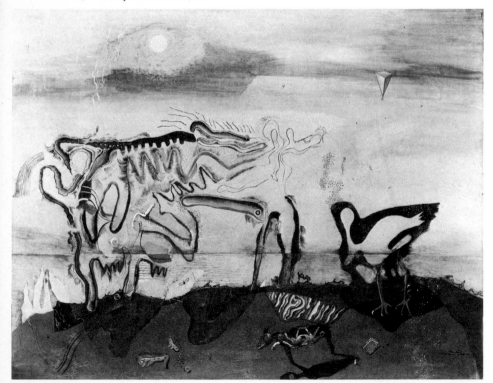

In October 1928 the Barcelona Autumn Salon turned down his painting *Big Thumb, Plate, Moon and Decaying Bird*, because the jury, it seems, was shocked by some of its erotic allusions. Dalí has claimed that it was in response to this that he painted *The First Days of Spring* early in the following year, which was, as he says, 'truly a veritable erotic delirium', and was the first of a series of canvases in a new style.

The end of Dalí's collaboration with *L'Amic de les Arts* was marked by the issue of 31 March 1929, almost entirely masterminded by Dalí, with a new layout and a bizarre 'anti-artistic' tone closest to *Variétés*. Dalí contributed several texts to it, including his interview with Buñuel and an appreciation of Harry Langdon ('one of the purest flowers of the cinema and, hence, of our CIVILIZATION'), as well as the front page editorial in which, summing up a number of the themes that had run through the previous two years, he announces the unique importance to him of Surrealism.

Gasch, whose friendship with Dalí came to an abrupt end in 1931, has left a vivid memoir of him during these years in Catalonia:

> Dalí had all the appearance of a sportsman. He wore a brown jacket made of homespun and coffee-coloured trousers. It was an extraordinarily baggy outfit which allowed complete freedom of movement to his very slim body with its tense or relaxed muscles of steel. . . . His hair was jet-black, smooth, and plastered down with plenty of brilliantine. His face, with skin as tight as a drum and as shiny as enamelled porcelain, was brown and seemed to have been recently made up as if for the theatre or the cinema. A wisp of moustache – a very fine line, imperceptible at first glance, as if traced with a scalpel – adorned his upper lip. In that hard, stiff, inexpressive wax doll's face, his tiny, feverish, terrible, menacing eyes shone with extraordinary intensity. Frightening eyes, as of a madman. The timbre of his voice was hoarse, rough, dull. . . . He had an abrupt, nervous manner in the way he spoke, but *what* he said was incontrovertibly logical. Everything he said was articulate, coherent, and to the point. He gave you the sensation that, having laboriously solved a series of moral and aesthetic problems, he had managed to secure certain crystal-clear ideals regarding the divine and the human, and now he was explaining this with absolute clarity – a clarity that betrayed his Ampurdán origins. . . . What may be stated without fear of contradiction is that in him irony reached the level of incredible cruelty. A cold, dauntless, terribly quiet cruelty. Everything he said and did revealed a total absence of heart. On the other hand his intelligence was exceptional, and disturbingly lucid. In all his doings, in all his sayings, and naturally in all his paintings, the man always appears cerebral, cold, calculating. This is the origin of his congenital cruelty, which became even more acute when he joined the Surrealists.

54

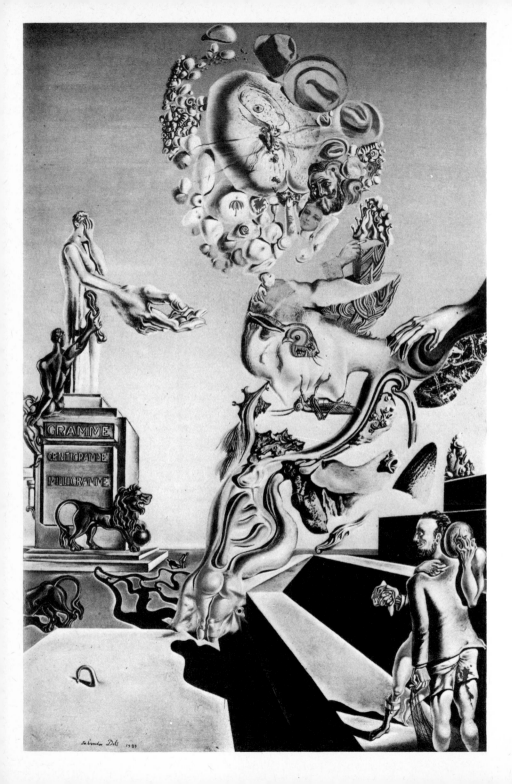

Dalí, Surrealism and psycho-analysis

Dalí's official affiliation with the Surrealist movement; the influence of Freud and psycho-analysis on his painting; collage; the legend of William Tell as obsessive theme; Dalí's theoretical differences with Breton, and relationship with Surrealism on questions of taste and politics; Dalí, history and tradition.

Dalí finally joined the Surrealist movement in the summer of 1929, and thereby moved into the centre of the European avant-garde. To be a full member of the group at this time it was essential to be at the heart of the activities, in Paris, attend the frequent café meetings and sessions in the apartment of André Breton, the movement's leader, contribute to the Surrealist reviews and participate in group exhibitions. Although Dalí retained contacts with his Catalan friends, returned regularly to Cadaqués in the summer – and gave a memorably scandalous lecture on Surrealism at the Ateneo in Barcelona in 1930 – his theatre of action now became, primarily, for the next five or six years, Paris.

The first public sign of his new affiliation was the catalogue preface Breton wrote for Dalí's first one-man show in Paris at the Camille Goemans Gallery in November 1929. The twelfth and last issue of *La Révolution Surréaliste* (December 1929), which contained the *Second Surrealist Manifesto*, reproduced two recent paintings, *Accommodations of Desire* and *Illumined Pleasures*. From this point until 1936 Dalí contributed texts regularly to the successive major Surrealist reviews, *SASDLR* (*Le Surréalisme au Service de la Révolution*, 1930–33) and *Minotaure* (1933–9). Goemans was the dealer for most of the Surrealist painters; after he closed down, Dalí moved to Pierre Colle, who not only put on one-man shows of his work in 1931, 1932 and 1933 but late introduced Dalí to his energetic New York dealer, Julien Levy. Many of Dalí's paintings were acquired by Surrealists: Breton bought *Accommodations of Desire* and *William Tell*, Eluard *Apparatus and Hand*, among others; the most notorious of his paintings of this period, though, *Le Jeu lugubre* (Dismal Sport), 53 was bought by the Vicomte de Noailles, Maecenas of modern art in Paris, and hung in his Paris dining-room between a Cranach and a Watteau.

This was the painting, centrepiece of the November 1929 Goemans exhibition, and effectively Dalí's 'reception piece' for Surrealism, on which he had worked passionately over the summer in Cadaqués. It was the consummation of a change that had already taken place in his work before

65

53 *Dismal Sport, 1929*

leaving Paris that summer, visible in *The First Days of Spring*. But before discussing this change in his painting further, and its relationship to Surrealism, it is worth disentangling the stages of Dalí's adherence to and acceptance by the Surrealists and considering what connections this may have had to the traumatic internal and external crises that had shaken Surrealism during 1929.

Dalí had remained in Paris, after the screenings of *Un Chien Andalou*, during most of the early summer of 1929, and had begun to achieve a certain notoriety, as well as the active interest of the Surrealists and other groups, notably that loosely centred on the review *Documents*, headed by Georges Bataille and including many dissident Surrealists. But the main impression from Dalí's various memoirs of this period is one of loneliness and isolation, and of a character, as he himself describes it, composed paradoxically of great timidity and naivety combined with Napoleonic ambition. Although he had begun, before leaving Paris, to see the Surrealist poet Paul Eluard, and the Belgian painter Magritte, to whom he was introduced at the apartment of Goemans, who was already Miró's, and now his, dealer, he was not invited to participate in Surrealist gatherings, nor was he circulated even as a 'fellow traveller' about the notorious meeting summoned by Breton in February

54 *The First Days of Spring*, 1929

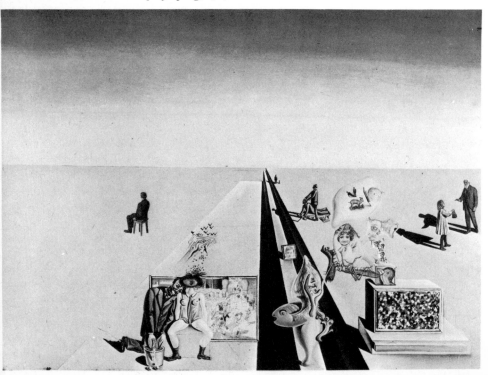

55 Photograph of Gala and Dalí, the frontispiece to his *L'Amour et la mémoire*, Paris, 1931. Dalí shaved his head when he was banished from his father's house. He poses here with a sea-urchin on his head

1929, to which a number of ex- and non-Surrealists, including Bataille, had been invited, ostensibly in an attempt to agree on some sort of common action against intellectual and political repression. It had ended in bitter acrimony between the various groups, had consecrated the break between Bataille and Breton, and led to the resignation of several other Surrealists disillusioned by the censorious attitude of the Surrealist leadership. At the heart of this crisis, of which the February meeting was one of many symptoms, was Breton's attempt to integrate Marxism into Surrealism, and this was the pole around which his quarrel with Bataille turned. The *Second Surrealist Manifesto* was an effort to reformulate Surrealist principles, and discussed at length the unhappy relationship with a sceptical French Communist Party into which Surrealism was locked; it also savagely attacked Bataille, in whom, Breton wrote, 'What we are witnessing is an obnoxious return to the old anti-dialectical materialism, which this time is trying to beat a path through Freud . . .' and at the same time excommunicated a number of dissidents like the poet Robert Desnos. Dalí himself was not directly involved in this crisis, but it did have immediate relevance for him, in that, before he left Paris in the early summer of 1929 his main contacts appear to have been with the dissident group around *Documents*. Miró, Dalí's fellow Catalan and first guide to Paris, was now comparatively estranged from Breton, and his latest work was reproduced in *Documents* rather than in *La Révolution Surréaliste*, while it was to Robert

Desnos, now a close collaborator of Bataille's, that Dalí showed his first painting in his new style, *The First Days of Spring*. Desnos could not afford, to his regret, to buy it, but 'waxed lyrically enthusiastic' and exclaimed that nothing like it had been seen before. *Documents* was in fact the first Paris review to reproduce paintings by Dalí: in September 1929 it showed the two pictures that had been exhibited at the Abstract and Surrealist Art exhibition in Zurich, juxtaposed interestingly with an anamorphic painting to suggest a source for Dalí's bizarre distended morphology, and also the painting now known as *Honey is Sweeter than Blood*, but more aptly and strikingly entitled by Bataille 'Blood is Sweeter than Honey'. In the same issue Bataille wrote about *Un Chien Andalou*, made by 'two young Catalans [sic]': 'Very explicit facts succeed one another, without logical connection it is true, but penetrating so far into horror that the spectators are engaged as directly as in adventure films. Engaged, and at the same time caught by the throat, and without any artifice: do the spectators know where they will stop, the authors of the film, or people like them? If Buñuel himself after the shooting of the cut eye was ill for a week (he had to film the scene of the donkeys' corpses in a pestilential atmosphere) how is it possible not to see at what point horror becomes fascinating and also that it alone is brutal enough to break what stifles.'

What becomes apparent is that Bataille saw in Dalí a possible accomplice in his attack on what he considered the anti-materialist idealism of the Surrealists. It is also true that Bataille probably understood Dalí better than Breton did, and could sympathize precisely with those aspects of Dalí's interest in the materiality of objects, and in the grotesque and the shocking, which Dalí himself felt were out of line with the Surrealists. There is a curious affinity between certain aspects of *Documents* and *L'Amic de les Arts* while it was under Dalí's influence – the deliberate inclusion of 'anti-artistic' material, praise of American 'review-girls', and the scattering of bizarre illustrations; the photographs accompanying Bataille's article 'The Big Toe' form an odd parallel to those close-ups of human fingers and thumbs in Dalí's 'The Liberation of the Fingers'. There is no evidence that Bataille and Dalí met at this time, but Dalí certainly read Bataille, and works like his erotic masterpiece *L'Histoire de l'œil* (The History of the Eye, 1928) remained for Dalí one of the capital books of his life. Bataille planned, for the December 1929 issue of *Documents*, an article on the painting which Dalí had completed over the summer and sent for exhibition at the Goemans Gallery in November, *Dismal Sport*. But Dalí, now alerted to the bitter ideological battle between Bataille and Breton, and fearing to be compromised in his new relations with the Surrealists by contact with Bataille, refused him permission to reproduce it. Bataille went ahead with the article, but reproduced in place of the missing picture a schematic drawing offering a psycho-analytical interpretation revealing the theme of emasculation. The article explicitly enlists Dalí in his

68

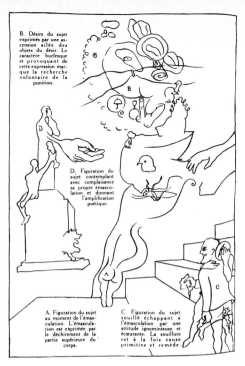

B. Désirs du sujet exprimés par une ascension ailée des objets du désir. Le caractère burlesque et provoquant de cette expression marque la recherche volontaire de la punition.

D. Figuration du sujet contemplant avec complaisance sa propre émasculation et donnant l'amplification poétique.

A. Figuration du sujet au moment de l'émasculation. L'émasculation est exprimée par le déchirement de la partie supérieure du corps.

C. Figuration du sujet souillé échappant à l'émasculation par une attitude ignominieuse et écœurante. La souillure est à la fois cause primitive et remède.

56 Georges Bataille's schematic drawing interpreting Dalí's *Dismal Sport* which appeared in *Documents*, December 1929

attack on the Surrealists. Bataille argues that in his paintings, as in *Un Chien Andalou*, Dalí rejects the 'artistic alibi' and offers a brutal affront to the polite world of poetic half-truths. Picasso's paintings may be hideous, he writes, but Dalí's are of a terrifying ugliness. He places Dalí in a direct line of descent from the Marquis de Sade and Isidore Ducasse, Comte de Lautréamont, both also heroes of the Surrealists, whom Bataille mocks for making of 'a man like Ducasse an abominable poetico-religious idol'. How, he adds in a note to the text, can the Surrealists have seen, in a painting with subject-matter like *Dismal Sport*, 'the mental windows opening wide' – as Breton had claimed in his catalogue preface to the exhibition.

It is clear enough, then, why, given his aim to join with the Surrealists, who demanded an exclusive allegiance, Dalí should have backed promptly away from too close an association with Bataille, who had touched, in his attacks on Surrealism, a particularly raw place. Apart from a natural affinity of ideas, the Surrealists offered him valuable contacts, a public forum, and the most stimulating intellectual and artistic environment. Dalí has never made it a secret either, that he nourished hopes of dislodging Breton from the leadership. It is impossible to say how serious this ambition was; in any event, if there was an attempted putsch it failed, and Dalí had to content himself with becoming, over the next few years, Surrealism's most exotic and prominent figure.

This leaves the question, still, of what Dalí himself offered the Surrealists, and why they were keen to welcome this new recruit. It was partly, of course, simply a matter of the need for new blood after the crisis already discussed. Dalí quite clearly already had, by 1929, an individual voice, and it is significant that the illustrations in the last issue of *La Révolution Surréaliste* – works by Magritte and Dalí, and collages by Max Ernst – marked a real break with the emphasis on a free flowing automatism which had dominated earlier issues. Different as they were from each other, these works had in common an emphasis on the image itself.

A decisive change, already mentioned, had taken place in Dalí's paintings in the late spring and summer of 1929, in *The First Days of Spring* and *Dismal Sport*. There is a new confidence in these paintings after the stylistic vagaries of the previous years, a concentration and clarification of the themes that lurk in the works of 1928. A major factor in this change was his discovery of ways of using his extensive readings in pyscho-analytical textbooks, of finding visual equivalents for that material and combining it with the very personal imagery that had begun to appear in the earlier paintings. One of the most striking characteristics of Dalí's new manner is the establishment of a dream-like setting based on the deep space of De Chirico and the early Surrealist paintings of Ernst; it is very possible that a direct impetus for Dalí was his opportunity of seeing in the flesh, as it were, the works by De Chirico and Ernst hanging in Eluard's apartment in Paris. Among other things Eluard owned Ernst's *Pieta, or Revolution by Night*, which seems above all to have cast its spell over Dalí.

The richest common ground between Dalí and the Surrealists was certainly at this point provided by their mutual interest in psychology and psycho-analysis. It is worth noting, perhaps, that both the Surrealists and Bataille leaned heavily on Freudian theory, and indeed it was the very closeness of their basic interests that exacerbated the ideological conflict between them. Bataille once described himself as 'Surrealism's old enemy from within'. Thus for Dalí to have held an interest for both camps is not so surprising. In many ways Bataille was better able to face the 'textbook case' nature of some of Dalí's imagery, the aberrations and perversities of his sexuality as revealed through his paintings, viewing it with the cold eye of the social psychologist, than was Breton, whose attitude to sex was curiously romantic and puritanical.

On his return to Cadaqués, then, in the summer of 1929, Dalí immediately began work on *Dismal Sport*. He was in a state of high mental excitement, bordering on hysteria, and would be gripped by sudden and violent fits of laughter, provoked by grotesque scenes conjured up in his imagination or for no reason at all. The arrival of his new friends from Paris, his dealer Camille Goemans, and then the Magrittes and Paul Eluard with his wife Gala did nothing to alleviate this: 'From hour to hour my fits of laughter grew more violent, and I caught in passing certain glances and certain whisperings about

me by which I learned in spite of myself the anxiety which my state was beginning to cause. This appeared to me as comical as everything else, for I knew perfectly well that I was laughing because of the images that came into my mind. . .'. Dalí's guests, attracted by his 'unusual personality', as he said, to come all the way to Spain, understandably failed to see anything comic in the images Dalí tried to explain to them – a little sculptured owl, for example, stuck on the head of a very respectable person, and on the owl's head a piece of his own excrement. The progress of *Dismal Sport* was followed with interest, and then with growing concern, by the little group of Surrealists. Finally Gala Eluard, who, after initially finding Dalí not only peculiar but obnoxious, with his 'pomaded hair and his elegance', his love of personal adornment left over from his student days in Madrid, and who had been startled and intrigued by 'the rigour which I displayed in the realm of ideas', was deputed to question him about the significance of certain elements in the painting. What worried them in general was the liability they thought Dalí ran of turning his paintings into mere psycho-pathological documents, and, in particular, the significance of the excrement-bespattered pants of the man in the right foreground, which they feared might reveal unacceptable aberrations on Dalí's part. Dalí successfully reassured her; 'I swear to you that I am not "coprophagic". I consciously loathe that type of aberration as much as you can possibly loathe it. But I consider scatology as a terrorizing element, just as I do blood, or my phobia for grasshoppers.' (Dalí presumably intended the more general term 'coprophilous', i.e. shit-loving, rather than 'coprophagic' or shit-eating.) Although doubts about Dalí's 'aberrations' lingered – they are there, for example, in Breton's catalogue preface for the Goemans exhibition – his protestations were accepted, and he was from that time considered a member of the Surrealist movement.

Dalí was spending almost all his day absorbed in working on *Dismal Sport*, and as he worked he began to relive childhood fantasies, or rather see images 'which I could not localize precisely in time or space but which I knew with certainty I had seen when I was little'. Among these were images of small green deer, 'reminiscences of decalcomanias', or of the marblings he used to make with his sister, and other more complicated and condensed images like the rabbit whose eye also served as the eye of a parrot, and a third head, 'that of a fish enfolding the other two. This fish I sometimes saw with a grasshopper clinging to its mouth.' Either separately or as a composite image, these creatures appear in most of the paintings of the extraordinarily creative months following *Dismal Sport*, as for instance in the *Portrait of Paul Eluard*. 67 The association of the fish and the grasshopper is interesting because it is one of the first instances of Dalí pursuing obsessively an image which inspired him with horror. Dalí is aware of, and makes explicit, the sexual impetus behind this obsessive horror. The fish/grasshopper is also a reference to an incident in

his childhood, which, he says, he had repressed until his father brought it to his attention, and which he describes in 'The Liberation of the Fingers'. He had loved grasshoppers when he was a child, until one day he caught a slimy little fish called a 'slobberer', brought it up close to his face to inspect it, and found that it had a face identical to the grasshopper. From that moment he had a fear of grasshoppers so intense that his schoolmates quickly found they could play upon it to terrorize him, catching grasshoppers to place among his books, which never failed to provoke him to a state of near hysteria. The grasshopper in *The First Days of Spring*, fastened to the mouth of the young man's head (Dalí himself), with a threat half-cannibalistic and half-sexual, is, then, an image of horror, repeated in *Dismal Sport* and *The Great Masturbator*.

Dalí decided to reproduce these images which appeared to him 'as scrupulously as it was possible for me to . . . following as a criterion and norm of their arrangement only the most automatic feelings.' He kept *Dismal Sport* on an easel at the end of his bed, so that it was the last thing he saw on going to sleep and the first on waking. 'I spent the whole day seated before my easel, my eyes staring fixedly, trying to "see", like a medium (very much so indeed) the images that would spring up in my imagination. Often I saw these images exactly situated in the painting. Then, at the point commanded by them, I would paint, paint with the hot taste in my mouth that panting hunting dogs must have at the moment when they fasten their teeth into the game killed that very instant by a well-aimed shot.' The comparison with a 'medium' introduces the idea of automatism, which was of course the core of the definition of Surrealism Breton gives in the first *Surrealist Manifesto*: 'Pure psychic automatism through which it is intended to express, verbally or in any other way, the true functioning of thought; thought transcribed in the absence of any control exerted by reason, and outside any moral or aesthetic preoccupation.' The way this had been interpreted by artists like Masson was, however, very different from the sense Dalí is giving his automatism. For Masson, the drawing would start without any preconceived subject, but as it proceeded would bring swimming to the surface of the conscious mind images from the unconscious, unrecognized obsessions, etc, which could undergo transformations in the process of the drawing. For Dalí, on the other hand, the images were rather waking dreams which arrived already fully formed rather than in the metamorphosing or half-realized state in which they would take shape within a purely automatic drawing. It is a question of transposing them on to the canvas more or less 'ready made', and it was in this way that Dalí saw his role as something like that of a medium – a comparison which still lies well within the Surrealist framework. The techniques of the medium, that for example of the self-induced trance, had played an important role in early Surrealist experimentation; but an essential difference between the Surrealist and the medium was spelt out later by Breton in his 'Message automatique' –

the Surrealist does not accept that the messages received unconsciously, or automatically, are transmitted from outside, as 'spirit voices' from elsewhere. The 'recording' is of the inner unconscious. The transcription of the waking dream or voluntary hallucination on to canvas, as rapidly and 'automatically' as possible, is then analogous to the 'recording' of the medium, but of the subject's own experiences or 'visions' rather than those of some outside person. In offering this explanation of his procedure Dalí is probably also trying to avoid the criticism that was levelled at the kind of 'dream image' offered by De Chirico, voiced for example in such texts as Max Morise's 'Enchanted Eyes' (*La Révolution Surréaliste*, no.1), which Dalí knew, and which argued that the pristine nature of the original dream image could not be retained in being transmitted to canvas because it was subject to the deformation of memory and to subsequent conscious manipulation. So Dalí insisted on the automatism of the transcription of the images that arose in his imagination – an insistence he has in fact returned to in his more recent work, once assuring me that large areas of *Hallucinogenic Toreador* were painted purely automatically.

In *Dismal Sport* Dalí uses a graphic visual conceit to invoke the mediumistic characteristics of the painting by showing a horde of multi-coloured images, little stones, etc, rising from his head, an image borrowed directly from a certain type of medium's drawing which similarly shows the medium's 'vision' rising from her own forehead.

What Dalí appears to be attempting, then, is to mesh visually the two strands of Surrealist activity dominant during the twenties, automatism and the dream narrative. Both of these are linked to Freud in the first *Surrealist Manifesto*, which pays homage to Freud for his scientific exploration of the human mind, thanks to which not only had hidden areas of the human psyche been revealed, but also mechanisms for reaching them: the dream, whose direct connection with the unconscious is explored in Freud's *Interpretation of Dreams*, and the monologue obtained from the patient under analysis. Freud's stress on the importance of the dream and the free, unconstrained monologue as routes to the unconscious provided models for the two main streams of Surrealist activity. However, what the Surrealists valued above all were the implications of Freud's discoveries for the liberation of the human imagination, and the value of the unconscious as a quarry for poetic images. Psycho-analysis as such was of less interest to them.

So far, Dalí's account of the making of *Dismal Sport* has been considered largely in so far as it relates theoretically to the Surrealist principles of automatism and so on. The only criterion Dalí had followed in arranging the images that came unbidden into his head as 'voluntary hallucinations' was his 'most uncontrollably biological desire'. They were, he claimed, determined neither by conscious thought nor by questions of taste, but the impression is none the less strong that they are linked by some kind of almost narrative

147

thread. If we look a little more closely at his description of the genesis of the picture's imagery, it becomes clear that it relates to Freud in a quite direct way, and not just as mediated through Surrealist theory.

The first point to note is that Dalí stresses the fact that many of the images that surfaced were, or were very closely related to, childhood memories. Freud emphasized the importance of a patient's childhood memories and associations as an aid to analysis, for they were often crucial to the unravelling of the latent content of a dream, or the cause of an obsession. Dalí's account of the making of *Dismal Sport*, too, does not claim that it is a single dream image; the images come severally and at different times into his head, and may have different sources. Nor are they restricted to one painting; they are, as we saw with the grasshopper, repeated several times in the paintings of this period. This repetition must be thematically significant, and suggests, given Dalí's references to his childhood and his known state of mind at the time, that they must be linked to some dominant obsession. The questions then arise, how 'innocent', how 'automatic' even, these images are, and how far Dalí is conscious of their source in a psychological sense?

Dalí had first read Freud's *Interpretation of Dreams* when he was a student in Madrid. 'This book presented itself to me as one of the capital discoveries in my life, and I was seized with a real vice of self-interpretation, not only of my dreams but of everything that happened to me, however accidental it might seem at first glance.' How far, then, does a painting like *Dismal Sport* consist of images springing directly from the unconscious, or are they rather images which have already been digested and analysed. Freud himself, when he was introduced to Dalí in London in 1938 by Stefan Zweig, was in no doubt of the answer. According to Dalí, Freud told him: 'It is not the unconscious I seek in your pictures, but the conscious. While in the pictures of the masters – Leonardo or Ingres – that which interests me, that which seems mysterious and troubling to me, is precisely the search for unconscious ideas, of an enigmatic order, hidden in the picture, your mystery is manifested outright. The picture is but a mechanism to reveal it.' Dalí's paintings, he is suggesting, contain both

57 Drawing for *Dismal Sport*, 1929

the latent cause of an obsession and its symbolic manifestation. The unconscious idea, obsession, which was for Freud so often of a sexual nature, which may exist hidden in, say, a Leonardo, has for Dalí become the open subject of the painting – provided of course one is familiar enough with the terminology of sexual symbolism from the psychology textbooks. The drawing for *Dismal Sport* is far more explicit in its sexual references than the final painting. 57

Yet what makes the paintings of 1929–30 so extraordinary is the way they hold in balance a real neurotic fear which is clearly very powerful, and a knowing use of psychology textbooks. Within a highly sophisticated and carefully structured pictorial mental landscape he uses devices to create formal visual analogies for the experience of dreams and hallucinations. In *Dismal Sport, The First Days of Spring, Illumined Pleasures* and *The Great Masturbator* 66, 58 he paints a stretch of undifferentiated land as a vista stretching away and out of sight to the horizon. This landscape is usually monochrome: in *The First Days of Spring* and *Dismal Sport* both it and some of the objects and figures are a dull grey, against which the brilliance of other objects stands out with all the force of a Technicolor dream. Within this landscape structure, which harks back to such paintings by Ernst as *Of This Men Shall Know Nothing* and immediately creates a sensation of great depth emphasized by the presence in the background of tiny figures, the foreground objects and figures are placed in apparently uunrelated groups and huddles. This suggests the dreaming mind at work, where certain things may happen or be seen with clarity but at the same time other things are going on just out of sight or on the margins of consciousness, 'at the back of one's mind'. Odd or apparently illogical connections are made between disparate objects or groups of objects, and people or things can metamorphose unexpectedly into something else, for no apparent reason.

The individual images that crowd into the paintings are autobiographical, frequently symbolic, and often ready-interpreted. But the symbolic images he chooses are of different kinds: some are commonplaces from the psychology textbooks; some, like the grasshopper or fish, belong to Dalí's own personal armoury of images which probably obsessed him before he read an extra meaning into them, and whose significance is made clear though juxtaposition and association in a series of paintings and through his own explanations; and others, like the deer, whose significance, if any, remains buried deep.

Many of Dalí's paintings of the previous summer were, it will be remembered, concerned with auto-sexuality. The dominant theme of the 1929 paintings is now a deep sexual anxiety in which masturbation still plays an important role, in, for example, the grotesquely enlarged and guilty hand of the statue in *Dismal Sport*, hiding its face in shame. The attendant parental threat of its terrible consequences, interpreted by the subject as emasculation, is

75

shown in the enlarged sex organ held up against the statue by the young man seated (probably intended to be Dalí himself) and in the bloodstained object in the hand of the grinning man in the foreground. Bataille, in his interpretative diagram of the painting, also suggests that the tearing of the upper part of the body in the centre of the picture expresses emasculation, drawing presumably on the classic Freudian concept of the substitution of the upper for the lower part of the body in dreams.

The potential remedy or alternative to masturbation, sexual relations with another, has its own attendant threat of impotence, which Dalí expresses through a number of images, the psycho-analytical weight of whose symbolism must be fully conscious. The little coloured drooping shape on the paving stone at the bottom left of the painting is a softened dripping candle, which Freud invariably interprets in his patients' dreams as a symbol of impotence. Staircases, on the other hand, stand commonly in psycho-analytical literature for sexual intercourse. But in this case, in *Dismal Sport*, there is a subtlety in the use of such symbolism which suggests a real personal authenticity. Far from being selected randomly or for shock value, the giant and dramatically lit staircase at the right of the picture is closely linked to its overall theme. The oppressive size of the staircase springs from the theme of impotence, and expresses a fear of sexual intercourse; it presents an almost impassable obstacle over which the scattered images pouring from Dalí's own sleeping head can only hover. The staircase could also be the pedestal steps of a monument, introducing the idea of a hidden statue, and therefore in addition another important, interconnected running theme, that of the father figure. The staircase, then, is not just a commonplace symbol with a given reading, but is endowed with a particular predominant significance, that of the possible desirability but overwhelming fear of sex. Other images concur with this reading: the grasshopper, fastened to his mouth, was as we know from his own testimony, a symbol of terror; its identification with a fish in his reminiscences (and in the *Portrait of Paul Eluard*) confirms its sexual significance.

This kind of analysis is necessarily amateur, but there is a justification for it, in that Dalí is in fact treating the iconography of the science of psycho-analysis as though it were common property, in the way that religious iconography was common property in the Middle Ages.

It is not hard to accept Dalí's claim that he was during this period of intense work and emotional upheaval in a state very close to madness. Still locked in the auto-eroticism and masturbation of the previous years, he had fallen in love with Gala and found his anxieties concentrating more and more on the fear of impotence. He had never had a full sexual relationship with a woman, and his fears had still not been resolved when she went back to Paris at the end of September – having, though, stayed on after the departure of the others. After she left he returned to Figueras and painted *The Great Masturbator* and

67

Portrait of Paul Eluard. Dalí explained *The Great Masturbator* as 'the expression of my heterosexual anxiety'. It was inspired by a *fin-de-siècle* chromolithograph of a languid lady holding a white lily to her face. Dalí has kept the arum lily, whose phallic symbolism is repeated in the lion's head beside it with the grotesquely obtruding tongue, but moved it to put in its place the lower part of a man's torso with shrouded genitals. Dalí's own head, expanded to fill the whole canvas and also intended to be a rock from the coast at Cadaqués, has a fish-hook embedded in the scalp. The rocks, like the fragment below the head in *Dismal Sport*, are jagged and sharp and lacerate bare limbs with ease – hence the torn and bleeding knees in *The Great Masturbator*, not too difficult to read as displaced castration symbolism. The rock-head also grows out of an

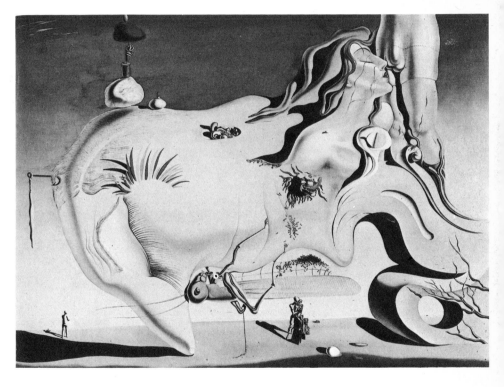

58 *The Great Masturbator*, 1929

59 Rocks at Cadaqués

unidentifiable fragment of 1900-style furniture, of a piece stylistically with the
woman's bare shoulders and head. In *The Enigma of Desire* the biomorphic
rock grows from a curly furniture leg; in the poem 'The Great Masturbator',
which Dalí wrote the following summer at Port Lligat, he explains the close
association of the image of a woman with this particular style of furniture
which comes from the typical iconography of *fin-de-siècle* lithographs: 'the
decorative coloured stained glass, with motifs of metamorphosis which exist
only in those horrible Modern Style interiors in which a very beautiful
woman with wavy hair a terrifying look an hallucinatory smile and a splendid
throat is seated at a piano. . .'.

The *Portrait of Paul Eluard*, Dalí's first Surrealist portrait, was painted, in
Eluard's absence, Dalí said, because 'I felt it incumbent on me to fix forever the
poet from whose Olympus I had stolen one of the Muses.' Dalí carefully
crystallized Eluard's fine, thin face in minute detail, cutting off the head at the
shoulders like an antique bust, an effect he emphasizes by turning the edges of
Eluard's coat into a calcareous landscape. The bust is then set floating above a
limitless horizon. At first glance it looks as though Dalí has revived the old
tradition of adding significant attributes to the portrait to say something about
the occupation, taste and so on of the sitter. However, the objects Dalí has
added belong to him rather than to Eluard, and many are familiar from other
paintings: the grasshopper, whose likeness to the 'slobberer' fish is neatly
underlined by making its head the fish's eye, and the woman-jug, for example.
The hand on the poet's forehead refers to Dalí's own experience while
painting *Dismal Sport*: 'I would feel the protective fingers of my imagination
scratch me reassuringly between my two eyebrows . . .', and sometimes he
would feel a pecking just behind his brow which here he translates into
butterflies.

In two other paintings of the same period, *Accommodations of Desire* and
Illumined Pleasures, the same themes of sexual anxiety predominate, with in
addition a more explicit reference to the father/son relationship which was to
become central to the 'William Tell' paintings of the following year. In
Accommodations of Desire Dalí convincingly imitates collage, painting a yellow
lion's head which looks as if it is cut from a child's book of exotic animals. The
lion's head is 'screened' on a white pebble, almost like an hallucination, and
Dalí has described his habit while on the beach of gazing at pebbles and 'seeing'
images in them. The lion's head is repeated but this time with the face 'cut out',
and then again with everything but the jaws eliminated. The halo of red on the
border of the latter, and the pure red outline head, both suggest the after-
image that occurs when, after gazing long at an object of a particular colour,
the gaze is shifted or the eyes are closed and the image is 'seen' in its
complementary colour. However, red is not the complementary of yellow,
but of green; it is the colour of blood, or heat, and hence, of passion or rage.

78

The lion figures almost invariably in paintings of this time; normally just the head is shown, though in *Dismal Sport* he appeared whole but in grisaille. Freud, in the 1919 edition of *The Interpretation of Dreams*, wrote 'Wild beasts are as a rule employed by the dream work to represent passionate impulses of which the dreamer is afraid, whether they are his own or those of other people. (It then needs only a slight displacement for the wild beasts to come to represent the people who are possessed by these passions. We have not far to go from here to cases in which a dreaded father is represented by a beast of prey. . . .) It might be said that wild beasts are used to represent the libido, a force dreaded by the ego and combated by means of repression.' However, although the lion is occasionally associated with what could be a father figure – in the little cluster of father and son figures in the top centre of *Accommodations of Desire*, for example – and certainly is the following year in *William Tell*, it is predominantly seen in 1929 paintings in conjunction with a woman. Dalí has said that the lion's maw 'translates his terror before the revelation of the possession of a woman'; he painted *Accommodations of Desire* after an outing with Gala that summer.

It is interesting that in the case of this obsessive image the immediate source was not Freud – though its use may have been inspired by him – but a

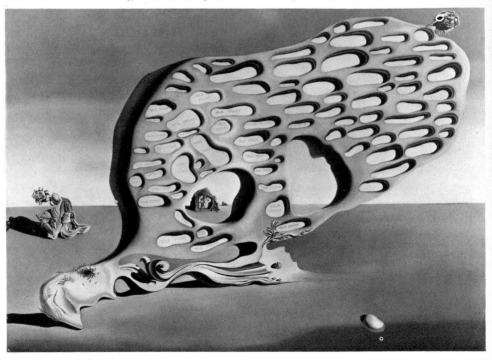

60 *The Enigma of Desire*, 1929

61 Lithograph entitled *The Fountain*, artist unknown

OPPOSITE
62 Max Ernst, *Pieta, or Revolution by Night*, 1923

63 Giorgio de Chirico, *The Child's Brain*, 1914

61 lithograph which hung in Dalí's room when he was a child, showing a girl at a well with a pitcher, and beside her a moulded relief on the well head showing a snarling lion's head which is very similar to that in the lower left of *Accommodations of Desire*. There is a striking difference, however, in this painting, between the styles of the lions' heads. That in the foreground has all the banal and simple realism of a textbook illustration, but those in the background are almost mannerist in their exaggeration. The figures themselves in these paintings, and frequently in subsequent works, share this distended realism. George Orwell was probably right, in his essay on Dalí's *The Secret Life*, 'Benefit of Clergy', to suggest that this elaborate and exaggerated style of drawing – for it is essentially an exaggeration of contour – belongs to Edwardian children's book illustration, to the never-never world of Barrie and Rackham, to the style, in other words, of Dalí's own childhood.

 Dalí once described *The First Days of Spring* as a 'veritable erotic delirium'; *Illumined Pleasures* is like a delirium of sexual anxiety, violent rather than erotic, and teeming with references to other paintings, a point underlined by the device of the three boxed 'pictures-within-a-picture', in the interstices between which the real action takes place. The lion's head, representing, interlocked, passion and threat, is linked to the head of a woman; by adding a handle to her head Dalí here, as elsewhere, turns her into a jug-container, in a neat visual shorthand for the psycho-analytical commonplace that receptacles stand (for obvious reasons) in dream symbolism for women. Recurring from *Dismal Sport* is the boy hiding his face in shame. Most interesting is the cluster of images in the immediate foreground; these do seem to spring from a kind of psychological automatism, and without trying to over-determine their

80

significance, which remains ambiguous, could be read as linking the parental threat with that of female sexuality, creating a veritable Scylla and Charybdis of sexual anxiety. To start with, the black shadow cast by an unseen object in the right foreground is identical to the shadow cast by the enlaced couple in the right of *Dismal Sport*. The couple is almost certainly father and son, a reading strengthened by its resemblance to that in De Chirico's *The Prodigal Son* (1924). The bloodied knife, gripped too late by a preventive hand, is inevitably linked to the bloodstained hands of the woman, who surely evokes, rather than the Venus rising from the waves that Harriet Janis suggests (in *Painting as the Key to Psychoanalysis*), Lady Macbeth trying in vain to wash her hands in her imaginary guilt while sleepwalking. Lady Macbeth would herself have killed Duncan, it may be recalled, had he not resembled her father while he slept. Clasping the woman is a bearded man, who is modelled on a figure from a painting deep in resonances for Dalí – Ernst's *Pieta, or Revolution by Night*. The *Pieta* shows Ernst himself dead (turned to stone) in the arms of a man intended to represent his father, and who also bears a resemblance to the brooding parent figure in De Chirico's *The Child's Brain*. In 1927 Ernst had published in *La Révolution Surréaliste* some childhood dreams and reminiscences called 'Visions de Demi-sommeil' (Visions of Half-sleep), in which his father appears as a threatening figure of whom the child is both frightened and jealous. 'Pieta' in the title apparently invokes the Deposition from the Cross, with Mary mourning Christ, but the theme is really an Oedipal one, with the father replacing Mary. The legend of Oedipus – whose father Laertes tried to kill him as a baby because of a prophecy that his son would kill him, a prophecy later fulfilled by Oedipus who then unwittingly

62

63

81

marries his own mother – is the dramatic prototype of a child's unconscious desires at the first stirrings of sexuality, accompanied by feelings of rivalry with his father. It is a story with its roots deep, as Freud put it, in 'primeval dream material'.

66 It is difficult in *Illumined Pleasures* to disentangle any one predominant reading in this cluster of foreground images, but there do seem to be mingled there both the highly personal themes of sexual anxiety we have already examined in other paintings, and references to some of the classic themes in legend and literature which incarnate unconsciously impulses lying deep within human sexuality, and to which Freud paid very close attention. Dalí's long-standing admiration for Freud was unexpectedly reciprocated when the two met in London in 1938. Freud wrote to Stefan Zweig afterwards: 'I really owe you thanks for bringing yesterday's visitor. For until now, I have been inclined to regard the Surrealists, who have apparently adopted me as their patron saint, as complete fools (let us say 95%, as with alcohol.) That young Spaniard, with his candid, fanatical eyes and his undeniable technical mastery has changed my estimate. It would indeed by interesting to investigate analytically how he came to create that picture. . .'.

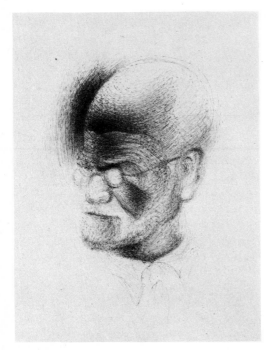

64 *Portrait of Freud,* 1938

A remarkable technical device at this period is the use Dalí makes of collage. In several paintings, he incorporates scraps of paper, photographs, or coloured lithographs, in such a way that the collage is almost indistinguishable from the painting (and completely so in reproduction.) With *The Enigma of Desire*, for example, you have to pay very close attention indeed, even with the painting physically in front of you, to distinguish the small portion of collage. The Surrealist poet Louis Aragon, writing on collage in 1930 in 'La Peinture au Défi', said: 'What probably best defies interpretation is the use of collage by Salvador Dalí. He paints with a magnifying glass; he can imitate the chromo [a kind of cheap coloured lithograph] so well that the effect is infallible: the parts of the pasted chromo look painted while the painted parts look stuck on. Does he want to foil the eye, and does he rejoice in provoked error? You could think that, but without finding the explanation of this double game, which cannot be put down to the despair of the painter before the inimitable, nor to his laziness before the ready-expressed [tout-exprimé].' Aragon suggests that Dalís paintings are incoherent over all – an incoherence closely parallel to that peculiar to collage – because they resemble novels. In doing so they are 'anti-pictorial', transgressing the demands of surface unity and autonomy of most post-Cubist painting.

Collage in Dalí's hands does not have the function it has in most Cubist painting, of stressing the surface of the picture and its texture, nor is it used primarily for the telling power of a particular image (readymade) in the manner of, say, Ernst. He seems to be using it as an anti-pictorial device in itself. Dalí wrote in *La Conquête de l'Irrationel* (The Conquest of the Irrational, 1935), 'to paint realistically according to irrational thought, according to the unknown imagination. – Instantaneous and hand-done colour photography of the superfine, extravagant, extra-plastic, unexplored, super-pictorial, super-plastic, deceptive, hyper-normal and sickly images of concrete irrationality. . .'. Oil on canvas, Dalí is suggesting, has no more and no less value than a ready-made image; what matters is that whatever means he uses should be able to represent, even 'photograph', his irrational thought. There is no essential difference, then, between a painted image and a photograph or print. Sometimes collage itself may be imitated, as in *Accommodations of Desire*. Or a particular photo or chromo may have played an important role in the provocation of a waking dream, or a chain of hallucinatory associations and is therefore included. But there has to be as little difference between these and his other modes of figuration as possible. In *Dismal Sport*, the scraps of collage include two of the hats, and fragments of a black and white microscopic photograph. In *Illumined Pleasures*, he sticks a black and white print of part of a church façade into a painted frame, as part of the boxed picture-within-a-picture structure of the painting. These framed pictures then act as snapshots of 'dream images'.

60

In all the paintings we have discussed, Dalí has been at great pains to suppress the visible marks of the brush, and leave the entire surface as smooth and glossy as the fragments of chromo-lithograph themselves. Almost all the paintings, with the exceptions of *The Great Masturbator* and *The Enigma of Desire*, are very small indeed – *Dismal Sport* is only just over a foot wide – and Dalí clearly relishes the miniaturist's scale.

Eleven oil paintings were exhibited at the Goemans Gallery in November 1929, of which nine, including those discussed above, had been painted since the early summer. André Breton, in the preface he wrote for the catalogue, saw, with his usual critical clairvoyance, that Dalí was poised between two possible routes, between, as he put it, talent and genius, or between vice and virtue. He did, then, have certain reservations about Dalí and his work from the beginning: 'On the one hand, there are the ticks which pretend to live in his clothes and not even to leave him when he goes into the street; the ticks in question say that Spain and even Catalonia is good, that it is ravishing that a man should paint such little things so well (and that it is even better when he makes them bigger), that a figure with clothes covered in shit, as there is in *Dismal Sport*, is worth ten properly dressed men, and, with all the more reason, ten naked men, and that it is not too soon that the vermin should be king of the road in our dear country and in the waste land of its capital. In the end, Surrealism good and dead, the professional talkers, which we are, crushed under heel, "documentation" triumphant, the cops re-established in their prerogative at least of *very honest men* – and then, of course, you're not thinking of changing the world? – we can perhaps assimilate on the quiet quite a few tough things (say the ticks to each other, after which they spread into old fashion journals, into what remains of abstract painting–? – into criticism where they pretend to engage in the "revolution of the word" in the politics of the anti-communist left and in the delicious, really sugary, material of the talking cinema).'

On the other hand, Breton continues, there is every hope that 'the admirable voice which is Dalí's' will not break in spite of the attempts of those 'materialists' (whom Breton has already attacked in the previous paragraph and by whom he clearly means Bataille) to confuse him. Against the sensation-seeking side of Dalí, on which Breton rightly puts his technique, is the fact that he is genuinely engaged in the same 'law suit against reality' as the Surrealists, and they have every intention of calling on their side 'the . . . witness of a man who . . . has nothing to save: *nothing, not even his head.*' 'It is perhaps, with Dalí, the first time that the mental windows have opened wide.' Dalí's paintings conjure up the possibilities of figures haunting 'a second landscape, of the second zone'. 'If only . . . we were rid of those wretched trees! And the houses, volcanoes, empires. . . . The secret of Surrealism lies in the fact that we are

persuaded that something is hidden behind them. Then, you only have to examine the possible modes of this suppression of trees to perceive that only one of these modes is left to us, that in the end everything depends on our power of voluntary hallucination.' Dalí's art, he concludes, 'the most hallucinatory we know, constitutes a real threat. . .'.

Breton is in this preface making the broadest possible claim for Dalí's importance within the total field of Surrealist thought, and is, just as deliberately, avoiding a more detailed discussion of the personal psychology of the paintings. He seems to see Dalí's use of psychology textbooks, of Freud and Krafft-Ebing, as potentially part of his deliberate sensationalism, and also probably as hinting at perversions of a type he regarded with distaste.

In a much later series of interviews, in 1952, Breton commented on Dalí's conscious use of psycho-analysis: 'on the mental plane, no one was more struck by psycho-analysis than he, but, if he uses it, it is to maintain jealously his complexes, to carry them to exuberance.' Dalí is using it, in other words, not to solve and therefore eliminate his obsessional complexes, but, in revealing them fully to himself, to explore them and give them the richest possible expression, elaborating on the original obsession with the help of psychology textbooks. What had been, in the 1929 paintings, overwhelming and literally irresistible, is subsequently systematically exploited to provide material for his work.

Dalí's involvement with psychology and psycho-analysis has so far been discussed exclusively in terms of Freud. Freud remained of central importance to him even with the more systematized imagery of the succeeding years. New sets of symbolic imagery which enter his work in 1930, often in association with the now familiar imagery of the 1929 pictures, are often still drawn from Freud. A frequent symbol is the key, which appears in the frontispiece Dalí drew for the publication of the *Second Surrealist Manifesto* as a book, in 1930, 68 arranged in careful niches either alone or in association with other objects such as nails, ants, chalices, a chair, while on the right is a familiar string of heads including Dalí himself, old man, woman, lion. The key had a very clear meaning for Freud in association with the common dream symbolism of a room for a woman, which may be 'locked' or 'unlocked', a meaning which Dalí makes explicit in the gouache *Combinations* (1931). There is, however, 69 also a useful warning to be drawn here about the potential multiplicity of meaning of symbols, and the danger of over-determining them; in *Combinations* the key and a swarm of ants are in the place of the girl's genitals, which suggests that Dalí is here giving his 'vermin' the sense Freud gives them of pregnancy or small children, but elsewhere it has quite other meanings.

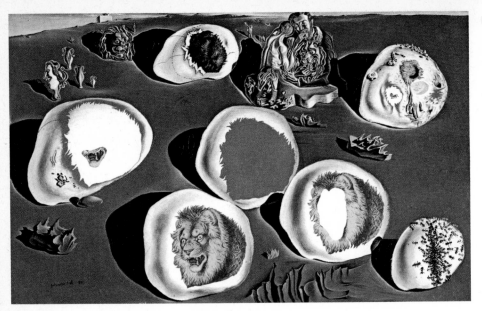

65 *Accommodations of Desire*, 1926

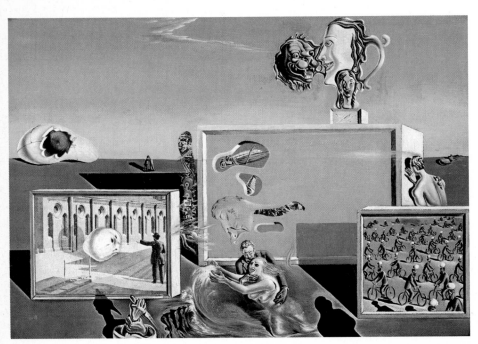

66 *Illumined Pleasures*, 1929

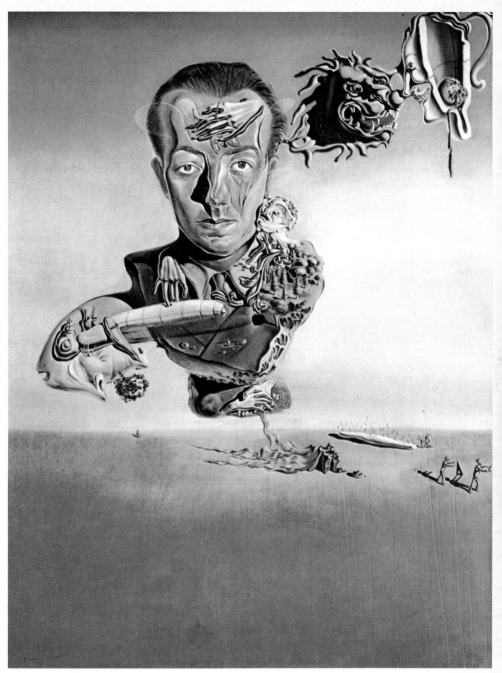

67 *Portrait of Paul Eluard*, 1929

68 Frontispiece to the
Second Surrealist Manifesto,
1930

69 *Combinations*, 1931

But Freud was not Dalí's only source, and when his Surrealist visitors in the summer of 1929 were anxious lest his paintings should be reduced to the level of 'psycho-pathological documents', they were pointing to an aspect of Dalí's sexual imagery which suggests a familiarity with psycho-pathological studies of a different kind. The most fruitful of these (for Dalí) was probably Krafft-Ebing's *Psychopathia sexualis* (1899), a treatise recording an enormous variety of psycho-pathological manifestations of sexual life, laying special stress on the symbolism of sexual aberrations like sadism and masochism. A number of cases gathered by Krafft-Ebing illustrate the nature of fetishism, and this seems to have been a particularly rich source for Dalí when he came to invent his elaborate 'Surrealist objects functioning symbolically' in the early thirties.

One way in which Dalí dramatized his own obsessions, the following year, was in his adoption of the legend of William Tell as the bearer or container of the father figure theme. Dalí interprets the legend of William Tell – the Swiss patriot and bowman who won a wager that he could pierce with an arrow an apple placed on his son's head at a distance of two hundred paces – as a castration myth. He is clearly following Freud's belief that those characters from myth, legend and literature who retain an inexplicable hold on man's imagination for generations, like Oedipus, Hamlet, or Moses, do so because they are, at a deep level, embodiments of primeval dream material, with a latent or 'real' content underlying the surface narrative. Dalí places William Tell with Abraham and God the Father as a symbol of parental authority, who does not flinch from sacrificing his own son.

Dalí's interpretation of William Tell is not, of course, objective. It has a personal significance for him, and coincides with a crisis in his relations with his father. He had, in an incident only obliquely referred to in *The Secret Life*, but fully explained in *The Unspeakable Confessions*, written a 'paranoid' inscription on a photograph of his mother which had deeply shocked his father, and this, in conjunction with violent parental disapproval of his affair with Gala, led to his banishment from the Figueras house until the end of the Spanish Civil War. At the severance of their relations Dalí shaved his head and buried the hair on the beach at Cadaqués, before going to Paris to rejoin Gala. He was never, from this time, to be separated from her again, and there is no question that she allayed the sexual neurosis which had led him to the edge of insanity. The father–son relationship had, as we saw, a tangential and ambiguous role in the 1929 paintings, but when it takes the centre of the stage, in 1930, the works do not have quite the same impact and intensity, as those which expressed the fears from which Gala delivered him.

William Tell was painted in 1930, followed in 1931 by *The Old Age of William Tell* and *The Youth of William Tell*, and then in 1933 by the

55

71, 72

89

overblown and theatrical *Enigma of William Tell*. But there is almost nothing apart from the titles which indicates that these paintings have anything to do with the legend of William Tell itself, for what they are concerned with is Dalí's reading of its latent content. Phallic and sexual references, symbolic and otherwise, teem in *William Tell*, and the threat from the father, horribly grinning (and with his name attached to his leg), is overt. Dalí also quotes deliberately from religious iconography, presumably to underline the Abraham/God the Father parallels: the shamed son, hiding his face and with a leaf in place of his genitals, reaches a finger towards the extended hand of his father in a gesture reminiscent of Michelangelo's Adam in the Sistine ceiling. *William Tell* is a much larger picture than the majority of those of the previous summer, and the distortion of the figures becomes proportionately greater and more grotesquely Mannerist. Dalí also uses an overall greenish tonality rather than the yellow or blue of the earlier paintings, which gives an almost underwater sense of disorientation.

The faint hints of an expulsion from the Garden of Eden in *William Tell* are made much more explicit in *The Old Age of William Tell*, where the young and sorrowing couple depart banished like Adam and Eve. But in place of Paradise is the old man, the father, tended by two women, in a scene which recalls the story of Lot and his daughters. Secret and ambiguous sexual activity takes place behind a sheet, as in a dimly recalled childhood memory. Dalí is evoking the same area of repressed childhood experience and dream as Ernst in 'Visions of Half-sleep', in which Ernst describes seeing, in a panel of false mahogany at the end of his bed, a man with his father's moustaches, who with a long, soft crayon began to conjure up ferocious animals filling the seven-

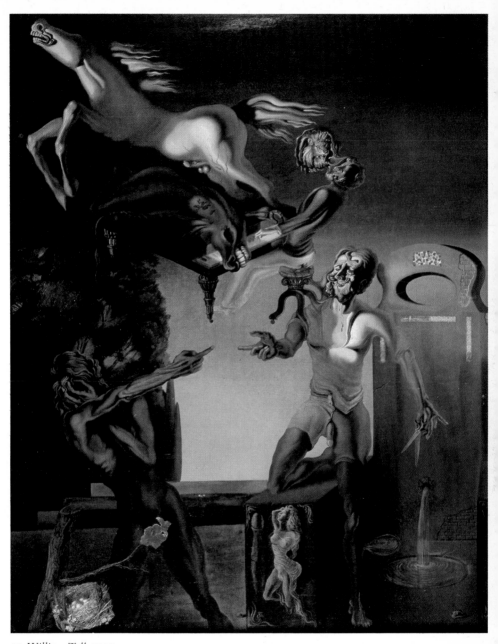

71 *William Tell*, 1930

70 *The Enigma of William Tell*, 1933

year-old child with terror: 'one day, during puberty, I examined very
seriously the question of finding out how my father conducted himself on the
night of my conception. In response to this question of filial respect the very
precise memory of the vision of half-sleep, which I had completely forgotten,
returned. After that, I could not get rid of a thoroughly unfavourable
impression of my father's conduct on the night I was conceived.' In Dalí's
version the sexual activity of William Tell/father is both enviable and
unsavoury, a theme continued in many drawings of this period.

The threat of the father is not limited to being sexually inhibitory; as Dalí
wrote in *XXième Siècle* (1974), in 'The Enigma of Salvador Dalí', 'Sigmund
Freud has defined the hero as he who revolts against paternal authority and
ends by defeating it. *The Enigma of William Tell* was painted at the moment the
young Dalí revolted against the authority of his father but didn't know
whether he would be victor or vanquished.' So the father, with Lenin's face,
holds the baby Dalí in his arms; on the child's head, in place of the apple, is a
raw cutlet, a sign that he had cannibal intentions and wanted to eat the child.
Just by William Tell's foot, and in imminent danger of being crushed, is a tiny
walnut shell with minute cradle and baby – like the little carved toy nuts found
in Spanish and Mexican markets – which represents Gala, and Dalí's future. In
The Old Age of William Tell, the head of Napoleon is collaged on to the
pedestal, and this was an image rich in significance for Dalí and entwined in
many childhood memories. Napoleon as hero had evidently successfully

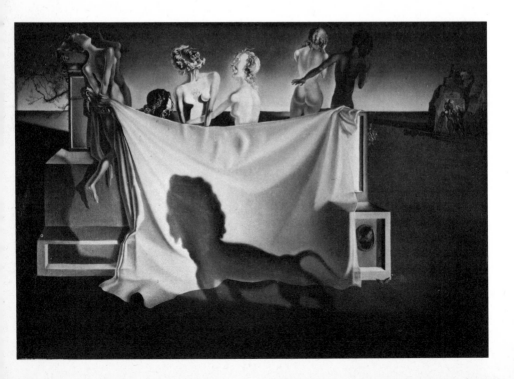

broken parental authority and had provided Dalí with a yardstick for his ambition since he was a child.

> My mother, in the Dalinian Olympus, is an angel. . . . She was the honey of the family. I would have liked to drink her the way our upstairs Argentine neighbours, the Matases, drank their afternoon *maté*, which they took . . . from a sucking-cup that they passed around the large living-room from mouth to mouth. I joined in partaking of this huge teapot, and felt the sweet warmth of the liquid flow into me, as I gazed at the little wooden keg of *maté* with the picture of Napoleon on it looking back at me. The emperor had pink cheeks, a white stomach, and black boots and hat. For ten seconds, his strength flowed onto me. I became Napoleon, master of the world. . . .

The theme of William Tell figures also in his poem 'The Great Masturbator' of 1930. This is an extended reverie of a landscape peopled with the objects and figures familiar from his paintings, beginning with the head of the Great Masturbator from the 1929 painting, and including

> two large sculptures of William Tell
> one made
> in real chocolate
> the other in false shit . . .

The objects in this landscape, their material presence minutely imagined, relate to Dalí's new interest in the fabrication of Surrealist objects.

Another series of paintings which Dalí began in 1931, and which includes *The Birth of Liquid Desires* (1932) and *The Signal of Anguish* (1936), relates to the long and elaborate masturbatory daydreams which Dalí fostered and noted down in great detail at this period, as in, for example, the 1931 text 'Rêverie'. The setting for these daydreams was often the grounds of the Pitchot family's country house, with its cypresses surrounding a little gushing fountain. This landscape evoked for Dalí the paintings of Böcklin, about whom he was then engaged in writing an extended study. The cypresses and fountain are variously transformed in Dalí's paintings in association with childhood memories and other themes, all capable of provoking, according to Dalí, prolonged erotic fantasies.

75, 76

73

72 (opposite) *The Old Age of William Tell*, 1931

73 Arnold Böcklin, *Island of the Dead*, 1880 version

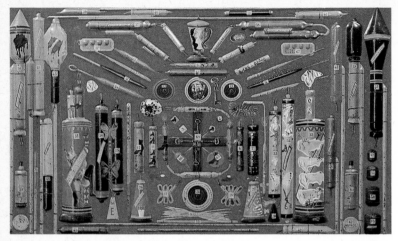

74 *Mad Associations Board* or *Fireworks*, 1930–31

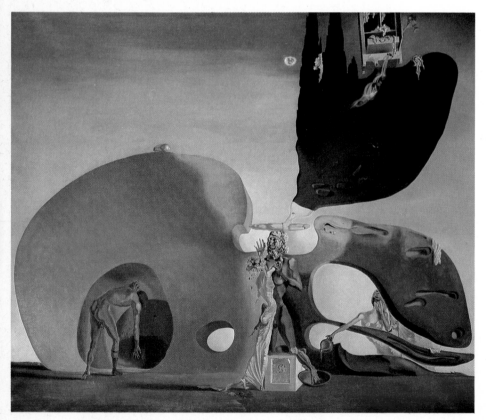

75 *The Birth of Liquid Desires*, 1932

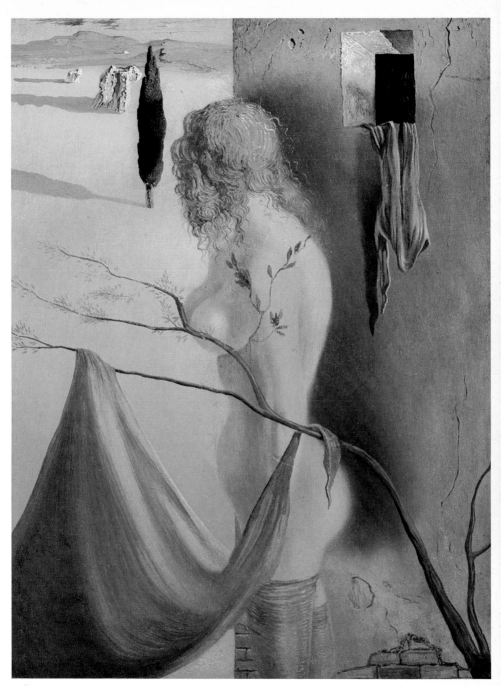

76 *The Signal of Anguish, 1936*

Dalí's paranoiac–critical method, which he began to develop in the winter of 1929–30, will be discussed in the next chapter. For the five or six years following his entry into the Surrealist movement he was in fact active in a number of different fields, and his inventive and fantastic spirit was a vital force within Surrealism, as Breton acknowledged in the lecture he gave at Brussels in 1934, 'Qu'est-ce que le Surréalisme?': 'Owing particularly to influences brought about by new elements, Surrealist experimentation, which had for too long been erratic, has been unreservedly resumed; its perspectives and its aims have been made perfectly clear; I may say that it has not ceased to be carried on in a continuous and enthusiastic manner. This experimenting has regained momentum under the master impulse given to it by Salvador Dalí, whose exceptional interior "boiling" has been, during the whole of this period, an invaluable ferment for Surrealism.'

But by the mid-thirties their relationship had begun to sour. In 1941 Breton wrote that Dalí's work 'from 1936 onwards has had no interest whatsoever for Surrealism.' Dalí did in fact participate in the great 1938 International Surrealist Exhibition in Paris, but certainly by 1939 was estranged from most of the Surrealists. The causes for their mutual estrangement are of two kinds. Firstly, in spite of a strong coincidence of interests in certain areas – a passionate commitment to Freud and certain aspects of psycho-analytical theory, belief in the free play of an irrational imagination and the pre-eminence of desire – there were also from the very start areas of basic disagreement or misunderstanding. For one thing, not only was Dalí indifferent to the political and social aims of the Surrealists, but he began to adopt attitudes which seemed to them unwarrantably frivolous. His tastes, too, ran along different lines. Secondly, Dalí himself changed in the course of the thirties, and there were very immediate causes for the Surrealists' disgust. As Calas wrote in 1941 in 'Anti-Surrealist Dalí: I say his flies are ersatz', in the New York magazine *View*, which had welcomed the other Surrealist expatriates: Dalí 'no longer believes in revolutionary values! He has rediscovered Spain, penitence, catholicism, classicism; he adores form and tries to draw as well as Ingres.' He seemed, therefore, to the Surrealists to be a renegade or a reactionary, although as we saw earlier he had already in adolescence flirted with classicism. But now he was adopting it in conjunction with, as Calas pointed out, a deliberately reactionary political position.

After the invasion of France in 1940 he left for the USA, where he could rely on the support of wealthy patrons, like Caresse Crosby, at whose house Hampton Manor, in Virginia, he installed himself and Gala, and wrote *The Secret Life of Salvador Dalí*. He began to paint a number of society portraits, like *Helena Rubinstein*, treated ironically by Dalí as Andromeda chained to the rocks by her emeralds. In Hollywood in 1945 he painted *Frau Isabel Styler-Tas*, for which he leans heavily on Piero's *Portrait of the Duke of Urbino* and on

78
79

96

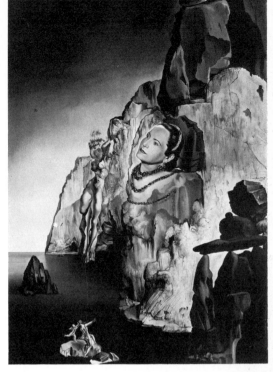

78 Helena Rubinstein's Head Emerging from a Rocky Cliff, c. 1942–3

77 Giuseppe Arcimboldo, *Winter*, 1563. His double images made him a particular favourite of the Surrealists

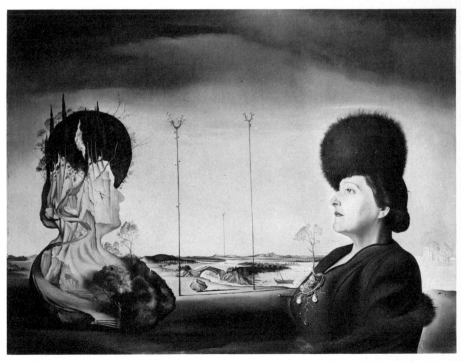

77 Arcimboldo. Breton's anagrammatic nickname 'Avida Dollars' summed up the Surrealists' opinion of him; after his return to Europe at the end of the war, the rupture was complete.

The most fundamental of the original differences between Breton and Dalí turned on the question of Surrealism's basic relevance – how, in other words, it was supposed to affect man's consciousness of the world. Both of them talk about discrediting rationality, but I think they understand by this something very different. When Breton, in his 'Introduction to the Discourse on the Paucity of Reality' of 1924, suggests that a Surrealist object introduced into the ordinary world could throw discredit on 'things of reason', he understood this in the context of the argument in the first *Surrealist Manifesto*, concerning the unacceptable relegation of everything that could not be explained by the 'absolute rationalism that is still in vogue' to the realm of superstition. Any way, therefore, of attacking and undermining this absolute rationalism should be pursued. The imagination, the dream, the unconscious, all belong to that part of the world excluded by narrow pragmatism. But this exploration into other areas of our mental life and our psychic experience should not in its turn be followed to the exclusion of the real world, for the Surrealists' aim was to restore to man a wholeness of life and experience: 'I believe', Breton wrote in a kind of *credo* in the first *Manifesto*, 'in the future resolution of these two states, dream and reality, which are seemingly so contradictory, into a kind of absolute reality, *a surreality*, if one may so speak. . .' It was not, therefore, a question of *opposing* surreality to what is normally understood as 'real', but of pushing out the boundaries of our understanding of the latter in order to include areas normally excluded from it. Surrealism would ultimately contain, not be opposed to, reality. The same idea is expressed again in Breton's *Second Surrealist Manifesto* of 1929: 'Everything tends to make us believe that there exists a certain point of the mind at which life and death, the real and the imagined, past and future, the communicable and the incommunicable, high and low, cease to be perceived as contradictions. Now, search as one may one will never find any other motivating force in the activity of the Surrealists than the hope of finding and fixing this point. . .'

The *Second Manifesto* coincided with Dalí's entry into Surrealism, and at a first glance his early writings seem very much in line with Breton's call in the 'Introduction to the Discourse on the Paucity of Reality' to 'discredit the things of reason'. Dalí wrote for example in 'L'Ane pourri' (*SASDLR* no. 1): 'I believe that the moment is at hand, when . . . it will be possible . . . to systematize confusion and contribute to the total discrediting of the world of reality.' However, it soon becomes clear that what Dalí wanted was to *maintain* the opposition between reality and surreality, between the irrational and the rational, not to bring about a future resolution. The 'things of reason' should be permanently discredited, and his world of imagination substituted for the

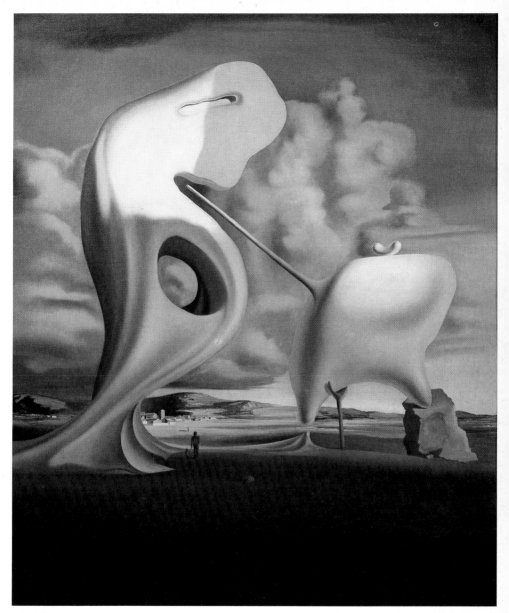

80 *The Architectonic Angelus of Millet*, 1933

real world. He sought to maintain the irrational, Breton noted, in the same way that he deliberately maintained his neurotic complexes in as high a state of exuberance as possible.

Ironic admiration from an unexpected quarter for Dalí's 1929 exhibition throws an almost comic sidelight on Dalí's attitude. Mondrian, the most intransigent proponent of abstract art, visited the exhibition, on Arp's recommendation, with a fellow abstract painter, Jean Hélion: 'I can't remember now whether I picked Mondrian up from his legendary studio on the rue du Départ or if we met in the rue Bonaparte but from the entrance he was won over. I was too, but differently. We admired above all the monument for the place d'Espagne and the man with shit on his shirt. Mondrian was enthralled. That's how you must treat nature, he said. Where I admired passionate excess formulated with discipline, my companion rejoiced in what he considered to be a demolition of the natural world.'

The bones of the difference between Breton and Dalí outlined above help to explain Dalí's provocative lack of interest in the political debates which engaged the Surrealists, and also to indicate how distorted a view of Surrealism could be which saw it only through Dalí's eyes. Dalí himself is most explicit about what it is that differentiates himself from the rest on the question of artistic and intellectual allegiances, and taste. In conversation with me he once drew for himself an ancestry quite distinct from those the Surrealists chose. They had always been fascinated by the idea of drawing up lists of their

81 Plate XVII from Comte de Lautréamont, *Les Chants de Maldoror*, Paris 1934. Dalí's image of Napoleon is derived from Meissonier's (see opposite)

favourite writers, poets and artists, in what was intended to be a recognition of kindred spirits in past ages rather than a demonstration of influences. Dalí joined in, but, with some exceptions – notably with such figures as de Sade and Lautréamont, whose *Chants de Maldoror* was illustrated by Dalí – his chosen 81, 121 spiritual kin was not the same as the Surrealists. Their taste was, Dalí said, uncultivated and romantic. They chose Rimbaud, Baudelaire, etc as their ancestors. His were, by contrast, he emphasized, 'classical' – naming Ledoux, Gaudí, Gustave Moreau, Ramón Lull. In adhering only to the Romantics, Dalí added, the Surrealists had failed to perceive that such classical writers as the seventeenth-century playwright Corneille created dramatic situations that were very Surrealist indeed. Setting aside for a moment Gaudí, and the fourteenth-century Catalan theologian and mystic Lull, Dalí's statement is clarified by adding two other nineteenth-century artists for whom he has frequently expressed enthusiasm in the face of the unanimous dislike of his contemporaries: Meissonier and Bouguereau. He has turned to the classical as 82 opposed to the Romantic tradition, but at the same time he has chosen those who are in some way aberrations from a neo-classical ideal or who exemplify this tradition in a state of decadence. Ledoux, the architect who lived through the French Revolution, designed bizarre and visionary schemes for buildings, which, although rooted in classical forms, at the same time used them with the greatest possible freedom. Dalí was attracted by the idea that departure from given rules can be more subversive than the most absolute given freedom.

82 Jean-Louis-Ernest Meissonier, *Napoleon I and his Staff*, 1868

Both Dalí and Magritte adopted a 'realistic' style to contain their unreal scenes, but they call on very different traditions. Magritte's deadpan, utilitarian style is closest perhaps to popular illustrations or children's lesson books. Dalí, on the other hand, appears to call on the full academic classical tradition of oil painting in both northern and southern Europe. His love of the meticulous oil painting technique of Vermeer certainly goes back to the mid-twenties, as does his passion for Velázquez. But, as one might expect, his most active enthusiasm was for its late or decadent practitioners. The neo-classicism of Böcklin had come to him through De Chirico, and when he reached Paris it was the *pompier* realism of Meissonier, diminished heir to the great tradition of French history painting running from David through Gros, that attracted him. Meissonier's *Napoleon* was one of his favourite paintings, and in 1967 he organized an exhibition and wrote a catalogue to commemorate five *pompier* painters, 'Hommage à Meissonier!'

Dalí has always insisted that, compared with any neo-classical painter, he was a nonentity. The following conversation once took place with Alain Bosquet:

S.D. A painting is such a minor thing compared with the magic I radiate.
A.B. Let's be rational for a moment. For myself and for all of us, it's your paintings that count most, and some of them go back forty years.
S.D. They don't count pictorially. They're badly painted.
A.B. I don't agree. What do you mean by badly painted?
S.D. I mean that the *Divine Dalí* of today would be incapable of doing even a mediocre copy of a canvas by Bouguereau or Meissonier, both of whom could paint a thousand times better than I can.

Dalí's 'failure', though, is seen in a slightly different light when it is remembered that he never set out to rival these painters; he was attracted by the technical expediency of their style and by an element of perversity. He has, paradoxically but consistently, maintained that it was a matter of indifference to him whether he expressed himself in paint or in words – a point confirmed by his prolific written output. Painting is, therefore, an expedient, a means more or less efficient to express a given idea or image.

83 Dalí's taste for the Catalan architect, Gaudí, and the 'modern style', seems to belong to a different category, for Gaudí lies definitively outside the classical tradition; it goes back at least to the beginning of his association with the Surrealists. In *The Secret Life* he explained it in terms of a deliberate revolt against the dominant fashion in Paris, when he arrived there, for African art – a fashion which had started in the early years of the century with the aid, among others, of Picasso, and which had been bolstered by the Surrealists, who had extended it to pre-Columbian and Oceanic objects. Both Breton and Eluard had large collections of primitive art. Against these 'savage objects' Dalí

83 Antonio Gaudí, *Casa Milá*, Barcelona, 1906–10

'upheld the ultra-decadent, civilized and European "Modern Style" objects. I have always considered the 1900 period as the psycho-pathological end-product of the Greco-Roman decadence...' Dalí was, then, partly fuelled by a characteristic desire to oppose current taste, but from what he wrote in *Minotaure* it is clear that he also had a genuine passion for them. With his texts were photographs by Brassaï and Man Ray emphasizing the Surrealist qualities of the iron Metro entrances in Paris, and others of the sculpture encrusting Gaudí's building in Barcelona, and of the façades themselves curved like frozen waves or the natural forms of rocks or trees. The texts themselves concentrate on the Surrealist rather than the decadent qualities that he was later to emphasize. 'On the terrifying and edible beauty of modern style architecture' (*Minotaure*, 1933) discusses the irrational side of art nouveau architecture, its capacity for the realization of unconscious desires, and even its similarity to the masterpieces of the nineteenth-century cake-maker Carême. Next to the article was a photo-collage by Dalí, *Le Phénomène de l'extase*, 84 which was a reference to an earlier Surrealist homage to Charcot, the great French psychiatrist and teacher of Freud, on the fiftieth anniversary of his discovery of hysteria, a homage in the form of photographs from the Salpêtrière records of a young girl in a state of hysterical ecstasy. The details of sculptures from Gaudí's buildings show heads of girls – or angels – in states of rhapsodic abandon, and Dalí makes the connection explicit in the text: 'Psycho-pathological parallel – Invention of the "hysterical sculpture" –

84 *Le Phénomène de l'extase*, 1933

continuous erotic ecstasy. – contractions and attitudes without precedent in the history of statuary (it concerns woman discovered and known after Charcot and the school of Salpêtrière). . . . Direct connections with dreams, reveries, waking fantasies. . .' Dalí goes on to say: 'In a modern style building, the gothic metamorphoses into the hellenic, into the far-east, and, while that is going through your head – by a certain involuntary fantasy – into the Renaissance which can in its turn become pure, asymmetrical-dynamic modern style all in the "feeble" time and space of *one single window*, that is to say in the time and space little known and truly vertiginous which are none other than those of the dream. . .'. The roots, then, of Dalí's later reading of modern style art and architecture are here, but the emphasis is as yet on all 'exotic' (anti-primitive) civilizations rather than just Greco-Roman. Dalí was probably responsible for spreading the taste for the 1900 style, and other Surrealists in the thirties had recourse to it: Oscar Dominguez, for example, whose *Arrivée de la belle époque* uses an art nouveau sculpture as a ready-made base.

Dalí has always claimed to be totally apolitical, and as such contributed to the polarization of Surrealism during the thirties between those who demanded active participation in programmes for revolutionary action and total commitment to the Communist Party, and those who saw their activity as artists or writers as autonomous and self-sufficient. Although it is impossible to summarize adequately here the ideological conflicts within the movement during the late twenties and the thirties, it is important to sketch them in because they form the background to Dalí's role within it. Breton's position within this debate was a very difficult one. While he had unequivocally offered the support of his movement to Moscow in a telegram reproduced on the first page of *SASDLR*, and was still a member of the Communist Party, he wanted at the same time to maintain the autonomy of Surrealism, and disagreed with the Association of Revolutionary Writers and Artists about the proper and possible role of the intellectual, writer or artist during a pre- or post-revolutionary period. In the face of the criticism that the Surrealists, in pursuing what seemed to many to be esoteric experiments, were contributing nothing to the revolutionary cause to which they claimed to be committed, Breton always maintained a need for a change in consciousness to run parallel to and even precede a change in material conditions, and that this was the area in which the Surrealists could most effectively operate. More than any other movement, Breton believed, the Surrealists were working for this change in consciousness, and in order to continue their explorations in this area, the writer or artist was entitled to freedom of expression. The exclusive pursuit of a 'proletarian' art or literature was artificial and impossible anyway in a capitalist society.

Two incidents from the thirties illuminate Dalí's position. In the first Dalí was, although passively, involved in the dramatic split between Breton and his oldest ally within Surrealism, Aragon. In the course of this episode Breton found himself defending two pieces of writing, with neither of which he had much sympathy. These two texts, Dalí's 'Rêverie', a highly erotic and masturbatory account of a daydream published in *SASDLR*, no. 4, December 1931, and Aragon's poem 'Red Front', a polemical attack on capitalist society, exemplify the two poles of Surrealism. Aragon had been wavering during 1930 and 1931 over the conflicting demands of Surrealism and the French Communist Party. At the end of 1931 he was prosecuted for inciting military disobedience and provocation to murder for lines in 'Red Front' beginning 'comrades, kill the cops . . .'. In Aragon's defence Breton published a pamphlet, 'Misère de la Poésie', which defends poetry against a narrow-minded attempt to interpret individual lines in a judiciary sense. But the argument did not rest there. Breton went on to castigate, too, the narrow-mindedness of the Communist Party, and gave as an example an incident reported to him by Aragon, who had been summoned before a control

commission of the Party and asked to publish a condemnation in *SASDLR* of Dalí's 'Rêverie', which they considered pornographic and anti-revolutionary. Breton had refused, not because of any intrinsic value he felt Dalí's text to possess but as a matter of principle. Aragon felt this affair should not have been made public, as it was an internal dispute within the Party; when Breton discussed it openly, attacking the petit bourgeois spirit of Party functionaries and their narrow attitude to art and literature, Aragon finally publicly denounced Surrealism.

In 1937 Dalí published an article 'Je défie Aragon' (I defy Aragon) in *Art Front*. In unusually sober prose he describes a characteristic, symbolic confrontation between himself and Aragon. In 1932 during a meeting devoted to Surrealist experimentation, he had proposed a complicated Surrealist object which he called a 'thinking machine', which would be made of hundreds of goblets filled with warm milk and suspended so as to form the structure of a large rocking-chair. To the stupefaction of the group Aragon objected to this project on the grounds that 'glasses of milk are destined not for the fabrication of Surrealist objects but for the children of the unemployed.' (When Dalí later made the *Aphrodisiac Jacket* he filled the little glasses with *crème de menthe*.) Dalí goes on to attack not only Aragon but the whole concept of socialist realism which had replaced the earlier call for proletarian art. Instrumental, probably, in sharpening Dalí's distrust of politics in the mid-thirties was the suicide of his close friend René Crevel, who had tried vainly to bring about a reconciliation between the Communist Party and the Surrealists on the occasion of the Congress of the Association des Ecrivains et Artistes Révolutionnaires in 1934.

The second incident is symptomatic of Dalí's wilful detachment from politics, and also of what seemed to Dalí a growing Stalinization of the movement. Dalí's behaviour during this incident is reminiscent of the old Dadaist Tzara, during the dying days of Dada in Paris, when he sabotaged attempts by the future Surrealists to turn Dada's attention to serious social and political questions. On 5 February 1934 Dalí was summoned to appear before the upper echelon of Surrealism at Breton's flat in the rue Fontaine. In *The Unspeakable Confessions*, Dalí quotes the 'Order of the Day', which had apparently been circulated prior to the meeting: 'Dalí having been found guilty on several occasions of counter-revolutionary actions involving the glorification of Hitlerian fascism, the undersigned propose – despite his statement of 25 January 1934 – that he be excluded from Surrealism as a fascist element and combated by all available means.' The most recent example of Dalí's 'counter-revolutionary actions' had been the painting *The Enigma of William Tell*, just then on exhibition at the Salon des Indépendants at the Grand Palais. This showed Lenin kneeling, in shirtsleeves, but otherwise naked, with one immensely elongated, flaccid buttock supported with a crutch, and another crutch in front holding the limp and exaggerated peak of

his famous cap. The evening before the inquisitorial meeting, Dalí recounts, Breton, Péret, Tanguy and others had tried to poke holes in the picture at the Salon, but had been unable to reach it. The specific example of 'glorification of Hitlerian fascism' that Dalí gives was the painting called *The Enigma of Hitler*, 91 which Dalí describes as containing a nurse sitting knitting in a puddle of water with a swastika on her armband that he was forced to remove. Dalí has described his fascination with Hitler in *The Unspeakable Confessions*: '[Hitler's] fat back, especially when I saw him appear in the uniform with Sam Browne belt and shoulder straps that tightly held in his flesh, aroused in me a delicious gustatory thrill originating in the mouth and affording me a Wagnerian ecstasy. I often dreamed of Hitler as a woman. His flesh, which I imagined whiter than white, ravished me. I painted a Hitlerian wet nurse sitting knitting in a puddle of water. . . . There was no reason for me to stop telling one and all that to me Hitler embodied the perfect image of the great masochist who would unleash a world war solely for the pleasure of losing and burying himself beneath the rubble of an empire: the gratuitous act par excellence that should indeed have warranted the admiration of the Surrealists. . .' It is hard to see how these sentiments could be confused with a Hitlerian fascism; as far as Dalí was concerned both Lenin and Hitler existed as dominant contemporary phenomena, whom he treated as 'delirious dream subjects'. In Dalí's novel *Hidden Faces* (1944), set in France and the USA before and during the last war, Hitler appears as himself, an insane masochist waiting for the end while listening to Wagner. Where, of course, Dalí overreaches himself as far as the Surrealists are concerned is in deliberately confusing Hitler's manic acts with a Surrealist *acte gratuit*.

Dalí appeared at the meeting, nervous and uncomfortable because he was running a fever, wrapped in layers of sweaters with a thermometer in his mouth. While Breton expounded the charges against him, Dalí regularly consulted his thermometer, and removed some of his clothes as he became too hot. Dalí probably did not intend to sabotage the meeting, but so obsessed was he with the state of his health that, as he put it, to remove the thermometer from his mouth would have paralysed him, and so his words were barely audible. Dalí began to defend himself by claiming that the 'dream remained the great vocabulary of Surrealism and delirium the most magnificent means of poetic expression'. The accusations levelled against him were 'based on political or moral criteria which did not signify in relation to my paranoiac–critical concepts'. 'So, André Breton,' I concluded, 'if tonight I dream I am screwing you, tomorrow morning I will paint all of our best fucking positions with the greatest wealth of detail.' Whether or not this was audible, Breton then called on Dalí to forswear his ideas on Hitler and confirm that he was no enemy of the proletariat. Kneeling down, Dalí swore. He was not expelled, but relations between him and the Surrealists now deteriorated steadily.

Dalí's behaviour could partly be explained by the fact that he took absolutely literally Breton's claim in the first *Manifesto* that Surrealist activity was to be undertaken outside any '*moral* or aesthetic considerations'. This he clung to as a defence although the climate of Surrealism had changed between 1924 and 1934. Also, I think, Dalí was peculiarly immune to the kind of change that was taking place within Surrealism, and to the kind of ideological debate mentioned above, because of the subtle but fundamental difference between the way in which he and Breton conceived of Surrealist activity. For Dalí it was inevitably an end in itself and therefore in some way inoculated against the real world. Hitler was not in his view different in kind from William Tell or his nurse, because all that mattered was their existence in his mind as dream subjects. Vivid and complete as Dalí's hallucinatory evocations of them may be – and his account of Hitler up in a tower with the steps blown away listening to *Tristan und Isolde* is psychologically extraordinarily intense, and horrifying – they have no reality outside this. Although it is possible to say that the Surrealists were therefore missing the point when they took Dalí to task for 'glorification of Hitlerian fascism', they were none the less right, from their point of view, to accuse his actions of being 'counter-revolutionary'.

Breton's 1936 essay 'The Dalí Case' was favourable, but by 1939 he had ceased to be so benign, and in 'The Most Recent Tendencies in Surrealist Painting' attacks Dalí both on the grounds of his political opinions, and for the growing monotony and repetitiveness of his paintings. 'Dalí even declared to me,' he wrote, 'in February 1939 – and I listened carefully enough to assure myself that he was being completely serious – that the basic trouble confronting the world today was *racial* and that the only solution was for all the white races to band together and reduce all the coloured people to slavery. I have no idea what doors such a declaration may open to its author in Italy and the United States, the two countries between which he shuttles, but I know what doors it will close to him. . .'

When Breton wrote a long account of the history and current state of Surrealism in painting – *Artistic Genesis and Perspective of Surrealism* – he even rejected the paranoiac–critical method itself as derivative: 'When Dalí insinuated himself into the Surrealist movement in 1929, his previous work as a painter had suggested nothing strictly personal. Thereafter he proceeded on the theoretical plane by borrowings and juxtapositions, the most striking example of which was the amalgamation, under the title "paranoiac–critical activity", of two separate elements: first the lesson taught by Piero di Cosimo and Leonardo da Vinci that one should allow one's attention to become absorbed in the contemplation of streaks of dried spittle or the surface of an old wall until the eye is able to distinguish an *alternative* world which painting is

equally capable of revealing; and secondly, processes such as *frottage* already proposed by Max Ernst as a means of "intensifying the irritability of the mental faculties". In spite of an undeniable technical ingenuity in organizing his own stage effects, Dalí's undertaking, spoilt by an ultra-retrograde technique (a return to Meissonier) and discredited by a cynical indifference to the means he used to advertise himself, has for a long time shown signs of panic, and has only been able to save appearances temporarily by putting into effect a scheme of deliberate vulgarization. By now his work has become engulfed in an academicism which claims, on its own authority alone, to be classicism, and which, in any case, from 1936 onwards has had no interest whatsoever for Surrealism.'

Dalí was not included in the first post-war exhibition in Paris, *Le Surréalisme en 1947*; but in the 1959–60 *International Exhibition of Surrealism, Eros*, he was represented in the 'Yesterday' section with *William Tell* (1930).

Dalí's response to the cataclysmic events in Europe in the thirties illuminates his claim to be apolitical, the sense in which he interprets historical change, and, in hindsight, the inevitable rift with the Surrealists.

These events he experienced at second hand; he kept well away from any contact with the conflict in Spain, and has never made any bones about his extreme physical timidity. As Breton once remarked sympathetically, 'the slightest material worry crushes him'. In October 1934 he had fled the Catalan uprising in Barcelona, crossing the border into France by night under the protection of an Anarchist taxi driver, with the paintings for his forthcoming exhibition in New York. The driver carried both a Catalan and a Spanish flag to cover himself whichever way the Revolution went; next morning Dalí and Gala learnt it had been suppressed, the Catalan Republic lasting only a few hours. But it cannot have been hard to see, as the Anarchist had warned Dalí, that the lid would soon blow off Spain.

On Dalí's return to France from the USA in 1935 he made the first studies for the large canvas of the following year, *Soft Construction with Boiled Beans: Premonition of Civil War*, which preceded the actual outbreak of civil war in Spain in July 1936 by a few months. 'In this picture,' Dalí wrote, 'I showed a vast human body breaking out into monstrous excrescences of arms and legs tearing at one another in a delirium of auto-strangulation. As a background to this architecture of frenzied flesh devoured by a narcissistic and biological cataclysm, I painted a geological landscape, that had been uselessly revolutionized for thousands of years, congealed in its "normal course". The soft structure of that great mass of flesh in civil war I embellished with a few boiled beans, for one could not imagine swallowing all that unconscious meat without the presence (however uninspiring) of some mealy and melancholy vegetable.'

85

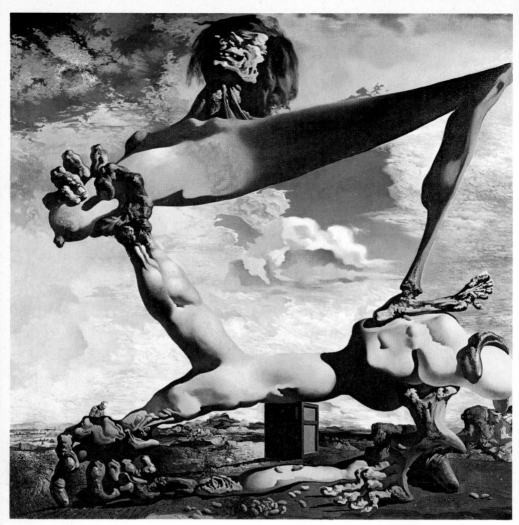

85 *Soft Construction with Boiled Beans: Premonition of Civil War*, 1936

Goya was clearly in Dalí's mind as he planned this painting, and the monstrous figure broods over the landscape like Goya's *Colossus* presiding over a ruined land. The face harks back to the suffering heads in Goya's *Disasters of War* engravings; the head in the drawing, though, bears an unmistakable resemblance to the Duc de Blangis at the end of *L'Age d'or*, interpreted by Buñuel as Christ. Dalí has set the figure over a landscape of the 87 Ampurdán plain very similar to that in *The Ampurdán Chemist Seeking*

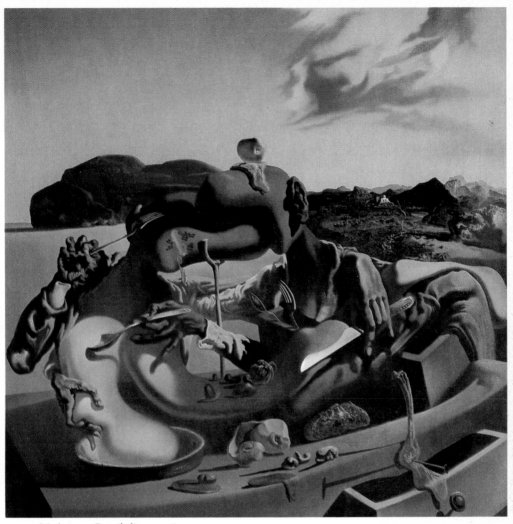

86 *Autumn Cannibalism*, 1936

Absolutely Nothing (1936), the chemist himself appearing just behind the grounded hand.

Dalí has symbolized the internal conflict as one giant figure reduced to a set of leprous and warring limbs, head and body tearing each other apart. The body is both Spain itself and the Civil War; it is shown by Dalí as both victim and aggressor, and probably therefore embodies for Dalí what he described as that 'blind history' that claimed so many of his friends including Lorca.

87 *The Ampurdán Chemist Seeking Absolutely Nothing*, 1936

86 At the end of 1936 Dalí painted *Autumn Cannibalism*, replacing the monstrous body with a couple devouring each other's flesh; lacking the frenzy of *Soft Construction*, *Autumn Cannibalism* is perhaps even more horrific, picturing its beastly feast as a gustatory and almost aesthetic phenomenon. Dalí commented on this painting: 'These Iberian beings, eating each other in autumn, express the pathos of the Civil War considered (by me) as a phenomenon of natural history as opposed to Picasso who considered it as a political phenomenon.'

 This is revealing for Dalí's attitude to history as a whole and to the events of contemporary history in particular, for he sees them as being as inevitable as evolution, a phenomenon equivalent to a biological or geological cataclysm. Change is irresistible, and though Dalí has an acute horror of it, he believes that it is none the less paradoxically necessary in order to reveal the true strength of tradition. 'It was going to be necessary for the jackal claws of the revolution to scratch down to the atavistic layers of tradition in order that, as they became savagely ground and mutilated against the granitic hardness of the bones of this tradition they were profaning, one might in the end be dazzled anew by that hard light of the treasures of "ardent death" and of putrefying and resurrected splendours that this earth of Spain held hidden in the depths of its entrails.'

 Dalí ignored the political realities of the Civil War – the struggle of the Republicans to maintain legitimate government and resist the Fascists – and

visualized it instead in terms of the warring of basic and instinctual forces. Unlike Goya, whose *Disasters of War* are essentially about human suffering in war, Dalí saw the Civil War as an emblematic polarization of ideological and inhuman forces, Death and Faith, revolution and tradition; he might, like Hugo Ball during the First World War, have described this emergence of atavistic instinct as pathological. In *The Secret Life* he wrote: 'The Spanish Anarchists took to the streets of total subversion with black banners, on which were described the words ¡VIVA LA MUERTE! (Long Live Death!). The others, with the flag of tradition, red and gold, of immemorial Spain bearing that other inscription which needs only two letters, FE (Faith). And all at once, in the middle of the cadaverous body of Spain half devoured by the vermin and the worms of exotic and materialistic ideologies, one saw the enormous Iberian erection, like an immense cathedral filled with the white dynamite of hatred. To bury and to unbury! . . .'

The Spanish Civil War was a prologue to the Second World War: 'Spain, spared by the other war, was to be the first country in which all the ideological and insoluble dramas of post-war Europe, all the moral and aesthetic anxiety of the "isms" polarized in those two words "revolution" and "tradition" were now to be solved in the crude reality of violence and of blood.'

In *The Face of War* (1940) Dalí stuffs the personified head of war with repeating skulls, 'infinite death'. In 1937 he painted another premonition of war, *The Inventions of the Monsters*. Dalí subsequently explained it as follows: 'According to Nostradamus the apparition of monsters is a presage of war. This canvas was painted in the mountains of Semmering, near Vienna, a few months before the *Anschluss* and it has a prophetic character.'

Tradition is, in some sense, for Dalí, a defence against history. The decadence of inter-war Europe he sees as part of the living order of tradition. In *The Conquest of the Irrational* (1935), an interesting text because Dalí is still writing, as it were, from within Surrealism although he is beginning to develop in it his apolitical ideas about tradition, he wrote: 'It is in such

88 Francisco José de Goya, *Why?*, from the series *The Disasters of War*, 1810–14

circumstances that Salvador Dalí, the precise apparatus of hand-done paranoiac–critical activity, less ready than ever to desert his uncompromising cultural post, has for a long while been proposing that it might also be desirable to eat the Surrealists, for we, Surrealists, we are the kind of good-quality, decadent, stimulating, extravagant and ambivalent food, which, in the most tactful and intelligent fashion in the world belongs to the *faisandé*, paradoxical and succulently truculent state which is proper to and characteristic of the atmosphere of ideological and moral confusion in which we have the honour and the pleasure to live at this moment. . . . One thing is certain: I hate simplicity in all its forms. . .'

His ironic analysis of the Surrealists, himself included, as decadent symptoms of an ideologically confused society has a good deal in common with inter- and post-war criticism of Surrealism from the Left. By the time he wrote *The Secret Life*, published in 1942, he had committed himself to a thoroughly reactionary position (which he still maintained was apolitical):

When I made my first attempt at keeping aristocracy standing upright by propping it with a thousand crutches, I looked it in the face and said to it honestly, 'Now I am going to give you a terrible kick in the leg.'

89 *The Inventions of the Monsters*, 1937

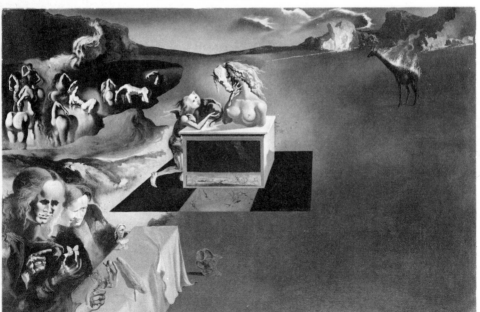

90 (opposite) *Spain*, 1938

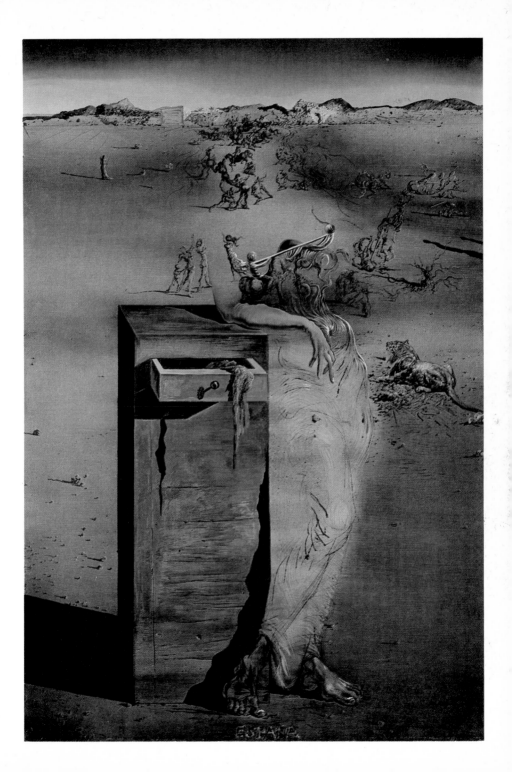

The aristocracy drew up a little more the leg that it kept lifted, like a stork. 'Go ahead', it answered, and gritted its teeth to endure the pain stoically, without a cry.

Then, using all my might, I gave it a terrific kick right in the shin. It did not budge. I had therefore propped it well.

'Thank you', it said to me.

'Never fear', I answered as I left, kissing its hand. 'I'll be back. With the pride of your one leg and the crutches of my intelligence, you are stronger than the revolution which is being prepared by the intellectuals, whom I know intimately. You are old, and dead with fatigue, and you have fallen from your high place, but the spot where your foot is soldered to the ground is tradition. . .'

A number of 1937–8 paintings reinterpret an already familiar fetishistic symbol in the light of the threat of European war: the telephone receiver. *The Enigma of Hitler* is the only one to make the connection with contemporary events and characters explicit. A scrap of a photograph of Hitler lies on the dish under the telephone, not a genuine collage but minutely reproduced by Dalí. The ghostly umbrella hooked over the branch in this unusually thinly painted work stands for Chamberlain, and the whole picture is intended to refer to the negotiations between Britain and Germany at the time of Munich when the telephone played a major role. Although these paintings do refer, obliquely, to contemporary events, they have little bearing on Dalí's attitude to history and tradition.

91

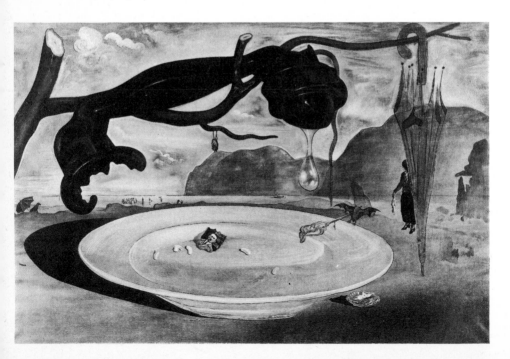

In the novel *Hidden Faces*, published in 1944, Dalí fictionalizes this attitude to the aristocracy and tradition, in an elegy to pre-war Europe. It is, as its translator Haakon Chevalier said, a novel of decadence in the tradition of Petronius' *Satyricon*. Its theme of love in death is decadent because for tragedy Dalí substitutes frustration and perversion. But there is a second theme in the novel which belongs to Dalí's deeply held belief in the life of the soil against all the vagaries of political events. This is symbolized by the young forest of cork oaks planted on Count Grandsailles's land, to which he returns after a long wartime exile in the United States. Dalí loves 'the hard granitic rock, the classic Mediterranean soil with its olive trees and its vineyards and its lean, tilled fields, ragged fishermen and peasants with gnarled, earth-stained hands, artisans and craftsmen everywhere, all men who work with their hands and with their brains . . .'. Tradition is embodied in the soil, faith and culture, defences against change. As he wrote in *The Secret Life*: 'The end of a war, the crumbling of an empire, and a hundred years of disorder have served only slightly to modify the tilt, the outline, the ornamental figure of the acanthus leaf, immediately reappearing in the first, still tender mouldings of the budding new flesh of civilization. . .'.

One of the most interesting critical accounts of Dalí in English is George Orwell's essay 'Benefit of Clergy' reviewing Dalí's autobiography *The Secret Life of Salvador Dalí*. Orwell was deeply shocked by what he felt was an absence of decent human feeling and by Dalí's anti-patriotic stance – deficiencies acutely felt in wartime Britain. Dalí was in his opinion as 'anti-social as a flea'. Knowing little about Surrealism and nothing independently of the autobiography about Dalí's career and work during the thirties, he took the book's often cynical, cruel and reactionary account as factual; he does, however, make some very perceptive comments to the effect that Dalí, although an exhibitionist and a careerist, is not a fraud, but a phenomenon demanding attention and needing to be explained. What is necessary, he suggests, are the analyses of the psychologist and the sociological critic as much as of the art critic or historian.

The problem for Dalí as an artist was to find a convincing language for his belief in tradition, which runs so deeply counter to the principles of Surrealism which he had earlier espoused. *Soft Construction* and *Autumn Cannibalism* are 85, 86 powerful visions of a rotting, decadent and doomed society, but how was he to find a form for a consciously reactionary (and ironic) attachment to tradition and belief in mysticism without reverting to epic parody or anachronism of a debilitating kind? For someone who had been one of the most inventive, fertile and bizarre spirits in a movement as fundamentally iconoclastic as Surrealism it presented great problems, and it is probably this that accounts for the unsettled heterogeneity of Dalí's post-war work.

91 *The Enigma of Hitler*, 1937

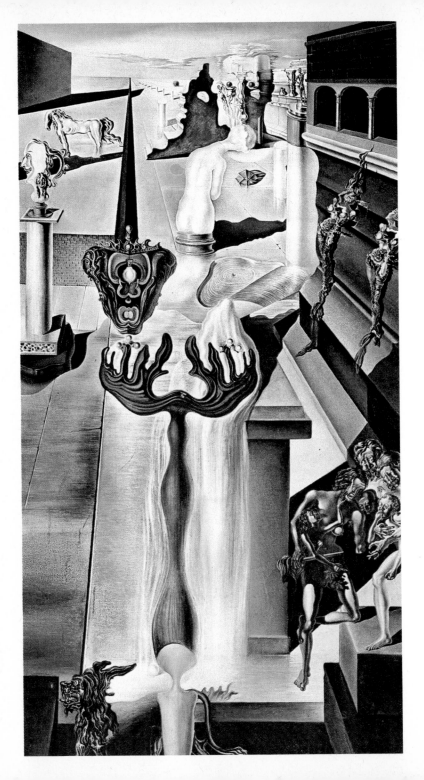

Painting and the paranoiac–critical method

Theory and practice of paranoia–criticism; influence of Lacan; relationship with other Surrealist methods like automatism and the dream; The Tragic Myth of Millet's Angelus *as paranoiac–critical analysis.*

'Dalí has endowed Surrealism with an instrument of primary importance, specifically the paranoiac–critical method, which has immediately shown itself capable of being applied with equal success to painting, poetry, the cinema, to the construction of typical Surrealist objects, to fashions, to sculpture, and even, if necessary, to all manner of exegesis.' (André Breton, 'What is Surrealism', a lecture given in Brussels in 1934.)

Dalí defined his paranoiac–critical method as a form of 'irrational knowledge' based on a 'delirium of interpretation'. It lies at its simplest in the ability of the artist to perceive different images within a given configuration. As such, it was not new, but has affinities with Max Ernst's technique of *frottage*, a kind of 'visionary irritation' which consisted in making rubbings from a textured surface and then reading and interpreting images in the rubbings. Ernst traces this back to Leonardo da Vinci's practice of gazing at the stains on old walls, at clouds, ashes or streams, out of which he could conjure fantastic scenes of battle, or landscapes. This is not unlike Hamlet teasing Polonius:

HAMLET: Do you see yonder cloud that's almost in shape of a camel?
POLONIUS: By the mass, and 'tis like a camel indeed.
HAMLET: Methinks it is like a weasel.
POLONIUS: It is backed like a weasel.
HAMLET: Or like a whale?
POLONIUS: Very like a whale . . .

Where Dalí differs, however, except perhaps from Hamlet, is that he links this activity, as the very name he chose for it indicates, with a form of madness or mental disturbance, which he deliberately sets out to simulate. His famous statement 'The only difference between myself and a madman is that I am not mad' takes on, in this context, a more specific meaning.

The paintings of 1929 were acutely personal documents, however far they made use of the symbolic language of the psychology textbooks. Two 'series' of paintings of the early thirties, running on the themes of William Tell, and of

119

93 *Paranoiac Face* from *Le Surréalisme au Service de la Révolution*, no. 3, December 1931

Millet's *Angelus*, show that he is jealously guarding his obsessions, though they have become objectified through 'mythical' figures. The practice of paranoiac–criticism is an attempt at 'the critical and systematic objectification of delirious associations and interpretations', drawing on his interest in psycho-analysis, and demonstrating in a more general way the relationship between perception and mental states.

In 'The Dalí Case' (1936) Breton describes Dalí's use of painting or any other medium as a means of escaping repressive constraints which would lead to psychosis. His 'great originality lies in the fact that he has shown himself strong enough to participate in these events as actor and spectator simultaneously, that he has succeeded in establishing himself both as judge of and party to the action instituted by pleasure against reality. This constitutes the *paranoiac–critical* activity . . .' He discusses Dalí's paranoia in Kraepelin's terminology as isolated levels of delirium: 'Dalí's first-rate intelligence excels at reconnecting these levels to each other immediately after the event, and at gradually rationalizing the distance travelled. The primary material of his work is furnished by the visionary experiences, the meaningful falsifications of memory, the illicit ultra-subjective interpretations which compose the clinical picture of paranoia, but which to him present a precious lode to be mined.'

There are antecedents of the paranoiac–critical image in Dalí's earlier works: the grasshopper's head that doubles as the eye of the fish, for example, and the voluntary visions conjured up in the pebbles on the beach at Cadaqués in *Accommodations of Desire.*

65

An important local source for such imagery was his familiar and beloved Catalan landscape. As he wrote in *The Secret Life*: 'But aside from the aesthetics of this grandiose landscape, there was also materialized, in the very corporeity

of the granite, that principle of paranoiac metamorphosis which I have already several times called attention to in the course of this book. Indeed if there is anything to which one must compare these rocks, from the point of view of 59 form, it is clouds, a mass of catastrophic petrified cumuli in ruins. All the images capable of being suggested by the complexity of their innumerable irregularities appear successively and by turn as you change your position. This was so objectifiable that the fishermen of the region had since time immemorial baptized each of these imposing conglomerations – the camel, the eagle, the anvil, the monk, the dead woman, the lion's head. But as we moved forward with the characteristic slowness of a row-boat . . . all these images became transfigured. . . . What had been the camel's head now formed the comb (of a rooster) . . .'

Dalí first attempted the double image in an ambitious painting which he began in the winter of 1929, and which was still unfinished when it was exhibited at the Pierre Colle Gallery in 1931 (where it was dated 1929–32). In *The Invisible Man* the whole figure of a seated man stretches down the length 92 of the canvas, constructed out of a landscape of ruins, statues and arcaded buildings, a landscape inspired by the memory of a colour plate in a child's picture book showing Egyptian ruins.

Dalí did not use the full term 'paranoiac–critical' until about 1933. In the first piece he published in *Le Surréalisme au Service de la Révolution*, 'L'Ane pourri' (The Rotten Donkey), he discusses his new method using simply the term 'paranoia', and relating it to Surrealist theory. He sees a crucial difference between paranoia and hallucination lying in the voluntary nature of the former, which is an active rather than a passive mental state: 'I believe that the moment is near when, through a process of thought of a paranoiac and active character, it will be possible (simultaneously with automatism and other passive states) to systematize confusion and contribute to the total discrediting of the world of reality.'

In the same year that Dalí wrote this, he illustrated Breton and Eluard's *L'Immaculée Conception* (The Immaculate Conception), the central part of which consisted of essays written in simulation of different states of madness, including 'delirium of interpretation'. (Kraepelin's *Lectures on Clinical Psychiatry* was an important classificatory source.) This convergence of interests with Dalí was, Breton said, fortuitous, but it should be remembered that Surrealism had from the very beginning turned its attention to madness, which it increasingly saw as a relative state defined by an erroneous or narrow concept of sanity and normality. The idea that the boundary between the sane and the insane was not fixed, that madness was not an absolute state but one defined by certain legal and social conventions was not new, but where the Surrealists differ from, say, the Romantics, was in the new mass of scientific and clinical research into the human mind available to them, which revealed

that madness could be directly connected to the degree of suppression or insurrection of that unconscious area of the psyche that exists in all people. Aspects of imaginative and intuitive mental activity are open to the mentally disturbed but closed to the sane – a subject explored by Breton in *Nadja*.

Paranoia, a term already in use in Classical Greece to mean delusion or derangement, and revived by Heinroth in 1818, was a recognized form of psychosis in the nineteenth century. Freud refers to the observation of the late-nineteenth-century Italian psychologist Sante de Sanctis that paranoia could arrive at a single blow after an anxious or terrifying dream in which delusional material is suddenly brought to life. Paranoia is a form of delusional insanity, classified by Charpentier in 1887 as involving morbid ideas of persecution. However, the notion of the 'persecution complex' was not essential to the definition of paranoia, and it retained the broader and vaguer meaning Dalí gives it, of a 'reasoning madness', a delirium of interpretation in which suites of images, ideas or events are perceived as having causal connections, or are all related to one central idea, and are internally coherent for the subject of the delusion though meaningless to an outside observer. In the essay by Breton and Eluard 'In Simulation of the Delirium of Interpretation' the imaginary subject feels himself to be like a bird and interprets everything in relation to this: 'The sun's double eyelid rises and falls on life. The birds' feet on the square of the sky are what I formerly called stars.'

One of the most influential modern writers on paranoia, Jacques Lacan, published some of his earliest work in the Surrealist review *Minotaure*. 'The Problem of Style and the Psychiatric Conception of the Paranoiac Forms of Experience' appeared immediately after Dalí's 1933 essay 'Paranoiac–critical Interpretation of the Obsessive Image of Millet's *Angelus*'. An even earlier text (1931) by Lacan and others on paranoia commented on the extraordinary degree of autonomy in Surrealist automatic writing like *L'Immaculée Conception* and its real similarity to the writings of the insane. Dalí had, of course, already begun to formulate the psycho-philosophical nature of the paranoiac activity in the context of Surrealism, in *La Femme Visible* (1930, which contained 'L'Ane pourri'), and independently therefore of Lacan. But he had read Lacan's thesis 'On Paranoiac Psychosis in its Relations with the Personality' (1932) by the time he was preparing his first *Minotaure* article, and welcomes Lacan's ideas as confirmation of his own, and as revelatory about the phenomenon of paranoia as a 'total and homogeneous idea'. Dalí's paranoiac–critical interpretation of Millet's *Angelus* of 1933 is not directly concerned with that painting, but rather with the paranoiac–critical activity itself, and the question of its relationship with the other two main areas of Surrealist activity, automatism and dreams. While acknowledging the continuing value of experiments in these areas, Dalí is clearly making a bid for the greater value and importance of paranoia–criticism. In this, he finds

94 *Mediumistic–paranoiac Image*, 1935

95 *Phantom Chariot*, 1933?

Lacan's thesis a major support, because it emphasizes the active and 'concrete' nature of the phenomenon in psychological terms: 'Lacan's work perfectly gives an account of the objective and "communicable" hyperacuity of the phenomenon, thanks to which the delirium takes on this tangible character, which is impossible to contradict, and which places it at the very antipodes of the stereotypes of automatism and the dream.' The paranoiac–critical method can, Dalí argues, save automatism and the dream from becoming stereotyped – it is therefore not an alternative to them, but a necessary additional tool, without which, he says, in a passage reminiscent of Bataille, 'the dream and automatism would only make sense as preserved idealist evasions, an inoffensive and recreational resource for the comfortable care of the sceptical gaiety of select poets'. It is in fact a crucial weapon in the Surrealists' 'lawsuit against reality', Dalí suggests: 'The paranoiac mechanism can only appear to us, from the specifically Surrealist point of view we take, as proof of the dialectical value of that principle of verification through which the element of delirium passes practically into the tangible domain of action, and as guarantee of the sensational victory of Surrealism in the domain of automatism and the dream.' Breton, however, states in his *Entretiens* (1952) that his and Eluard's intentions in *L'Immaculée Conception* go considerably further than Dalí's in his parallel exploration of paranoia, because their major preoccupation was 'to reduce the antimony between reason and unreason', while Dalí's was to magnify it.

96 In a film scenario unpublished, undated – though certainly prepared before 1933 – and never realized, Dalí wrote: 'The paranoiac activity offers us the possibility of the systematization of delirium. Paranoiac images are due to the delirium of interpretation. The delirium which, in the dream, is wiped out on waking, really continues into these paranoiac images and it is directly communicable to everybody. In effect we are going to see how the paranoiac delirium can make it so that an odalisque is at once a horse and a lion. The odalisque arrives, she lies down lazily. Notice the beginning of the movement of the horse's tail; it becomes odalisque again and now it is a lion which disappears in the distance. There again is a real phantom.' The triple image which Dalí presents here in a sketch for a cinematic sequence occurs in several works of 1930, one of which was destroyed that same year when it was slashed to pieces by a group of right-wing students while on exhibition in the foyer of

97 the cinema where *L'Age d'or* was showing. In another version, *Invisible Sleeper, Horse, Lion*, the reclining nude should read also as a lion, with its maned head to her right, or as a horse, its head formed by her draped arm. However, Dalí has not yet mastered that complete switch between consistent and independent alternative readings, which he was to achieve in such canvases as

108 *The Slave Market with the Disappearing Bust of Voltaire. Invisible Sleeper, Horse, Lion* would probably work more effectively animated as in the film scenario

96 Page from an
unpublished film
scenario, early 1930s

97 Invisible Sleeper,
Horse, Lion, 1930

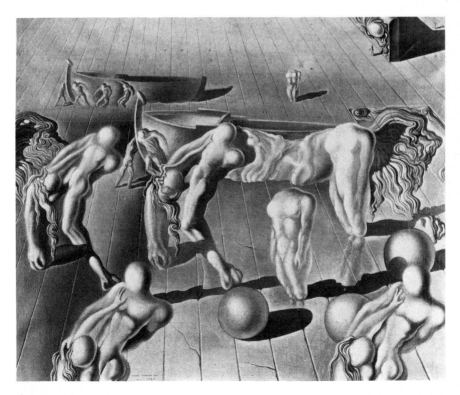

than as a static image. In *The Slave Market* the paranoiac–critical method is immobilized, the switch between images is complete and they are mutually exclusive, while in *Invisible Sleeper, Horse, Lion* there is a metamorphosis from one image to another which gives it the sense of lying half-way between an animated sequence and a painting.

Dalí's most complete discussion of the paranoiac–critical activity is in *The Conquest of the Irrational* (1935), in which he elaborates on the definitions he gave in the 1934 essay 'Latest Fashions of Intellectual Excitement for the Summer of 1934' and explains the genesis of the method. It was in 1929, he says, that he first saw the possibility of 'an experimental method based on the sudden power of the systematic association proper to paranoia.' Paranoiac–critical activity is a '*spontaneous method of irrational knowledge based upon the interpretive–critical association of delirious phenomena*'. This spontaneous irrational knowledge enables the subject to pass from the 'world of delirium' on to the 'plane of reality' through the discovery of new and objective 'significance in the irrational', and it can be transferred to the material plane in pictures: 'Paranoiac phenomena: common images having a double figuration; – the figuration can theoretically and practically be multiplied; – everything depends upon the paranoiac capacity of the author. The basis of associative mechanisms and the renewing of obsessing ideas allows, as is the case in a recent picture by Salvador Dalí now being elaborated, six simultaneous images to be represented without any of them undergoing the least figurative deformation: – athlete's torso, lion's head, general's head, horse, shepherdess's bust, death's head. – Different spectators see in this picture different images; needless to say that it is carried out with scrupulous realism.' (The picture he refers to seems never to have been completed.)

This throws perhaps more light on Breton's criticism of Dalí. An important ground for his objection must have been that Dalí saw his method as one primarily to be applied in painting, rather than to 'the resolution of the principal problems of life' as Breton had written in the first *Surrealist Manifesto*. For the leader of the Surrealists this was not a problem that was confined to Dalí among the painters; Breton had earlier expressed strong doubts about Miró, who, he suspected, may have used automatism to produce what were undeniably great paintings but without having understood its 'profound value and significance'. But whereas Miró is accused of making automatism, the Surrealist instrument of discovery, function purely aesthetically, Dalí takes quite the opposite line, claiming that his paintings have no aesthetic value as such at all – with results that were, in the end, as we shall see, just as distasteful to Breton. 'My whole ambition', Dalí wrote in *The Conquest of the Irrational*, 'in the pictorial domain is to materialize the images of concrete irrationality with the most imperialist fury of precision. . . . The illusionism of the most abjectly *arriviste* and irresistible imitative art, the usual

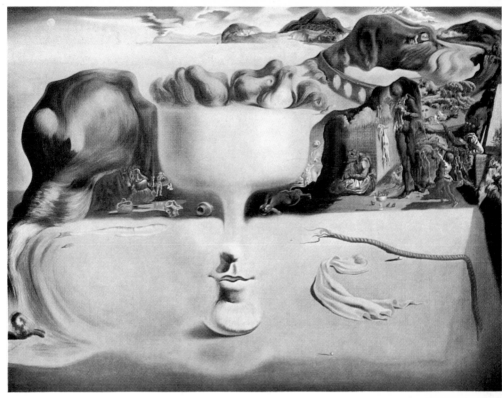

98 *Apparition of Face and Fruit Dish on a Beach*, 1938

paralysing tricks of *trompe-l'œil*, the most analytically narrative and discredited academicism, can all become sublime hierarchies of thought. . . . In the degree that the images of concrete irrationality approach phenomenal reality the corresponding means of expression approach those of the great realist painters – Velázquez and Vermeer of Delft – . . . images which provisionally are neither explicable nor reducible by the systems of logical intuition or by the rational mechanisms. . . .' He goes on to attack other Surrealist methods: 'pure psychic automatism, dreams, experimental dreaming, Surrealist objects functioning symbolically', etc, on two counts. Firstly, 'They cease to be unknown images, for in falling into the domain of psycho-analysis they are easily reduced to ordinary logical language', though he allows that they retain a residue of

enigma, especially for the majority of the public. Secondly, their 'virtual and chimeric character no longer satisfies our "principles of verification". The period of organic abstraction in Surrealist painting, of which traces still lingered in his own 1929 pictures and which he now characterizes as the period of 'inaccessible mutilations, of unrealizable sanguinary osmoses, of loose visceral torn holes, of rocks'-hair and catastrophic emigrations', is now over.

It is clear that Dalí's chief claim for his method is that it will enable him to make concrete irrational images, cultivating confusion rather than contributing to the breakdown of the antinomy between mad and sane, etc. Dalí ignores completely that aspect of Breton's interest in madness which led him into direct conflict with directors of lunatic asylums; he ignores the social and moral responsibility which by this period Breton felt to be an integral part of Surrealist activity.

Dalí experimented off and on with his paranoiac–critical method through the thirties, perfecting the technique of multiple figurations in about 1938. Two earlier examples where he uses it very effectively, though not exclusively, are

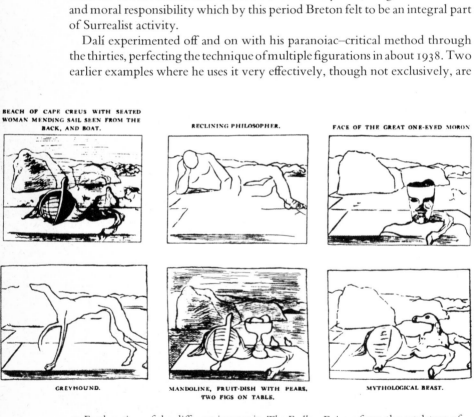

99 Explanation of the different images in *The Endless Enigma* from the catalogue of the Dalí exhibition at the Julien Levy Gallery, New York, in 1939

128

The Phantom Chariot (1933?), where two figures in a cart can also be read as the 95 towers of the town they are approaching in the distance across the plain, and *Suburb of the Paranoiac–critical Town; Afternoon on the Outskirts of European* 101 *History* (1936). There are in this painting several different sets of paranoiac phenomena, not all of which function as double images as in *The Invisible* 92 *Man*, but which explore various ways of visually interlocking objects unexpectedly or irrationally linked. The first set concerns the architecture: three separate architectural spaces are ranged horizontally across the painting, but in disjunctive planes, rather like three different stage sets. Each represents a place well known to Dalí – on the left a building from Palamós, south of Barcelona, where Dalí's friend and contemporary the mural painter José Maria Sert lived, and where Dalí was staying when he painted this picture; in the centre, framed through the archway is the village Vilabertràn, just outside Figueras, and on the right, the Calle del Cal, main street of Cadaqués, leading down to the harbour. The left and centre buildings are linked through the formal conjunction of the archway or door combined with the circular

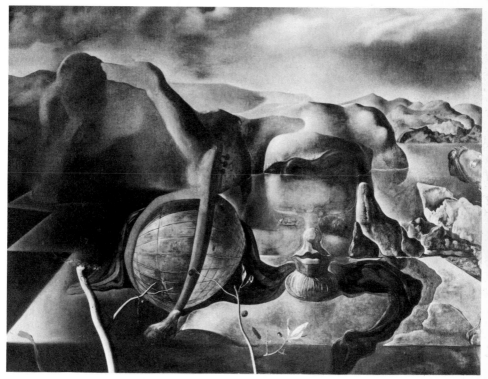

100 *The Endless Enigma*, 1938

skylight, which in the central view becomes a small ball on the bell tower. Each of these scenes, in itself a separate pictorial space, also offers a glimpse through into an unspecified inner space, a door leading through into another world. In some ways they are most like De Chirico's metaphysical architecture, and function mainly as a setting for the more specifically paranoiac phenomena. The Palamós building on the left evokes the Bramantean dome from Raphael's *Marriage of the Virgin* (which Dalí was to reproduce in *The Secret Life* to demonstrate 'sacerdotal space').

The second set of paranoiac phenomena – and this time more properly so described – is contained in the central section of the canvas left free of architecture, and links the bunch of grapes in Gala's hand, the skull on the table beside her, and the hindquarters of the horse behind, isolated on his pedestal like a De Chirico statue. A page of sketches shows him trying out ways of fusing these various objects; in the final painting the formal similarities are only hinted at.

The third set is scattered over the canvas, and includes several small figures dotted about, for which Dalí uses nearly a miniaturist's technique and which become quite difficult to read in reproduction. It 'starts' with the girl seen through the central archway, direct descendant of De Chirico's running child in *Mystery and Melancholy of a Street*, who repeats the configuration of the swaying bell in the tower embrasure. The bell is repeated again in the curious knob-topped chess-like pair of figures on the dressing-table in the foreground, and again on the upper storey of the left-hand building where they are more recognizably human figures. The keyhole in the chest in the right foreground – an image repeated in several paintings – also relates to the same configuration. This by no means exhausts the list of images paranoiac or otherwise in the painting – there is, for example, a disturbing link between the.

101 *Suburb of the Paranoiac–critical Town; Afternoon on the Outskirts of European History*, 1936

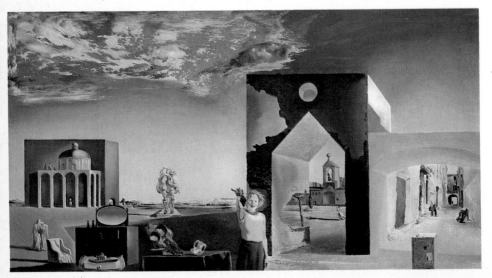

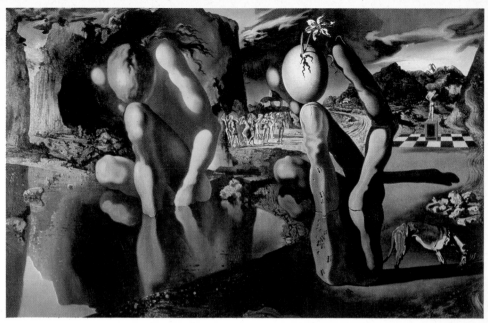

102 *The Metamorphosis of Narcissus*, 1937

103 *Impressions of Africa*, 1938

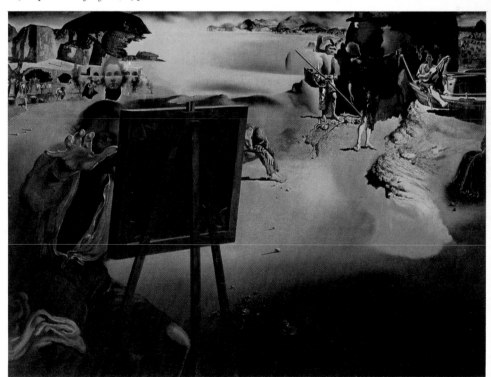

two draped and ghost-like figures in the lower left, and the imprint of an absent figure in the armchair in front of them. But it does provide an introduction to the way Dalí is using the paranoiac–critical method in this work – it is not as highly controlled as in some later paintings like *The Endless Enigma* (1938), nor does it offer the same kind of rather limited satisfaction akin to that of solving a puzzle, but it does provoke a genuine hallucinatory perceptual confusion and gives the spectator a licence of interpretation explicitly allowed by Dalí.

What exactly Dalí means by the reference to European history in the title is not really clear; the amphora on the table in the foreground is repeated in several of a group of slightly earlier paintings like *White Calm*, *Paranoiac–astral Image*, or *Mediumistic–paranoiac Image*, extraordinarily open, empty, shimmering beach scenes by contrast with the crowded *Suburb*. The amphora certainly evokes the Greco-Roman civilization so amply present in Catalonia and the Ampurdán plain, itself named after the Phoenician settlement Emporion, later colonized by the Romans, just south of Cadaqués. Dalí is perhaps here, then, referring in a more allusive manner than he was later to do, to the continuity of the Greco-Roman civilization.

The Metamorphosis of Narcissus, like *Suburb*, uses repeated images of similar configuration, with interconnected significance. The seated bowed figure of

104 *White Calm*, 1936

Narcissus becomes an ossified hand holding a cracked egg from which springs a narcissus flower. The relationship between reality and illusion is perfectly embodied in the myth of Narcissus, who fell in love with his own reflection and was drowned trying to reach it. In the background is what Dalí described in his poem 'Metamorphosis of Narcissus' as the 'heterosexual group' in attitudes of 'preliminary expectation', looking rather like a parody of a group of figures in a 'Golden Age' painting of the Renaissance, only that their attitudes are not innocent. It is spring, season of Narcissus, and to the right and just visible over the mountains is the god of snow, 'his dazzling head leaning over the dizzy space of reflection', who is beginning to melt with desire – he is the third version of the same configuration. Narcissus himself is painted in soft, golden colours, and, as Dalí claimed, he does if gazed at begin to dissolve too and melt into the red and gold rocks and their reflections. As Dalí describes it in the poem:

> Narcissus, in his immobility, absorbed by his reflection with the digestive slowness of carnivorous plants, becomes invisible.
> All that remains of him
> is the hallucinatory oval of whiteness of his head,
> his head more tender again,
> his head, chrysalis of biological after-thoughts,
> his head held up at the tips of the fingers of water . . .

Dalí also in the poem describes a conversation between two of the Port Lligat fishermen:

> First fisherman: 'What does that boy want to look at himself all day in the mirror for?'
> Second Fisherman: 'If you really want me to tell you: he has an onion in the head.'

As Dalí comments, 'onion in the head' for the Catalan fishermen indicated exactly the same as the psycho-analytical notion of a 'complex'.

Dalí was as conscious of Leonardo's method of conjuring imaginary scenes as Max Ernst had been, and in *The Secret Life of Salvador Dalí* describes his own similar habits as a child: 'The great vaulted ceiling which sheltered the four sordid walls of the class was discoloured by large brown moisture stains, whose irregular contours for some time constituted my whole consolation. In the course of my interminable and exhausting reveries, my eyes would untiringly follow the vague irregularities of these mouldy silhouettes and I saw rising from this chaos which was as formless as clouds progressively concrete images which by degrees became endowed with an increasingly precise, detailed and realistic personality.' Once seen, these images could, Dalí claimed, be realized at will – a quality he stressed of the paranoiac–critical method.

Dalí also refers to Leonardo in paintings like *Woman's Head in the Form of a*

105, 90 *Battle*, *The Great Paranoiac* and *Spain*, and such drawings as *September*, an illustration for *The Secret Life*. In *Woman's Head in the Form of a Battle* and *Spain*, the woman's head is formed of men and horses fighting; the technique is

97 considerably more successful (in terms of a static image) than in *Invisible Sleeper, Horse, Lion*, where the spectator is aware of alternative readings

90, 107 without being particularly convinced by any of them. In *Spain* we see *either* the face with red lips and huge melancholy eyes, *or* the spread red cloak of standing figure and a man on horseback. The prancing horses and battles are modelled on Leonardo, and the combination of these with a monochromatic

106 sandy ground recalls Leonardo's unfinished *Adoration of the Magi* with its sketched brownish background and strange horsemen set ambiguously in a half-landscape behind the Virgin and Child. There is also a hint that Dalí is using the Leonardo itself in the way that Leonardo may have used a mossy wall or a cloudy sky.

105 *The Great Paranoiac*, 1936

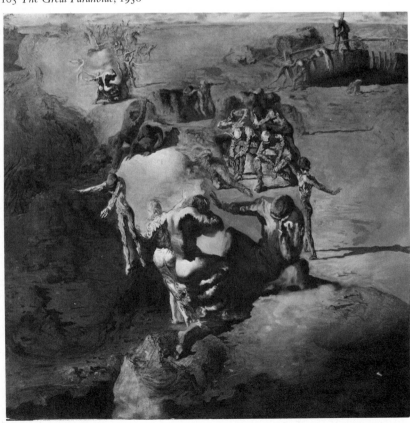

106 Leonardo da Vinci,
Adoration of the Magi, begun
1481, unfinished

107 Detail of *Spain*,
1938 (see ill. 90)

108 *The Slave Market with the Disappearing Bust of Voltaire*, 1940

109 Dalí's drawing for the head of Voltaire

108 One of the most successful of the many double images was *The Slave Market* (1940), in which the seated figure of Gala on the left gazes at a group of figures, including two women dressed in black and white in the style of seventeenth-century Spain. They, together with the gaping arch in the ruined building behind them, form the bust of Voltaire (Dalí uses a black and white drawing after the sculpture by Houdon), their faces become his eyes, their gloved and ruffled hands and arms his jaw, the glowing sky through the arch his domed head. Dalí places a third woman similarly dressed at the right rear of the group of figures, which resists any alternative reading. A similar *tour de force*, but this time with the configuration repeated for its alternative reading, is *Swans and Elephants* (1937).

110 In 1938 Dalí produced a series of paintings with multiple simultaneous images, including *Beach with Telephone* (now in the Tate Gallery), *Invisible*

136

110 *Beach with Telephone*, 1938

Afghan with the Apparition on the Beach of the Face of García Lorca in the Form of a Fruit Dish with Three Figures, the similar *Apparition of Face and Fruit Dish on a Beach*, and, the most elaborate of all, *The Endless Enigma*. When this painting was exhibited at Julien Levy's gallery in New York (where Levy was Dalí's regular dealer and energetic promoter) in 1939, the catalogue contained six schematic drawings breaking the composite image down to its various readings: the beach at Cape Creus with a seated woman mending a sail seen from the back, and a boat; reclining philosopher; face of the great one-eyed moron; greyhound; mandolin, fruit dish with pears, two figs on table; mythological beast. It was probably this group of paintings Breton had in mind when he wrote in 'The Most Recent Tendencies in Surrealist Painting' (1939) that the refinement of the paranoiac–critical method had reduced Dalí 'to concocting entertainments on the level of crossword puzzles.'

137

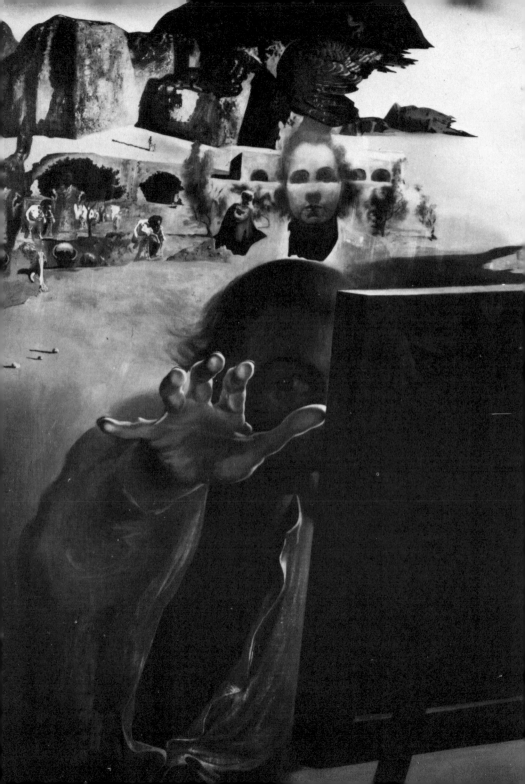

Impressions of Africa (1938) still retains some of the intensity of earlier 103, 111
paintings. Dalí crowds the double images up into a corner of the canvas, so
that to read the smallest (and there are images within images as in a Chinese
box puzzle) it is necessary to get very close up to it. He uses again the structure
of the medium's drawing, as in *Dismal Sport*, but in a much more explicit and 53
logical way: he depicts himself seated at the canvas 'my eyes staring fixedly,
trying to "see", like a medium', as he described it in *The Secret Life*. The first
image he 'sees' is Gala's head, summoned up in his imagination, and her eyes
then become the arcades of the building behind. Successive images with
multiple readings then spread out sequentially to the left, culminating in the
priest, who, in an anti-clerical Buñuel-like twist, also forms the head of a
donkey. This painting borrows its title from the play by Raymond Roussel,
whose games with alternative or irrational linguistics and double meanings
had fascinated Duchamp and the Surrealists. Roussel had no more been to
Africa than had Dalí; the painting was in fact executed shortly after a visit to
Rome, and the red cloth draped over Dalí's knee, and the dramatic
foreshortening of his hand and arm recall the perspectival and chiaroscuro
effects of Baroque painting.

Although Dalí has never abandoned the paranoiac–critical method, there
was never again the same burst of double images that there was in the late
thirties. In 1969, he started work on the first double image for some years, the
huge canvas *Hallucinogenic Toreador*, which had been inspired by the 147
reproduction of the Venus de Milo on a packet of Venus pencils, in which he
had seen the head of a toreador, whose eye is formed by the head of the left-
hand Venus. I watched him working on this canvas, and he painted
systematically with a surprisingly small brush, covering the canvas
methodically from one side to the other and creating a completely smooth
texture. He claimed that his procedure while working on the canvas was
automatic. The little boy in the right foreground in a sailor suit with a large
and ossified penis is, he explained, himself. It is a more or less exact repetition
of the child in *The Spectre of Sex Appeal* though the confrontation there 112
between the stuffed and rotting female and the child belongs to the persistent
theme of sexual fear and inhibition examined in the previous chapter;
Hallucinogenic Toreador is, really, a spectacular for its own sake, and includes
almost an anthology of earlier images. It is interesting that he was at this period
working simultaneously on a ceiling painting for the future King of Spain, a
circular canvas of the Three Graces among rosy clouds, seen in dramatic
foreshortening from below: a practice of working on pictures of different
styles at the same time that goes back to his student days.

111 Detail of *Impressions of Africa*, 1938 (see ill. 103)

One of the most sustained examples of Dalí's experimental use of the paranoiac–critical method outside the field of his own painting is his book *The Tragic Myth of Millet's Angelus*, which he wrote in 1938, but which was only published in 1963, having been lost for twenty-two years after being hidden during the fall of France in 1940. The book sets out to explore and analyse a peculiarly vivid experience Dalí had in June 1932, when Millet's *Angelus* suddenly appeared in his mind's eye, transformed by a latent meaning so strong that the painting became for Dalí the 'most troubling, enigmatic, dense, richest in unconscious thoughts' in the world. He called this the 'initial delirious phenomenon', and it was followed by a number of 'secondary delirious phenomena' of various types but all directly associated in his mind with the *Angelus*. Some of these were the products of fantasies or daydreams – as when two of the pebbles he played with on the beach which were of peculiar configurations, one much larger than the other and slightly inclined towards

113
115 it, brought clearly to mind the two figures in the *Angelus*, and also became associated with two of the rocks above Cape Creus, and two menhirs in Brittany. Others were the result of 'objective chance' of a peculiarly Surrealist kind, as when he saw in the window of a shop a tea-service decorated with reproductions of the *Angelus*, which reminded him significantly of a mother hen surrounded by her chickens. He saw the *Angelus* also in the fragment of a coloured lithograph of cherries – the most violent, he said, of all these 'secondary' paranoiac phenomena. Dalí then proceeds to a detailed analysis of these phenomena, which are, he insists, psychic rather than visual – in other words they are nothing to do with any traceable double image connected with the *Angelus*. These analyses themselves are rich in associations of personal or objective kinds: the cherries, for example, stand for the 'couple', as the stones did, but are also associated with the teacups, with teeth and therefore the aggressive stance of the woman, and are also a familar erotic symbol, 'a classic obsessive theme in popular thought with prolific examples in the most

116 evolved hierarchy of that thought: the picture postcard'.

In its apparently simple piety, the *Angelus*, with the couple resting from the labours of the day to pray at the sound of the church bell announcing evening prayer, has commanded the same kind of mass popular appeal as Constable's dream of rural peace in *The Haywain*. It had fascinated Dalí as a child, but he did not attempt to analyse this obsession until the early thirties. When he did, he found latent in the picture 'the maternal variant of the immense and atrocious myth of Saturn, of Abraham, of the Eternal Father with Jesus Christ and of William Tell himself devouring their own sons'. Each of the 'secondary delirious phenomena' he experienced fed into this interpretation; the

114 resemblance of the expectantly aggressive woman to the form of a praying mantis, notorious for its practice of devouring the male after the sexual act, suggested the latent 'sexual cannibalism', while a fantasy in which he imagined

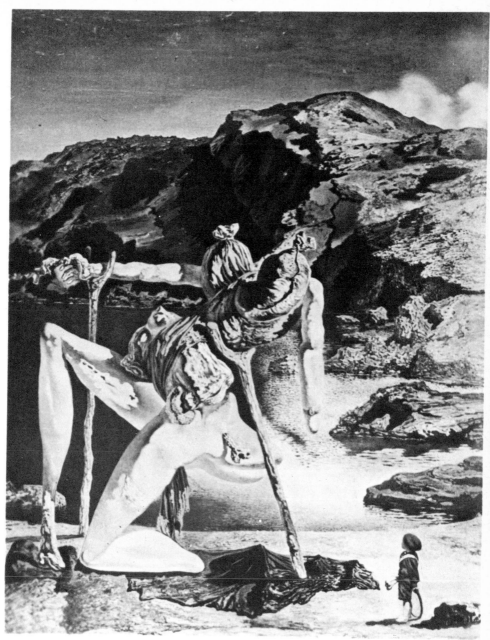

112 *The Spectre of Sex Appeal*, 1934

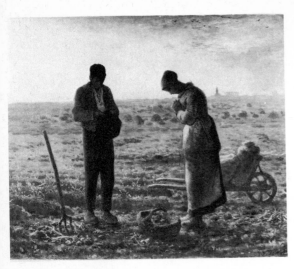

113 Jean-François Millet, *The Angelus*, 1858–9 together with 114–116 A photograph of the praying mantis and two of the popular postcards which Dalí used to illustrate his paranoiac–critical analysis in *The Tragic Myth of Millet's Angelus, a 'Paranoiac–critical' Interpretation*, published in 1963

the picture dipped in milk which submerged the figure of the man recalled to him an illustration of a kangaroo with its young in its pouch that he had seen as a child and that immensely troubled him then because he read the white of the pouch as milk. The kangaroo, too, reminded him of the mantis and therefore of devouring, engulfing maternal dominance. The milk, incidentally, was an obsessive theme in a number of works of the thirties including Dalí's first

Surrealist object 'functioning symbolically'. It is worth noting, in defence of the praying mantis, that Dalí received a letter from an entomologist, while preparing the book for publication, which pointed out that Fabre's account of the female mantis's sexual behaviour (Dalí's source) was true only of insects in captivity. Not to lose the reference, Dalí swiftly pushed out the analysis on another front: 'this letter comes magnificently to support my thesis: the customs of the peasants, under the restrictive and ferocious constraint of morality, reduce them to a state of veritable captivity'. An X-ray of the painting taken since the original text was written revealed a black shape in the picture which had been painted out by Millet, and which Dalí takes as a coffin, and confirmation that the painting is unconsciously about the death of the son. Dalí takes pains to link this 'myth' to his own experience, and suggests that Gala took the place of the threatening mother in the early stages of his relationship with her, through which he eventually overcame his fear of sex, which he had, before he met her, thought would inevitably bring his own death with it. The analysis of the *Angelus* is, then, a *tour de force* of mental disequilibrium leading to the creation of what Dalí suggests is a 'primal' and atavistic 'tragic myth' parallel to that he had already explored in earlier paintings of William Tell.

Dalí's analysis has obvious and immediate connections with the techniques of psycho-analysis. In his 1933 essay on the subject he had reproduced the *Angelus* and other paintings by Millet of harvesters and peasants together with Leonardo's *Virgin, Jesus and St Anne*, with the comment: 'How can the image, sublime symbolic hypocrisy of the *Angelus*, obsession of the crowds, escape such a flagrant unconscious "erotic passion [*furie*]"? The whole configuration constituted by the child's mouth and the tail of the famous and invisible maternal vulture interpreted by Freud in Leonardo's painting coincides intentionally with the head of the child in Millet's *Les Moissonneurs*.' Although in the book itself he plays down the purely visual parallels, he clearly had in mind from the start as a model *Leonardo da Vinci and a Memory of his Childhood*, Freud's famous essay on the hidden and unconscious eroticism of Leonardo's *Virgin, Jesus and St Anne*. However, he also makes it clear that he is not under any illusions that he is engaged on a purely psycho-analytical interpretation of Millet's picture. Although he is leaning very heavily on psycho-analytical theory (Oedipus complex, etc) and technique, which he falls into almost automatically to explain the phenomenon of *déjà vu*, and in the interpretation of symbols, he admits that he knows nothing whatsoever of Millet's life, which would have been a necessary preliminary to a psycho-analytical account of the *picture*; in so far as he himself is the subject – and this, of course, is where the ambiguity begins – he is careful to emphasize that he never *dreams* of the Angelus, but that it is the subject of daydreams or fantasies. Dalí had always been concerned to distinguish the paranoiac–critical method from psycho-analysis in that the

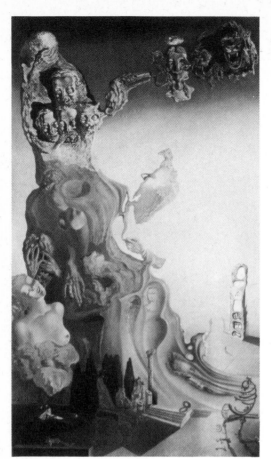

latter reduced phenomena to rational language, while the former was a method of 'spontaneous irrational knowledge' irreducible in the end to daily logic. It did, however, still have to be transmittable. The analysis Dalí gives is, then, inevitably somewhat paradoxical, in that it presents a more or less coherent reading of the painting in psycho-analytical terms which has been arrived at through the subjective obsessive 'delirious' associations of the paranoiac–critical 'method'. He ends up with an objective interpretation of the painting based on his own personal neurotic sexual fear, or rather unexpectedly awakened memories of it.

The figures from the *Angelus* first appear in one of Dalí's own paintings in *Imperial Monument to the Child Woman* (*c.* 1930), which also contains the *Mona Lisa* and a bust of Napoleon. From 1933 he regularly pursued the *Angelus* as a

117

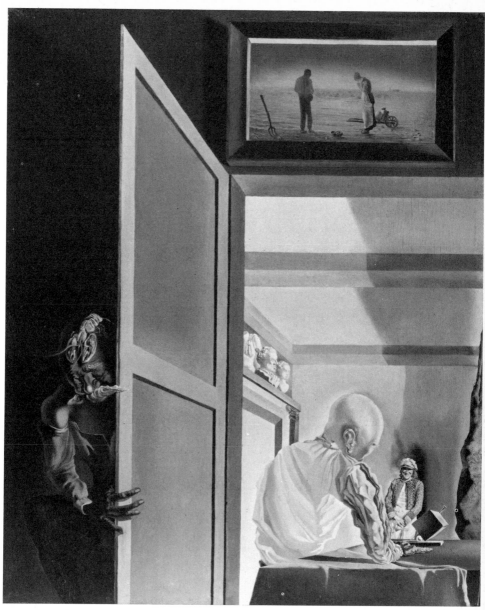

118 *Gala and the Angelus of Millet Preceding the Imminent Arrival of the Conic Anamorphoses*, 1933

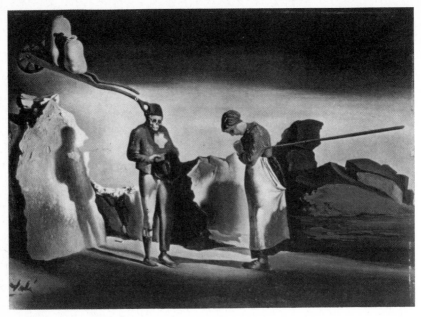

119 *The Atavism of Dusk*, 1933–4

118 theme; in *Gala and the Angelus of Millet Preceding the Imminent Arrival of the Conic Anamorphoses* he includes the Millet – the original image left, rarely, intact – above the doorway, round which Gorky is peering at the back of 80 cover Lenin, who faces a grinning Gala across the room. In both *The Architectonic Angelus of Millet* of 1933 and *Atavistic Remains After the Rain* (1934) he transforms the figures into biomorphic stones, atavistic menhirs which he links in *The Tragic Myth* to reveries about the age of the dinosaurs. In *Atavistic Remains* the 'female' has almost completely devoured the male; gazing on them as though on ancient monuments, looming over the Ampurdán plain, is 119 another couple, Dalí, as a child, with his father. In *The Atavism of Dusk*, which Dalí used to illustrate *The Tragic Myth*, the man has become a skeleton, a wheelbarrow extending from his head. In a preface to an exhibition at the Galerie des Quatre Chemins in 1934, Dalí wrote 'The *Angelus* is, to my knowledge, the only painting in the world which permits the immobile presence, the expectant meeting of two beings in a solitary, crepuscular and 120 mortal landscape.' In the 1935 *Portrait of Gala*, Dalí re-places the couple from the *Angelus* within the wheelbarrow, which he analysed in *The Tragic Myth* in terms of its popular symbolic–erotic presentations in postcards.

146

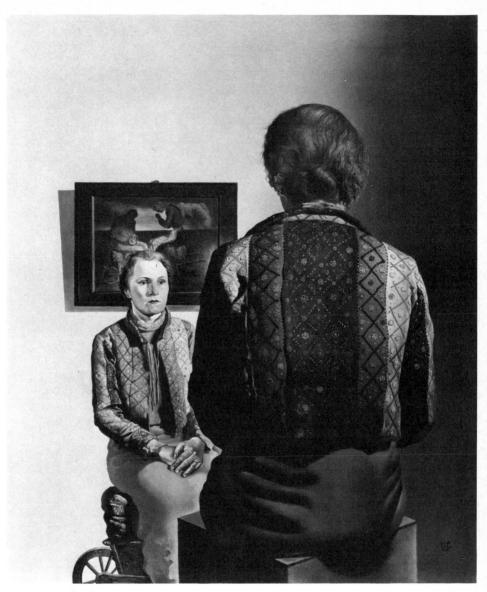

120 *Portrait of Gala*, 1935

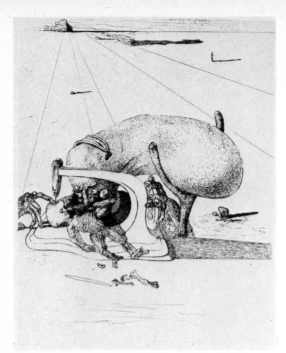

81, 121 In 1933–4 Dalí illustrated Lautréamont's *Les Chants de Maldoror*, one of
the Surrealists' most valued books, violent and hallucinatory, of which he said
the *Angelus* was the best equivalent in painting. Many of the etchings use the
Angelus as the basis of a series of variations on the themes of sexual cannibalism,
death and eroticism. In Plate XIV 'Saturn' is devouring a child trapped in a
sewing machine, introducing a reference to the phrase of Lautréamont's made
famous by the Surrealists, 'as beautiful as the chance encounter of a sewing
machine and an umbrella on a dissecting table', a phrase of whose sexual
symbolism the Surrealists were in no doubt. Dalí interpreted the sewing
machine and the umbrella as the two figures from Millet's *Angelus*.

Just as the initial stage of the paranoiac–critical activity that culminated in
The Tragic Myth had been the vivid apparition of the *Angelus*, so on occasions
other images would suddenly come into Dalí's mind, which he would then put
into paint, and which would subsequently lead to irrational but significant
links with other images. The paranoiac–critical activity lay in the chain of
association which may or may not be susceptible to significant interpretation.
So, he describes at the end of *The Tragic Myth*, 'In 1932, at bedtime, I see the
bluish and very shiny keyboard of a piano whose perspective offers me a
decreasing series of little yellow phosphorescent haloes surrounding Lenin's
122 face.' This is the image that appears in the painting *Composition – Evocation of
Lenin* (1931), which also recalls an incident from Dalí's childhood when he had

been shut up in a dark room, for having pushed another child off a bridge, and had found there a bowl of cherries. During the same summer he had a series of other 'seeings' involving the repetition of a number of other images: ink-wells, fried eggs, little flying batons on a loaf-like shape. All of these he eventually manages through the 'systematization of the delirious contents of this succession of images' to connect to the repetition of the *Angelus* on the tea-service and hence to the elaboration of the Myth of the Angelus as a whole.

It is in the nature of paranoia to draw into the orbit of delusive obsession all kinds of unrelated experiences and images. Therefore it could be said to be illogical to charge certain of Dalí's images for which he claims significance in terms, say, of the Myth of the Angelus, of being then connected in a purely arbitrary, and therefore meaningless fashion. The very nature of the paranoiac–critical activity, he has already assured us, is to systematize confusion. However, it would, I think, be fair to draw a distinction between purely formal analogies of the kind Breton castigated as 'crossword puzzles', like *The Endless Enigma*, and such psychologically pertinent sets of interlocked phenomena as *The Tragic Myth*.

100

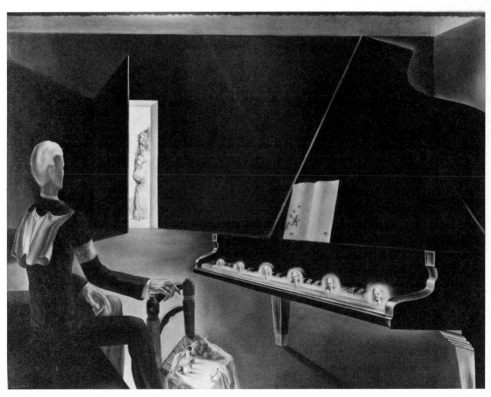

122 *Composition – Evocation of Lenin*, 1931

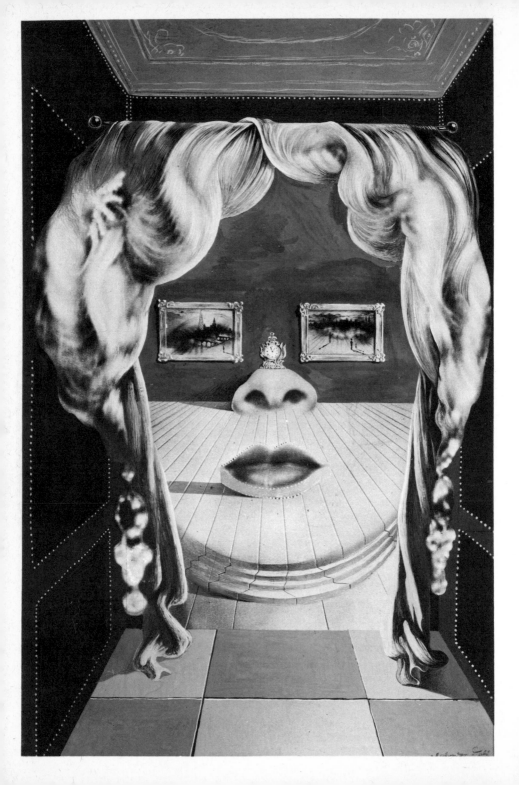

Dalí and the Surrealist object

*Dalí's 'Surrealist object functioning symbolically'; the object in relation to
Surrealist theory; found or 'involuntary' and imaginary objects; furniture, spectacle,
installations and exhibitions; Dalí's jewels.*

Although Dalí's paranoiac–critical activity had been welcomed by Breton as
authentically Surrealist and potentially of the widest application, it was not
adopted by other Surrealists. This is not surprising, given its technical
sophistication, which would be difficult for an untrained hand to accomplish.
The creation of a Surrealist object, on the other hand, was open to anyone,
writer or artist, thus conforming to the Surrealist ideal of an experimental
activity that was not governed by learned skills or aesthetic predilections.
Although the manufacture of a Surrealist object was not literally communal in
the way, say, the *cadavre exquis* is, neither was it exclusive. After the crisis 124
within Surrealism of 1929, which Breton's *Second Surrealist Manifesto* had
attempted to resolve, an urgent need was felt for something to draw the group
together. Dalí and a young Marxist member of the Surrealist movement,
André Thirion, were detailed to organize a commission to put forward
definite proposals for communal action. Thirion, at the suggestion of Aragon,

124 *Cadavre exquis, c.* 1930. This
Surrealist method of obtaining a
surprising juxtaposition of
images is based on the children's
game of Consequences. The
participants in this drawing, in
descending order, were: Dalí,
Gala Eluard, André Breton and
Valentine Hugo

123 (opposite) *The Face of Mae
West (Usable as a Surrealist
Apartment)*, 1934–5

proposed a concerted campaign of anti-clericalism. Dalí on the other hand proposed the Surrealist object, and thus inaugurated a new and fruitful period of Surrealist activity which lasted through the thirties. These alternative proposals, too, highlight the increasing polarization within Surrealism.

Dalí's first concrete proposal was the short text in *Le Surréalisme au Service de la Révolution* (no. 3, December 1931) which describes six different types of Surrealist object:

1. Symbolically functioning object (automatic origin)	suspended ball bicycle saddle, sphere and foliage shoe and glass of milk sponges and bowl of flour gloved hand and red hand
2. Transubstantiated objects (affective origin)	Soft watch Watches in a straw
3. Objects to project (oneiric origin)	In a physical sense In a figurative sense
4. Wrapped objects (diurnal fantasies)	Handicap Sirenion
5. Machine objects (experimental fantasies)	Rocking-chair for thinking Board for associations
6. Mould Objects (hypnagogic origin)	Car–table–chair–blind Forest

Dalí then elaborates on the first of these, the symbolically functioning object; in the second column are examples of such objects, in this case descriptions of the objects reproduced in the review – Giacometti's *Suspended Ball*, and four newly-created objects by Breton, Dalí, Gala Eluard and Valentine Hugo. Such objects, which 'lend themselves to a minimum of mechanical functioning, are based on phantasms and representations susceptible of being provoked by the realization of unconscious acts', and have their origin in unconscious desires and erotic fantasies. Dalí fully acknowledges Giacometti's *Suspended Ball* as the immediate precedent and inspiration for the idea of the symbolically functioning object, although he distinguishes between Giacometti's work which must still be defined as sculpture, and the true Surrealist object which is usually constructed from ready-made materials or found objects and lies outside any interest in form for its own sake. 'The symbolically functioning objects were envisaged following the dumb and mobile object, Giacometti's *Suspended Ball*, [an] object which already posed and united the essential principles of our definition, but which still held to the means proper to

125 Alberto Giacometti, *Suspended Ball*, 1930–31 126 *Aphrodisiac Jacket*, 1936
127 Charles Ratton Gallery, Paris. Surrealist Exhibition, May 1936

sculpture. Symbolically functioning objects leave no room for formal preoccupations. They depend only on the amorous imagination of each person and are extra-plastic.'

All the examples Dalí reproduces are elaborately constructed and accompanied with a full description. Some could move but this was not essential. Dalí's own object was the most sexually explicit:

129 A woman's shoe, inside which a glass of milk has been placed, in the middle of a paste ductile in form and excremental in colour. The mechanism consists of plunging a sugar lump on which an image of a shoe has been painted, in order to watch the sugar lump and consequently the image of the shoe breaking up in the milk. Several accessories (pubic hair stuck on a sugar lump, small erotic photo) complete the object which is accompanied by a box of sugar lumps for spares and a special spoon which is used to stir the grains of lead inside the shoe.

All the objects are complicated and fussy to a certain extent, but Valentine
128 Hugo's, in which a hand gloved in red lies over the wrist of a white-gloved hand and slips one finger under the white glove lifting it slightly, has a lightly suggestive eroticism, while Dalí's seems more like a compendium of sexual references running from fetishism to pornography. In his examples of fetishism, incidentally, in *Psychopathia sexualis*, Krafft-Ebing associates shoes with masochism. Another of Dalí's early objects seems to belong to the fifth category of Surrealist object he described above, to judge from its title: *Mad*
74 *Associations Board* or *Fireworks* (1930–31). This was a found object, an enamel advertisement board for a firm of firework manufacturers, which Dalí altered by the addition of tiny pictures in oil, and inscriptions. Many of the images are familiar elements from Dalí's iconography of this period: the woman's head which becomes a jug, the horribly grinning, leering man, swarming ants, his
58 own head lying horizontal and distorted as in *The Great Masturbator*, and the woman's high-heeled shoe with a glass of milk in it, which Dalí had realized in palpable form in the Symbolic Object described above.

The construction of such objects enjoyed a period of popularity among the Surrealists, but although the Surrealist object itself remained central to Surrealist activity during the thirties, it evolved, and the highly complex 'symbolically functioning object' was simplified, while the variety of types of object increased. Breton had already expressed doubts about the effectiveness of Dalí's type of symbolically functioning object in *Les Vases communicants* in 1932; while, he says, he has no reservations about their explosive value and their 'beauty', he finds them less effective, narrower in the possible range of interpretations, than objects less systematically determined. 'The voluntary incorporation of the latent content in the manifest content here weakens the tendency to dramatization and magnification that the psychic censor makes in

154

128 Valentine Hugo, *Surrealist Object*, 1931

129 *Surrealist Object*, 1931

the opposite case.' Breton is here voicing the same doubts Freud was later to express to Dalí himself, regarding the way in which Dalí does the interpretation himself of the latent content of his work and incorporates it. In Breton's opinion objects like Dalí's, too personal and particular in conception, lose the astonishing power of suggestion of such scientific apparatus as the gold-leaf electroscope, whose two perfectly joined leaves spring apart at the approach of a rubbed stick.

Both the concept of the Surrealist object, and the actual fabrication of objects from ready-made materials, of course long predated Dalí's first proposals. On the eve of the First World War Marcel Duchamp, whose interventions on the fringes of Dada and Surrealism were to be crucially formative for each movement, had begun to evolve his Readymades and Assisted Readymades. In the expanded version of Dalí's *SASDLR* text on the symbolically functioning object, 'The Object as Surrealist Experiment Reveals It', which was published in *This Quarter* in 1932, he quotes Breton's description of one of Duchamp's Assisted Readymades, *Why Not Sneeze, Rose Sélavy?*: 'I think of Marcel Duchamp going to fetch some friends to show them a cage which seemed to them empty of birds but half full of pieces of sugar, asking them to lift the cage which they were amazed to find so heavy, what they had taken for lumps of sugar being in reality little cubes of marble which Duchamp at great expense had sawn to those dimensions.' Man Ray, too, since the days of Dada, had been making disturbing or witty objects; an enigmatic photograph of one of these, an unidentified object (sewing machine, perhaps?) wrapped in a black cloth and tied with string, appeared in the first issue of *La Révolution Surréaliste* in 1924. In 1928 an object made by Breton and Aragon was reproduced there: called *Ci-gît Giorgio de Chirico* (Here lies Giorgio de Chirico), it consisted of miniature objects like a sewing machine and a model of the leaning tower of Pisa set within a little framed theatre stage. The sewing machine, a constant element in Surrealist iconography, refers to the phrase (mentioned above) of the nineteenth-century poet so admired by the Surrealists, the Comte de Lautréamont, 'as beautiful as the chance encounter of a sewing machine and an umbrella on a dissecting table', an image which itself conjures up an imaginary Surrealist object, and whose hold, as Breton said, is basically sexual.

Theoretically, too, the idea of the Surrealist object goes back to the very first days of the movement, to the time when the idea of Surrealist painting was limited to a footnote in the first *Surrealist Manifesto*. At the same time as the publication of this *Manifesto*, in 1924, Breton had also published his 'Introduction to the Discourse on the Paucity of Reality'. Here, he discusses the possible fabrication of objects which should enter the real world like any book or toothbrush, but which would have no obviously discernible function. Fetishism alone, he suggests, could understand the desire for the palpable

verification of a poetic as opposed to a utilitarian fact. 'I recently proposed', wrote Breton, 'to fabricate, in so far as possible, certain objects which are approached only in dreams and which seem no more useful than enjoyable. Thus recently, while I was asleep, I came across a rather curious book in an open-air market near Saint-Malo. The back of the book was formed by a wooden gnome whose white beard, clipped in the Assyrian manner, reached to his feet. The statue was of ordinary thickness, but did not prevent me from turning the pages, which were of heavy black cloth. I was anxious to buy it, and upon waking was sorry not to find it near me. It is comparatively easy to recall it. I would like to put into circulation objects of this kind, which appear eminently problematical and intriguing.' This text had a profound effect on Dalí, who presented its argument with care in an article he wrote for *L'Amic de les Arts* in March 1929: 'Review of Anti-artistic Tendencies, Surrealist Objects, Oneiric Objects'.

Certainly the implied conflict between the world of dreams and the world of reason appealed to Dalí much more than the ideal union between the two envisaged in the first *Manifesto*. Breton had gone on to say, of the creation of dream objects, 'Who knows, by doing that I would help perhaps to demolish these concrete trophies, which are so hateful and cast a greater discredit on those beings and things of "reason".' This is the idea that lies at the heart of Dalí's conversion to Surrealism, and it runs right through the 'Review of Anti-artistic Tendencies', one of the first of Dalí's writings to claim the absolute importance of Surrealism. In 'Surrealist Objects' (*SASDLR*), Dalí picks up and magnifies another idea from Breton's 'Introduction'; Breton had continued, 'There would be idle machines of a very scientific construction; we would draw up in minute detail plans for immense cities which, although we could never carry them out, might at least classify the present and future capitals. Absurd automatons, perfected to the last degree, which would function like nothing else on earth, might give us an accurate idea of action. . . .'

'Will poetic creations soon be called to take on this tangible character, to displace so singularly the limits of the so-called real? It is desirable that the hallucinatory power of certain images, the real gift of evocation which certain men possess independently of the faculty of memory, should not remain unknown any longer. . . . It is perhaps up to us alone to build on the ruins of the old world the foundations of our terrestrial paradise.' Dalí's proposal was as follows: 'The museums will fast fill with objects whose uselessness, size and crowding will necessitate the construction, in deserts, of special towers to contain them.

'The doors of these towers will be cleverly effaced and in their place will flow an uninterrupted fountain of real milk, which will be avidly absorbed by the warm sand.' But there are more than superficial differences between Breton's and Dalí's ideas. Breton is thinking in social and philosophical terms;

it becomes clear that what he is attacking is an attenuated notion of reality in which certain human needs (fetishism for example) or potential fields of action are ruled out by a blinkered reliance on 'reason'. Dalí is thinking in cultural and sexual terms. If his objects have any *raison d'être* beyond their inutility, it is as symbolically functioning simulacra of private desires.

Dalí does appear to have experimented from the start with different types of object. In June 1931 he included three 'moderne-style [*sic*]' objects at his exhibition at the Pierre Colle Gallery, which were presumably 'found' objects, and which herald Dalí's fascination with modern style, art nouveau objects and architecture. He described them in the catalogue note: 'Ornamental objects of the "modern-style" reveal to us in the most material way the persistence of dreams through reality, for these objects submitted to a scrupulous examination offer us the most hallucinatory oneiric elements.' This is true above all, he says, of modern-style architecture, 'In the dreadful street, eaten on every side by the perpetual torment of corrosive reality which abominable modern art reinforces and upholds with its despairing appearance, in the dreadful street the delirious and wholly beautiful ornamentation of those modern-style Metro entrances appears to us as the perfect symbol of spiritual dignity.'

In *SASDLR* no. 5 (May 1933) Dalí's text 'Objets psycho-atmosphériques-anamorphiques' introduced the idea of the construction of objects from descriptions of existing, bizarre but unseen objects examined by touch alone. After various procedures, the original and the new objects (now photographed) are reduced to fragments of molten and congealed metal. Dalí compares this to the contemplation of a luminous dot which the dreamer thinks is a star but which turns out to be only the tip of a lighted cigarette, but whose mystery returns once it is realized that the tip is only the visible part of an immense 'psycho-atmospheric-anamorphic object'.

In 1932 Dalí exhibited at the Pierre Colle Gallery two objects derived from the painting *The Persistence of Memory*: *Hypnagogic Clock* and *Clock Based on the Decomposition of Bodies*. The *Hypnagogic Clock* 'consisted of an enormous loaf of French bread posed on a luxurious pedestal. On the back of this pedestal I fastened a dozen ink-bottles in a row, filled with "Pelican" ink, and each bottle held a pen of a different colour.' The following year, 1933, at the joint Surrealist exhibition at the Pierre Colle Gallery, at which a number of Surrealist objects by different people were shown for the first time, Dalí exhibited *Retrospective Bust of a Woman*. For this object, he is pressing into service themes he had already pursued in a number of paintings, notably those of sexual and psychological cannibalism which he explored both in the William Tell paintings, and in those using Millet's *Angelus*. The object

145

130

158

130 *Retrospective Bust of a Woman*, 1933

consisted of a porcelain bust of a woman to which Dalí added a cartoon-strip collar, with two maize cobs suspended over the shoulders, while on the head was balanced a loaf of French bread inside which was embedded a pair of ink-wells, with the figures from Millet's *Angelus* in bronze under its original title *L'Abondance*. The object was first exhibited at the Salon des Surindépendants in Paris in 1933, when Picasso's dog ate the bread. In using bread, Dalí later commented, he was 'rendering useless and aesthetic that thing so completely useful, symbol of nutrition and sacred subsistence. What is easier than to dig cleanly two neat holes in the back of the bread and encrust in it a pair of ink-wells. What more degrading and beautiful than to see the bread stain itself with spots of Pelican ink.'

The bread balanced on the woman's head, transformation of the apple on the head of William Tell's son, links this object to a running image in Dalí's work, the balancing of objects edible or inedible on the heads of figures in his paintings, on objects, on models he then photographed, on characters in his films, even on his own head. In the course of a lecture he had been invited to give to a revolutionary Anarchist group in Barcelona in 1930, he had given instructions for a loaf of bread to be strapped to his own head. The root of this image must be Dalí's obsessional interpretation of the William Tell legend, but its use in his work is so widespread that its original sense has often been enlarged, extended or shifted. In *The Secret Life*, for example, he has said that when he painted Gala with a couple of chops on her shoulder, he subsequently discovered that it showed that instead of eating her he had chosen to eat the chops instead. In 'Les Nouvelles Couleurs du sex appeal spectral' (The New Colours of Spectral Sex Appeal), an article Dalí wrote for *Minotaure* in 1934, he included photographs by Man Ray of models, posed by Dalí himself, with a stick and then a shoe balanced on the head. In the 'Portuguese Ballet' William

131 *Lobster Telephone*, 1936

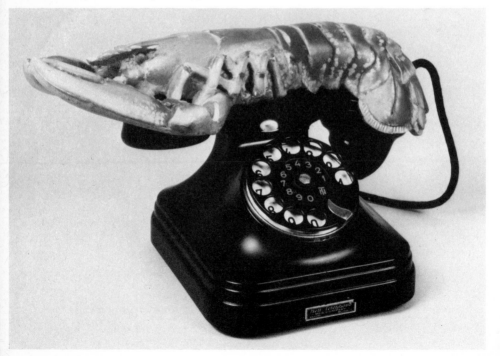

Tell, which concluded the film script *Babaouo* of 1932, the curtain rose to reveal thirty-five cripples each with a live chicken fastened to his head. It is of course possible that the obsession with something balanced on the head preceded Dalí's interest in the William Tell legend, and indeed perhaps determined the choice of this legend as a 'carrier' for his obsessions, in which case it would suggest a degree of interpretive analysis, rather like that in the case of Millet's *Angelus*, which is quite in harmony with Dalí's procedure. The finding of the subsequent 'interpretation' of the original fascination or irritant, which is a not uncommon practice in Surrealism, where works and their subjects had the capacity to 'surprise' their own authors because they may come into existence 'unconsciously', was carried by Dalí to new heights of systematic analysis.

Bread was also the theme around which Dalí built one of his elaborate campaigns, in the early thirties, related to the Surrealist object. He wanted to bake a loaf fifteen metres long, for which a special oven would have to be constructed. This bread would then be deposited at some comparatively unfrequented spot, like the gardens of the Palais Royal, without any indication as to who had made it or why. The bread would then be discovered as an 'insoluble fact' in the heart of Paris; a few days later it would be followed by another loaf twenty metres long, and this in turn by others culminating in the appearance of a new loaf of French bread forty-five metres long lying on the sidewalk in New York, edible ancestor of Claes Oldenburg's huge soft city monuments, and a potential advertising stunt *par excellence*. Dalí is, of course, here playing games with the original notion of the Surrealist object's manifest purposelessness throwing discredit on the ordinary functional objects of the real world, because the sense of confusion comes in this case from the reverse, from the introduction of the most practical object of all into a context alien to it and in a vastly exaggerated dimension. That Dalí's purpose, although expressed in a more cynical way in *The Secret Life*, is to sow confusion, is clear: 'no one would be able to question the poetic efficacy of such an act which in itself would be capable of creating a state of confusion, of panic and of collective hysteria extremely instructive from an experimental point of view and capable of becoming the point of departure from which, in accordance with my principles of the imaginative hierarchical monarchy, one could subsequently try to ruin systematically the logical meaning of all the mechanisms of the rational practical world.' However, bread is not only basic food but the sacramental symbol, and Dalí discusses the likely hypotheses about the meaning and function of these loaves, which could, he suggests, be attributed to the Communist Party who would be demonstrating 'that it took a lot of bread to feed everybody', or perhaps were making the point that 'bread was sacred'. The baking of the bread would be symbolic without symbolizing anything, a phantom symbol.

In *Minotaure* nos 3–4, December 1933, Dalí published a series of photographs of 'sculptures involontaires', involuntary sculptures, torn and rolled bus tickets, an ornamental bread roll, a used piece of soap, a blob of toothpaste. These *are* sculpture to the extent that they are formed by the hand, but otherwise resemble the object 'found' by chance in that they owe nothing to premeditation. This page of photographs immediately precedes Dalí's article on 'The Terrifying and Edible Beauty of Modern Style Architecture', and what fascinated Dalí was the formal automatic similarity between the curved and undulating shapes of these moulded, squeezed, pressed and rolled fragments and the grand organic shapes of art nouveau architecture, wrought ironwork, etc, of which he reproduces many examples. One should beware, though, of thinking that Dalí intended these involuntary sculptures as 'found' natural objects (strangely shaped stones or sticks, for example, were frequently picked up and interpreted by the Surrealists). They were formed by the human hand, and therefore lay, even though unconsciously, under the forming power of the imagination. Dalí was far too deeply embedded in Freud to think that because an action or word was unconscious, it was therefore innocent of meaning.

132 From an article by Dalí in *Minotaure*, December 1933, 'On the Terrifying and Edible Beauty of Modern Style Architecture'. This page is headed 'Have you seen the entrance to the Paris Metro?' and the photographs are captioned as follows: (*top left*) 'As opposed to the functionalist ideal here is the symbolic–psychic–materialist function'; (*top right*) 'This is another atavism in metal from the Angelus of Millet'; (*bottom left*) 'Eat me!'; (*bottom right*) 'Me too'

133 *Surrealist Object*, 1936

For Dalí the Surrealist object was inseparable from a whole range of activities and inventions. We have already seen, for example, how a theme like that of William Tell, or of Millet's *Angelus*, occurs in objects. This might be a matter of a particular image recurring in whatever medium Dalí is working in, but he also experiments with the palpable differences an object in three-dimensions can have from a two-dimensional painting. In *Minotaure* no. 6 (winter 1934–5) he published 'Apparitions aero-dynamiques des êtres-objets' (Aerodynamic Apparitions of Object-beings) to accompany which he had photographs taken of himself wearing a kind of hood extending down to his waist and completely covering his face, on which are reproductions of two paintings by Millet including the *Angelus*. Round his feet are four ink-wells.

One area which cross-fertilized particularly successfully with the Surrealist object was that of furniture design and interior decoration: to be understood, though, in a strictly non-functional sense. Dalí's passion for modern style objects and ornaments soon extended to making his own, and one of the first experiments in this direction seems to have been the transformation of two chairs he was given by a decorator friend, Jean Michel Franck, which were in the purest 1900 style. He changed the leather seat of one for another made of chocolate, and added a golden Louis XV door-knob to one foot of the second, thereby rendering it highly unstable. Dalí created another fantasy on the

135 theme of the chair–object in 1960, embellishing a wooden cane-seated chair
with spoons; in 1970 he made a version of this chair in bronze. His most
complete project of this type was the design for the installation of a whole
room based on the paranoiac–critical method, the original subject of which
 West's face. A drawing of 1937 is called *The Birth of Paranoiac*
tail the mouth transformed into a sofa and the nose
e in the Art Institute of Chicago shows the complete

123 he eyes doubling as a pair of pictures hanging each
Michel Franck made a version of the sofa for Dalí,
s close as possible to Schiaparelli's lipstick 'Shocking

134 s were made for one of Dalí's patrons, Edward James,
London. This divan–mouth was, according to Dalí,
pot among the jagged rocks beyond Cadaqués, which
rtable for sitting. He links it, too, with the Gaudí façade
s, and it also has close connections with a series of
ranoiac face is created out of a landscape in which the
back of the nurse. The whole room has been created in
the Teatro Museo Dalí in his home town of Figueras. Her swathes of blonde
hair have become curtains framing the room as though it were a stage set; a
small platform has been constructed so that the ensemble is seen from a
particular height and angle.

134 *Mae West's Lips Sofa*, 1936–7

In 1936 an exhibition entirely devoted to objects was put on at Charles 127
Ratton's gallery in Paris, and a special edition of *Cahiers d'Art* was devoted to
the object. Dalí exhibited *Monument to Kant* and *Aphrodisiac Jacket*; in *Cahiers
d'Art* he published the article 'Honneur à l'objet!', which included a
commentary on the swastika, and a short text on the *Aphrodisiac Jacket*, 126
comparing the dinner jacket bristling with liqueur glasses filled with sticky
crème de menthe in which worm larvae were hatching, to the legend of St
Sebastian. It fell into the category, in his opinion, of the *machine à penser*, the
thinking machine. Also in the exhibition was Gala Dalí's maquette for a 136
Surrealist apartment, in which a staircase leads upwards to nothing but a huge
photographic reproduction of a sculpture of Cupid and Psyche, a pagan
Jacob's ladder.

Dalí also collaborated on the exhibition which contained the most
spectacular collective manifestation of the Surrealist object, at the Galerie
Beaux-Arts in Paris in 1938, although he was by now on more distant terms
with the Surrealists. He was named in the catalogue as 'special adviser',
together with Max Ernst. This exhibition was not limited to objects, including
all kinds of Surrealist productions, but it was the first of the Surrealist
exhibitions to take place within a specially prepared and wholly strange

136 Gala Dalí's maquette for a Surrealist apartment, from *Cahiers d'Art*, 1936

137 *Rainy Taxi* at the International Exhibition of Surrealism at the Galerie Beaux-Arts, Paris, 1938

complete environment, so that the works, rather than being presented as isolated oddities, are integrated into a transformed and marvellous setting. Marcel Duchamp, the *générateur–arbitre*, was largely responsible for this, having conceived of an underground grotto in the main room, with reed-fringed pools in the corners and a ceiling hung with sacks of coal. The room was in darkness, visitors carrying flashlights to see the works. The 'street' passage which led to the main room was lined with mannequins, each presented by a Surrealist, and there had, according to Dalí, been some trouble in getting Breton to accept the 'dressing' some artists had given their dummies. Dalí's had a toucan's head, an egg between its breasts, and was embellished with little spoons. A number of his objects, paintings and drawings were exhibited, but his active participation was kept to a minimum. However, shortly before the exhibition opened he asked for a monument to be set up in the entrance to the gallery: 'a taxi, with a roof full of holes that would let a continual rain seep through on a Venus lying among the lichens, and driven by a monster.' There were to be two hundred Burgundy (i.e. edible) snails and twelve frogs inside the cab, and the woman was to wear a 'sordid cretonne print, displaying Millet's *Angelus*'. Breton was apparently opposed when Dalí put forward his proposal, but the rest of those present were in favour, and so the object was hastily assembled. They never found the frogs, but otherwise it was much as it had been planned.

Dalí has from the late thirties tended to favour the creation of whole environments and objects on a monumental scale, often with a highly theatrical flavour. In 1939, for example, he created a pavilion for the New York World's Fair, in association with the intermediary of his New York dealer Julien Levy. The installation, baptized the Dream of Venus, was to be on a stand in the Amusement Area of the fair, and was to consist of a giant water tank to be filled with both real and model sirens, various other objects (a man made of rubber ping-pong bats), a Surrealist landscape backcloth with soft watches, and huge reproductions of the *Mona Lisa* and Botticelli's *Birth of Venus*. It was not, in the end, according to Levy, a complete success, because of the problems of getting the 'middlemen', in this case those putting up the money for the installation, to agree to Dalí's more extravagant suggestions: extravagant, that is, in terms of the imagination rather than money. One promoter, a rubber manufacturer, wanted, against furious resistance from Dalí, to fill the tank with rubber mermaids, in Dalí's understandable opinion a banal and second-rate idea. He was in turn horrified by Dalí's plan to have Botticelli's *Venus* on a vast scale on the façade, with a fish's head. He complained to the organizing committee, who prohibited it, and thus provoked Dalí to write a spirited parody of the American Declaration of the Rights of Man: 'Declaration of the Independence of the Imagination and of the Rights of Man to his Own Madness'. 'The committee responsible for the

Amusement Area of the World's Fair has forbidden me to erect on the exterior of "The Dream of Venus": the image of a woman with the head of a fish. These are their exact words: "A woman with a tail of a fish is possible; a woman with the head of a fish is impossible." This decision on the part of the committee seems to me an extremely grave one. . . . Because we are concerned here with the negation of a right that is of an order purely poetic, and imaginative, attacking no moral or political consideration. I have always believed that the first man who had the idea of terminating a woman's body with the tail of a fish must have been a pretty fair poet; but I am equally certain that the second man who repeated the idea was nothing but a bureaucrat. In any case the inventor of the first siren's tail would have had my difficulties with the committee of the Amusement Area. Had there been similar committees in Immortal Greece, fantasy would have been banned and, what is worse, the Greeks would never have created . . . their sensational and truculently Surrealist mythology, in which, if it is true that there exists no woman with the head of a fish (as far as I know) there figures indisputably a Minotaur bearing the terribly realistic head of a bull.

'Any authentically original idea, presenting itself without "known antecedents", is systematically rejected, toned down, mauled, chewed, re-chewed, spewed forth, destroyed, yes, and even worse – reduced to the most monstrous of mediocrities. The excuse offered is always the vulgarity of the vast majority of the public. I insist that this is absolutely false. The public is infinitely superior to the rubbish that is fed to it daily. The masses have always known where to find true poetry. The misunderstanding has come about entirely through those "middlemen of culture" who, with their lofty airs and superior quackings, come between the creator and the public.'

It was Levy who set up another project, the same year, which ended in one of Dalí's involuntary news-catching escapades. He arranged for Dalí to do a window dressing for the Bonwit-Teller store on Fifth Avenue, and, as he says, 'Dalí was enchanted by the rich prospect of realizing his inventions in this workshop.' Dalí set up a window which included a bath-tub with a mannequin reclining inside; unfortunately, overnight the mannequin was moved out of the bath by a zealous employee to give a better view of its gown. Dalí flew into a rage when he saw his idea ruined, and in the resulting mêlée he and the bath-tub crashed through the window into the Avenue. Dalí was arrested pending criminal charges of wilful destruction, but was released later the same day. He certainly had not intended this as a publicity stunt, but the effect was that he was confirmed in the public eye as the most outrageous artist of the time.

The installation of the Teatro Museo Dalí, in Figueras (inaugurated in 1974), is also highly theatrical, and most of the motifs in it are repetitions of earlier ideas (like the installation of the central foyer during the Dalí

retrospective exhibition at the Pompidou Centre in Paris in 1980, which included the suspended old black Citroën car, which first appeared in the painting of *c.* 1930 *Imperial Monument to the Child Woman*). Certain rooms at Figueras have a stagey, *fin-de-siècle* setting with red velvet and elaborate art nouveau objects. Also at the Museum are a number of kinetic and moving objects which fit in interestingly with Dalí's other optical experiments in paintings of the sixties. One room is full of constructions set up to test stereometric effects. Another series of objects involves hinged mobile constructions which when activated are transformed from one shape to another – from a cross to a figure, for example. Some recall the kind of constructions used during the Renaissance to demonstrate mathematical or geometrical principles. To work them one puts money in a slot as though at a fairground or penny arcade, and it is interesting to speculate whether Dalí had in mind the brilliant transformations of philosophical toys and of slot machines by the American Surrealist Joseph Cornell.

117

Are Dalí's objects the nearest Surrealist prototype of Pop Art? There is something in his pursuit of theatrical kitsch which does parallel some Pop Art constructions, and his paranoiac–critical room (Mae West's face) could very well be compared with Oldenburg's *Bedroom Ensemble 1*; both are, among other things, three-dimensional environments ironically dependent on two-dimensional pictorial devices.

But Dalí's objects and installations differ fundamentally from the streamlined fifties vigour of Pop Art; they lean to a fussy elaboration rather than simplicity, and their real affinity remains with *fin-de-siècle* decadence and wit. Perhaps that is why his magnificently vulgar jewel-objects are among his best. They are highly contrived but totally appropriate – a quality lacking from objects like *Michelin Slave* or *Otorhinologique Head of Venus*. Some jewels revitalize a poetic cliché by taking it literally, like *Ruby Lips*, framing a set of real pearl teeth. The first person to use this metaphor was, as the Surrealists said, a poet, the second, a hack. Especially striking among the jewels are those which move – the pulsing ruby *Royal Heart, The Living Flower* with waving fronds, the eye-watch. A surprisingly high proportion of the jewels are devoted to religious themes, and the precious stones and mineral take on symbolic connotations, though of Dalí's own invention rather than those of the Church. The angel cross, for example, is intended to symbolize 'The hyperxiological concept of existence . . . the treatise of existence . . . the gradual transformation from the mineralogical to the angel,' with each stage represented by a special stone or material: 'The lapis lazuli is the mineral. The coral cross – the Tree of Life – is the plant world. The rhythm of the spines represents the animal world . . . The topaz is the tabernacle gate. . .'

139, 140

138

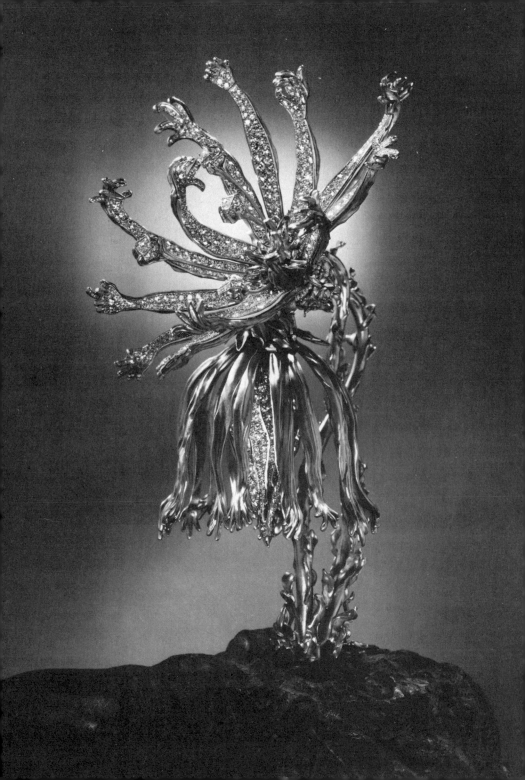

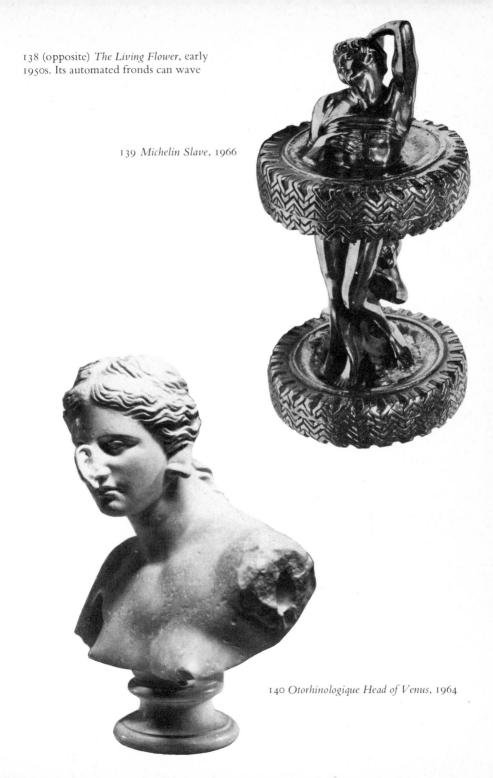

138 (opposite) *The Living Flower*, early 1950s. Its automated fronds can wave

139 *Michelin Slave*, 1966

140 *Otorhinologique Head of Venus*, 1964

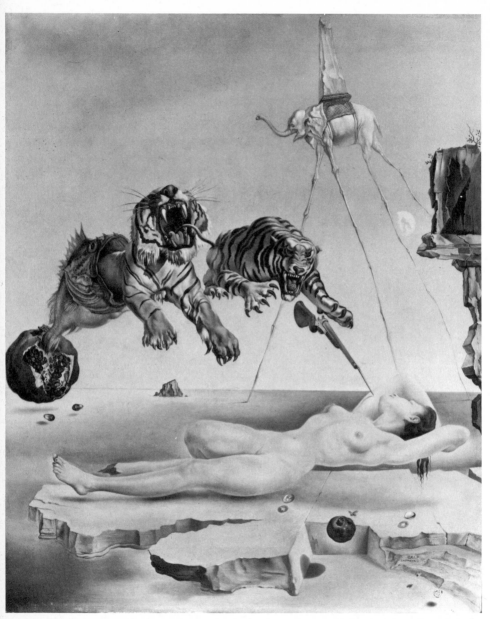

141 *Dream Caused by the Flight of a Bee Around a Pomegranate One Second Before Awakening*, 1944

Dalí's post-war painting

Modern science and mysticism; variety of visual experiment; use of photography, holography and stereoscopy.

Since 1945, Dalí has both shown a paradoxical openness to experimental techniques and to the innovations of the post-war generations of painters, and has produced what have been described, I think mistakenly, as his first 'historical' pictures. Such works as *The Dream of Christopher Columbus*, huge 148 and epic in scope, in fact run on the theme familiar with Dalí of faith and the strength of tradition. But in being pro-tradition he was by no means anti-modern. Not only did he express his enthusiasm for the American Abstract Expressionists, especially de Kooning, whose influence is visible in Dalí's work in the late fifties, and collaborate with the most prominent exponent of the French version of Abstract Expressionism, Georges Mathieu, but he was particularly in favour of the discoveries of modern science (not least because, in the branch of cryogenics, a way might be found of preserving him alive). Among the problems to be reconciled in this post-war period is the relationship between his desire to emulate the great achievements of the oil paintings of the old masters and his pursuit of visual experiment. The result of Dalí's apparently unending appetite for new ideas and techniques is that once again, in his later years as in his early ones, he paints in a number of different styles simultaneously.

Linking the manifestations of Pop Art, optically illusionistic painting, photographic hyperrealism, Divisionism, Abstract Expressionism, stereoscopy, and holography, all of which make their appearance in his post-war work, is the theme of realism, although this could be subdivided into the pursuit of pictorial and scientific realities. However, such a subdivision does not hold completely, and Dalí is profoundly antagonistic to the separation of scientific from other modes of human knowledge. As he said in an interview published in 1976 in the review *Le Sauvage*: 'The progress of the sciences has been colossal, even Auguste Comte could not foresee it. But from the spiritual point of view, we live in the lowest period of civilization. A divorce has come about between physics and metaphysics. We are living through an almost

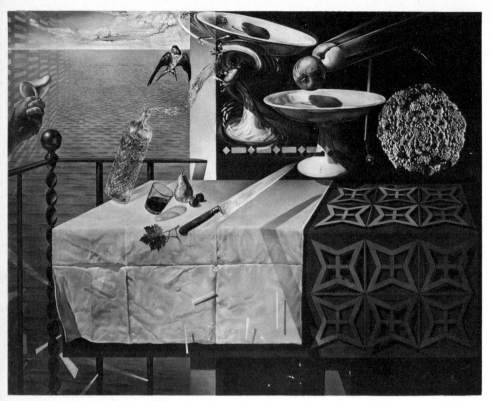

142 *Animated Still Life*, 1956

monstrous progress of specialization, without any synthesis. . .' Although Dalí
admits to ignorance in most branches of science, this does not prevent him
from pursuing such a synthesis himself, and this in itself becomes a major
theme.

The event that influenced Dalí most deeply was the explosion of the atom
bomb at Hiroshima at the end of the war: 'The atomic explosion of 6 August,
1945 shook me seismically. Thenceforth, the atom was my favourite food for
thought. Many of the landscapes painted in this period express the great fear
inspired in me by the announcement of that explosion. I applied my
paranoiac–critical method to exploring the world. I want to see and
understand the forces and hidden laws of things, obviously so as to master
them. To penetrate to the heart of things, I know by intuitive genius that I
have an exceptional means: mysticism. . .'

174

The discoveries of the atomic physicists concerning the structure of matter, which had revealed the release of energy involved in breaking up atomic particles, were immediately fastened on by Dalí if only to be applied metaphorically. *Inter-atomic Equilibrium of a Swan's Feather* (1947) suspends disparate objects in space in what appears to be a state of immobility brought about by the forces of mutual attraction and repulsion. It is not, of course, 'inter-atomic' at all, since he is using not atomic particles but particles of objects or even whole objects. Striking here, and in *Nature morte*, is precisely that sense of relative weight and texture abolished by generalized theories of atomic matter. However, the overall sense of the divisibility of matter – first posited by the Greeks two thousand years ago but only proved with such devastating force in our century, appears again and again in different forms in Dalí's paintings of this period. *Exploding Raphaelesque Head* (1951) and the *Madonna of Port Lligat* (1949) offer interesting contrasts in his treatment of this 151 theme. Each is very closely related to Italian Renaissance painting too; in the first, Dalí has linked a Raphael head of a Madonna with the interior of the Pantheon in Rome, and then shattered them into multiple elements taking the form of rhinoceros horns (for reasons which will be explained below). 'To the continuous waves of Raphael', Dalí commented on this painting, 'I added discontinuous corpuscles to represent the world of today.' The model for the *Madonna of Port Lligat* is Piero della Francesca's Brera Altarpiece, *Madonna and Child with Angels and Six Saints*, with the Madonna translated as usual into Gala. Although the figures and the architecture are pierced and dismembered, the effect is still one of equilibrium, emphasized by the egg suspended from a shell balanced immediately over the Madonna's head, as it is in Piero's altarpiece (except that Dalí reverses the shell) where it probably stands as a symbol of eternity.

An even more curious merging of the theories of nuclear physics and Dalí's brand of mysticism occurs in the *Anti-Protonic Assumption* (1956). Dalí here is 144 drawing on the combination of the theories of quantum mechanics with relativity, which showed that corresponding to any particle was an anti-particle of the same mass, and that when they met and annihilated each other they let off an enormous amount of kinetic energy. The Assumption of the Virgin takes place, he suggests, not by the power of prayer but by the power of her own anti-protons. She is, in Dalí's opinion, a kind of Nietzschean super-woman, representing the 'paroxysm of the will-to-power of the eternal feminine'. Christian dogma, here, becomes a form of superior science-fiction.

In the Preface to the catalogue of his exhibition at the Carstairs Gallery in New York in 1958–9 Dalí included a 'Manifesto of Anti-matter', in which he wrote: 'I want to find out how to transport into my works anti-matter. It is a question of the application of a new equation formulated by Dr Werner Heisenberg which . . . can give the formula of the unity of matter.

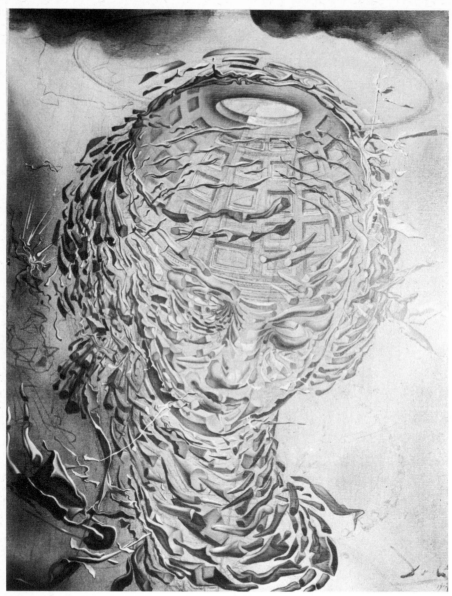

143 *Exploding Raphaelesque Head*, 1951

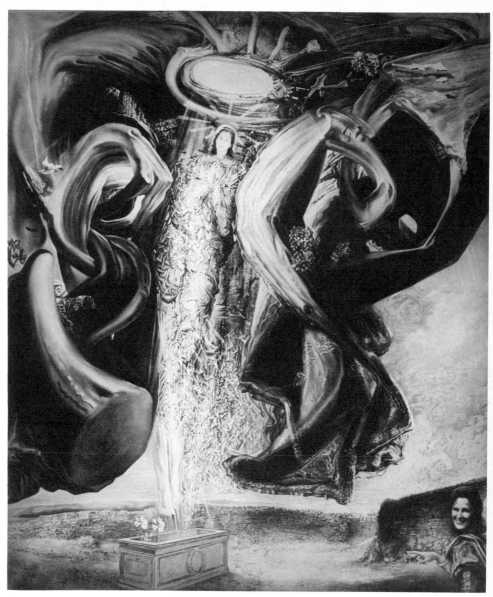

144 *Anti-Protonic Assumption*, 1956

'I love physics. Recently I had to stay for a month and a half in hospital to recover from a delicate appendix operation. I had the leisure to study nuclear physics during this convalescence. . .

'Today the external world – that of physics – has transcended that of psychology.

'Today my father is Dr Heisenberg . . .' (whereas during the Surrealist period his father had been Freud).

Dalí's frequent use of religious subject-matter during this period is part of his overall strategy to reintroduce metaphysics into physics. While he was working on *Corpus Hypercubicus* in the summer of 1953, a group of young nuclear physicists came to visit him, bringing with them coincidental confirmation of Dalí's choice of cubic form for the cross: 'they left again, intoxicated, having promised to send me the cubic crystallization of salt photographed in space. I should like salt – symbol of incombustibility – to work like me and like J. de Herrera on the question of the *Corpus Hypercubicus*.' Herrera, the sixteenth-century Spanish architect of Philip II's palace, the Escorial, wrote a *Discourse on Cubical Form* which had initially inspired Dalí's painting. Herrera was only a generation or so older than Velázquez and Zurbarán, and it was specifically to them, and above all Zurbarán, that Dalí had looked to find a way of painting, as he put it, the 'metaphysical beauty of Christ'. 'I want', he wrote in his 'Mystical Manifesto' (1951), 'my next Christ to be the painting containing the most beauty and joy of anything anyone has painted up to the present day. I want to paint the Christ who will be the absolute antithesis of the materialist and savagely anti-mystical Christ of Grünewald.' So he adopts the same technique that he had used in the two versions of *The Basket of Bread* from Zurbarán, for his two versions of Christ on the Cross, of 1951 and 1953–4. The dramatic angle of the cross in *Christ of St John of the Cross* was in fact inspired by that in the drawing of Christ on the Cross by the Spanish mystic St John of the Cross.

In *Exploding Raphaelesque Head*, and in several other pictures of the fifties like *Corpuscular Madonna*, Dalí, as already noted, represents the disintegrating particles of matter in horn-like shapes, which he identifies as rhinoceros horns. In 1955 he gave a lecture at the Sorbonne in front of an enthusiastic audience to whom he attempted to prove that Vermeer's *Lacemaker* was morphologically a rhinoceros horn. 'That summer of 1955, I discovered that in the junctions of the spirals that form the sunflower there is obviously the perfect curve of the rhinoceros horn. At present the morphologists are not at all certain that the spirals of the sunflower are truly logarithmic spirals. They are close to being so, but there are growth phenomena which have made it impossible to measure them with rigorously scientific precision, and the morphologists do not agree on whether or not they are logarithmic spirals. However, I was able to assure the audience at the Sorbonne yesterday that there never has been a more

156
155
143
18

perfect example in nature of logarithmic spirals than those of the curve of the rhinoceros horn. Continuing my study of the sunflower and still selecting or following the more or less logarithmic curves, it was easy for me to distinguish the very visible outline of the *Lacemaker. . .'*. There is a long and detailed discussion of spirals in horns, sunflowers and shells (which are specifically compared) in D'Arcy Thompson's classic study *On Growth and Form*, first published in 1917 and which Dalí knew well.

Dalí's thought has taken, here, as so often, a route that is a bewildering mixture of scientific and paranoiac logic. So, for example, his interest in the logarithmic spiral, and hence in the rhinoceros horn, led on to the making of the film *The Prodigious Adventure of the Lacemaker and the Rhinoceros*.

In the 1955 lecture Dalí also claimed that *The Persistence of Memory* was the first occasion on which the form of the rhinoceros horn began to detach itself. This may be, and is clearly hindsight anyway, but it is interesting to compare this famous image of soft watches with the post–war atomic and rhinoceros pictures, because it does have a greater and unforced hold on the imagination, partly because it is less obviously and consciously determined. The soft watches are an unconscious symbol of the relativity of space and time (Camembert of time and space, Dalí described them), a Surrealist meditation on the collapse of our notions of a fixed cosmic order. Dalí wrote much later in his 1951 'Mystical Manifesto', 'Since the theory of relativity substituted the

145

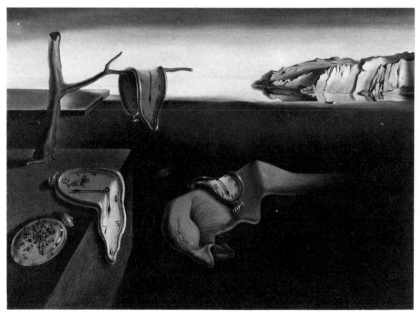

145 *The Persistence of Memory*, 1931

substratum of the universe to the ether dethroning and thus bringing time back to its relative role already accorded it by Heraclitus when he said "time is a child" and also Dalí when he painted his famous "soft watches", since the whole universe seems filled with this unknown and delirious substance, since the explosive equivalent mass–energy, all those who think, outside the Marxist inertia, know that it is up to the metaphysicians to "work out precisely the question" of substance!'

Later in the fifties, Dalí turned increasingly to the Abstract Expressionists for formal inspiration. *Velázquez Painting the Infanta Margarita with the Lights and Shadows of his Own Glory* (1958) is obviously influenced by gestural painting. As Dalí commented, 'I like de Kooning, the colossus straddling the Atlantic with one foot in New York and the other in Amsterdam, whose paintings suggest the geological dreams of the earliest ages and the cosmic happenings that record the adventures of the planet' – an opinion he repeats in the article 'The 300,000,000th anniversary of de Kooning', whose title refers to the geological happenings on the earth hundreds of millions of years ago, when Europe separated from America. The influence of the free and lyrical abstraction of Mathieu, 'ecstatic', as Dalí called it, is evident in the ink drawings of 1958, or such oil paintings as *The Servant of the Disciples of Emmaus* (1960). In 1956 he produced a series of lithographs to illustrate *Don Quixote*, using a variety of more or less improbable methods which produce a curiously abstract Mathieu-esque calligraphy: for one, he dropped an egg filled with ink on to the lithographic stone, for another he fired an arquebus given him by Mathieu on to the stone. At about the same period Dalí arranged for a work to be 'danced' rather than painted, when he brought the Spanish dancer La Chunga to Port Lligat, laid out a stretcher on the terrace with a couple of square metres of canvas on it, and, as she danced to the accompanying guitarist, squeezed paint from tubes round her feet which mixed it and spread it across the canvas.

It was more or less simultaneously with these experiments that Dalí was painting the gigantic epic compositions, *Santiago el Grande* and *The Dream of Christopher Columbus* (1958–9), 'history paintings' which are oblique, paradoxical and probably ironic affirmations of the continuity of tradition, culture and religion, and above all of mystical experience.

Even in Dalí's continuously productive life, the late fifties were years of exceptional activity and disconcertingly various ideas. He began to experiment with Pop and Op Art, culminating in the stereoscopic paintings and holographs of the seventies.

146 *Velázquez Painting the Infanta Margarita with the Lights and Shadows of his Own Glory*, 1958

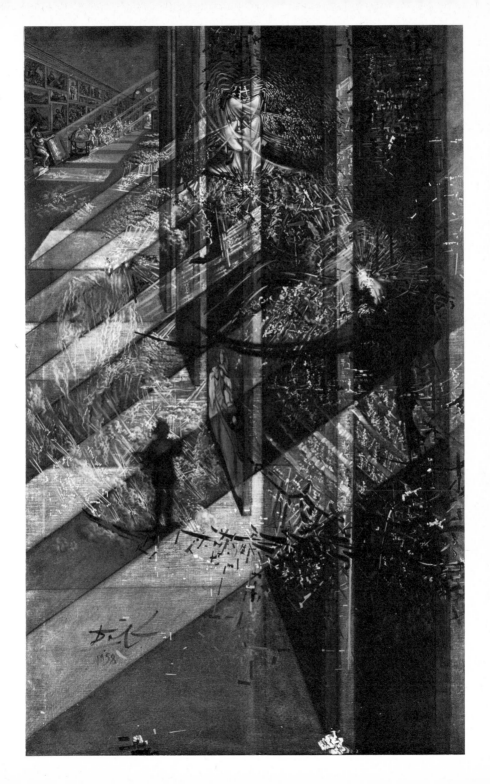

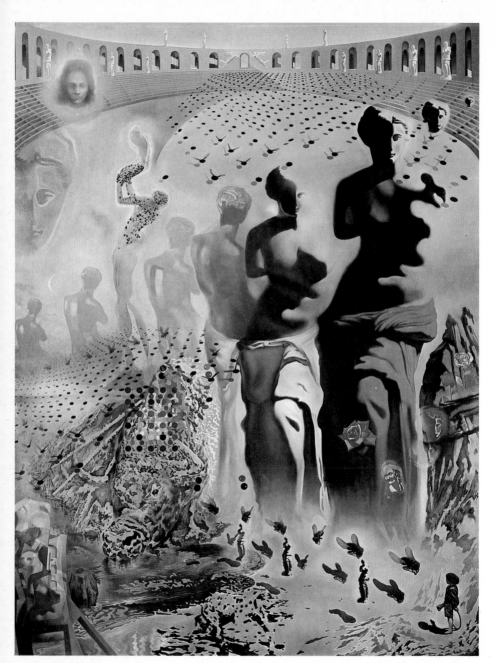

147 *Hallucinogenic Toreador*, 1969–70

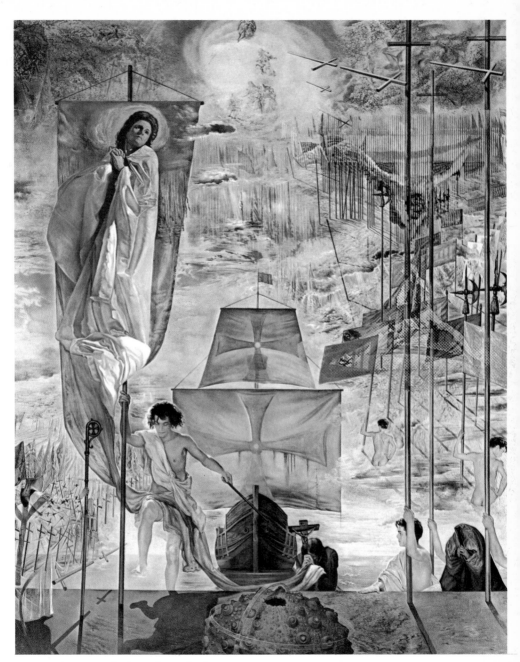

148 *The Dream of Christopher Columbus*, 1958–9

149 *The Sistine Madonna*, 1958

150 *Portrait of my Dead Brother*, 1963

Dalí first presented his *Sistine Madonna* at the Carstairs Gallery at the end of 1958, in the context of his exploration of anti-matter. However, it could be said that it is really doing the opposite of the *Exploding Raphaelesque Head*, because, rather than taking an object and shattering it into fragments, he is starting from a regular pattern of, in this case abstract, particles, and from them building up an image. It has obvious connections with the screened dot paintings of a Pop artist like Lichtenstein, but is in fact too early to be placed in

149

143

the context of Pop Art. He has obviously used a perforated screen. Raphael's Sistine Madonna takes shape out of the dots, and then a second image, of an ear, framing the Madonna and intended to offer a morphological resemblance of the kind Dalí suggested between the rhinoceros horn and *The Lacemaker*. Closer to Lichtenstein, in such works as his screen-print *Cathedral* of 1969, is Dalí's *Portrait of my Dead Brother* (1963), which similarly resembles the dotted image of a blown-up newspaper photograph.

150

Dalí had, of course, been using photography in various ways almost since the beginning of his career. Gala's face in *Gala with Two Lamb Chops Balanced on her Shoulder* (1933), for example, is copied from a photograph of Gala and Dalí taken at Port Lligat that year. In *The Conquest of the Irrational* Dalí had stated that painting was only 'hand-done colour photography', and, as he said in *Unspeakable Confessions*, he was convinced that Vermeer used an optical mirror to trace the subjects of his paintings. For *Santiago el Grande* (1957) Dalí used a photograph of the vault from a book on Santiago de Compostela that the Vicomtesse de Noailles had shown him: 'I was immediately struck by the shell-shaped architectural vault that is the palm tree of the famous shrine which I decided to reproduce.' He then searched for a photograph of a horse which he copied in the same way. Dalí had had, incidentally, a glass floor built into the studio of his house at Port Lligat, which he could use to get the dramatic foreshortening effects in paintings of this period, by placing the model above or below himself.

Dalí was also using the technique of projecting a photographic image on to the canvas and copying it: certain areas of *Tunny-Fishing* (1966–7), for example, are produced like this.

In holography and stereoscopy, Dalí delighted in finding an area where technology could help create a new means of expression. He is not, of course, the first artist to experiment with stereoscopy to reproduce the spatial dimension lacking from a single two-dimensional image. By using binocular vision, a sensation of three-dimensionality is created. Dalí's most important predecessor was probably Duchamp, always fascinated by optical ingenuities, who added to a 'readymade' stereopticon slide, in 1918–19, a geometrical figure, and who was still interested in binocular vision in his last work *Etant donnés* (1946–66), which has to be viewed through two holes pierced in a wooden door. Dalí, after some experiments in the early sixties with small post-cards, turned in about 1975 to full-sized oil paintings: two more or less identical images, some as in *The Chair* (1975) differing in light and tonality, are placed side by side and then viewed through a stereoscope. A special stereoscope using mirrors was adapted by Roger de Montebello to accommodate the monumental scale of *The Chair*.

152

Dalí's first holograms were shown at the Knoedler Gallery in New York in April 1972. Dr Denis Gabor, the inventor of the hologram, wrote the

151 First study for *The Madonna of Port Lligat*, 1949

catalogue, where he explains what it is and how an artist can use it:

> For the artist, the hologram represents the opening towards the third
> dimension. The first stage, now achieved, is the photography in three
> dimensions of objects and scenes, which, having been impressed onto a
> holographic film where they remain invisible, are reconstituted in three
> dimensions in their original aspect and can be seen from all sides but in only
> one colour.

The most ambitious of Dalí's holographs or holograms was *Holos! Holos!
Velázquez! Gabor!*, shown at the Teatro Museo Dalí in Figueras; it attempted
to realize a double image formed of the *Meninas* and a photograph of card
players. Dalí had, with the help of a holograph expert, Selwyn Lissack,
mounted the two images on sheets of glass disposed in different planes, thus

152 *The Chair*, 1975, stereoscopic painting in two sections

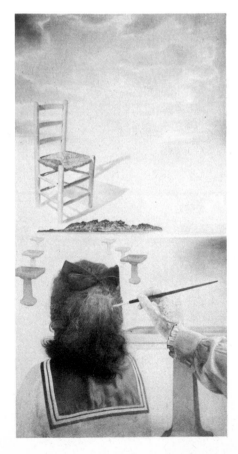

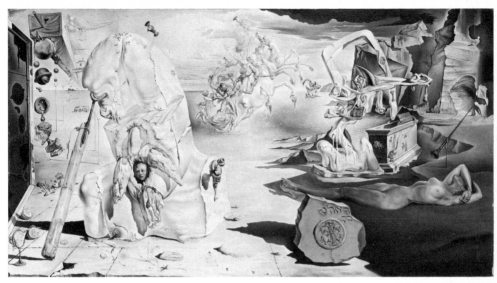

153 *The Apotheosis of Homer*, 1945

154 *The Disintegration of the Persistence of Memory*, 1952–4

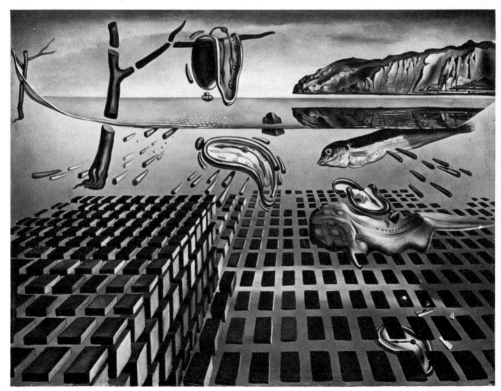

155 Drawing of Christ attributed to St John of the Cross

creating the first holographic photomontage. The second and third stages of the holograph foreseen by Dr Gabor were the use of natural colours and the combination of natural colours with 'an unlimited restitution of distance. The artist will be able to create in his studio landscapes which will spread to the horizon and need never have existed.' Holographic technology has not yet advanced as far and as fast as Dalí had hoped, and such landscapes so far remain unrealized. With the hologram, as so often with Dalí's work, it was the initial idea which passionately interested him, and it was not the first time the ambitious scale of Dalí's idea outstripped the capacity of the medium to contain it.

190

156 *Christ of St John of the Cross*, 1951

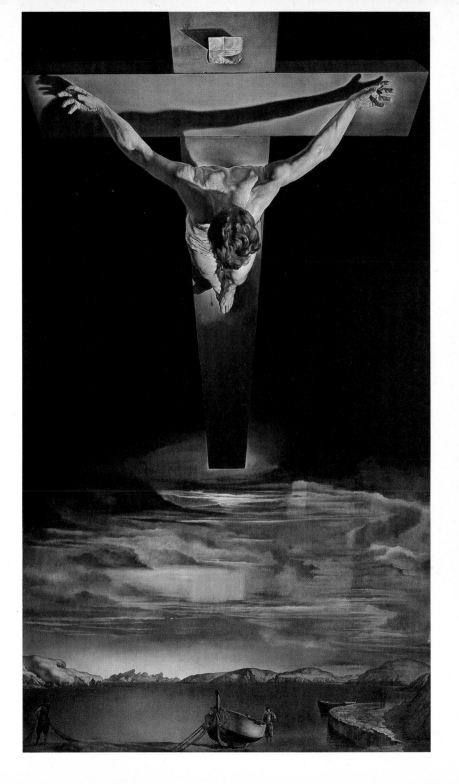

CHAPTER SEVEN

Dalí and the cinema

Dalí and L'Age d'or; Short Critical History of the Cinema; *unrealized scenarios; Hollywood collaborations and other film projects.*

It must have looked possible, in 1929, that Dalí would devote as much energy to film and photography as to painting. Not only had he published four articles on photography and the cinema between 1927 and 1929, but he had created with Buñuel one of the most extraordinary films ever made, *Un Chien Andalou*. Both from his writings and from the film itself it was clear that in many ways this medium was better suited to the expression of his visual ideas of the period than painting. Other critics have agreed about its peculiar appropriateness for Dalí: Pierre Naville, former Surrealist and first editor of *La Revolution Surréaliste*, wrote in his memoirs, *Le Temps du Surréel*, 'His obsessions create myths of the modern world because they not only spring from his subjectivity but derive in the end from everything revealed by the sciences to be unlikely or incongruous in the very matter of the universe. The violence of the emotions which impregnate the myths are even better expressed in cinematographic movement than in the calm and crystallization of painting. *Un Chien Andalou* and *L'Age d'or*, where the collaboration of Buñuel allowed Dalí's genius to spread itself in full freedom, remain among the most inspiring, irreplaceable, supremely Surrealist works, forever intact from cowards, fools and the vain, ranking among the definitively nourishing inventions of Jarry and Roussel. . .'.

Although *Un Chien Andalou* remained Dalí's supreme intervention in the cinema, it has been discussed in Chapter Two in some detail rather than here because of its intimate relationship with his other pictorial ideas at the time and its crucial role in the most formative period of his life. After *Un Chien Andalou*, Dalí collaborated again with Buñuel, on *L'Age d'or*, which was as powerful a film, in a different way, and provoked an even greater scandal. *L'Age d'or* is about passion, desire frustrated by convention and social repression, and revolt. Narrative is transposed into a sequence of events governed by emotional truth, interspersed with symbolism. In the ball scene, for example, the Marquis stands in polite conversation with a guest, his face covered with flies, while the decadent aristocracy, the old order, takes no notice as a horse and farm cart with drunken labourers forces its way through the ballroom.

157–164

192

157, 158, 159 Stills from
the film *L'Age d'or*, 1930

The Surrealists wrote a manifesto for inclusion in the programme of *L'Age d'or*, which Dalí signed, emphasizing the importance of love: 'But it is *Love* which brings about the transition from pessimism to action; Love, denounced in the bourgeois demonology as the root of all evil. For Love demands the sacrifice of every other value: status, family and honour. And the failure of Love within the social framework leads to Revolt. This process can be seen in the life and works of the Marquis de Sade, who lived in the *golden age* of absolute monarchy . . . so that it is no coincidence if Buñuel's sacrilegious film contains echoes of the blasphemies which the Divine Marquis hurled through the bars of his gaol.' The final scenes of the film are an adaptation of Sade's *120 Days of Sodom*; as the four survivors of the orgy at the Château de Selliny slowly emerge, the figure of the leader is unmistakably that of Jesus Christ. It was the film's blasphemy more than its erotic or obscene elements which upset the French audience, though it tended to be the other way round with the English. When Orwell attacks the film in 'Benefit of Clergy', on the evidence of hearsay, he quotes Henry Miller's account which claimed the film showed 'detailed shots of a woman defecating'. This scene in the script is in fact described as follows: 'Insert of the young woman sitting on an immaculately white lavatory. (This location is only suggested and not made explicit, so that we have an uneasy suspicion that this is where she is, rather than a certainty. The young woman is dressed immaculately and everything about her conveys an impression of great purity.)'

L'Age d'or was first shown privately at the house of the Vicomte de Noailles, who had financed it, and then once or twice publicly. Having been passed by the Paris Film Censor, it was then put on at Studio 28 from 28 November 1930. On 3 December, however, representatives of the right-wing League of Patriots and Anti-Semitic League rioted, throwing ink at the screen at the moment when a reliquary is taken out of a car in which guests have arrived for the ball, hurling smoke bombs into the audience, tearing up the books and magazines on view in the foyer, slashing the paintings hanging there on exhibition (including Dalí's *Invisible Sleeper, Horse, Lion*), cutting the telephone wires, and causing 80,000 francs worth of damage. A campaign against the film in the right-wing press followed, *Le Figaro* calling for the suppression of Surrealism. On 10 December, the Censor's sanction was revoked and the film banned. It was subsequently shown in England by Nancy Cunard.

It is difficult to know how much in the end Dalí contributed to *L'Age d'or*. Aldo Kyrou claims that his intervention was limited to one gag, the man walking down the street with a stone on his head. Having collaborated on the script, Dalí was, it seems, present at only one working session on the film. Dalí and Buñuel had grown apart largely because of Dalí's infatuation with Gala, whose influence Buñuel felt to be malign and destructive. Buñuel seems to have decided to go ahead on his own to make the film. When Dalí saw the final

160, 161, 162 Stills from *L'Age d'or*. The cross with women's scalps nailed to it is the final scene of the film

version he was, he claimed in *The Secret Life*, enormously disappointed. 'It was but a caricature of my ideas', he wrote. 'The "Catholic" side of it had become crudely anti-clerical, and without the biological poetry that I had desired. . .'. How far, once again, this is a reaction coloured by hindsight, is unclear. Perhaps with Dalí's active intervention the 'Catholic' scenes would have been more ironic, but there is not a great difference of approach to the anti-clerical scenes in *L'Age d'or* and in *Un Chien Andalou*, in which he was closely involved. Dalí's suggestion in *The Secret Life* that he would have preferred the film to be 'subversive rather through excess of Catholic fanaticism than through naive anti-clericalism' sounds as if even his new adherence to the Catholic faith announced in *The Secret Life* in 1942 is ironic. Apart, though, from individual scenes and motifs which spring from Dalí's iconographical repertoire – the skeletal archbishops propped on the jagged rocks at Cadaqués, for example, the flies, the girl sucking ecstatically at the big toe of the marble

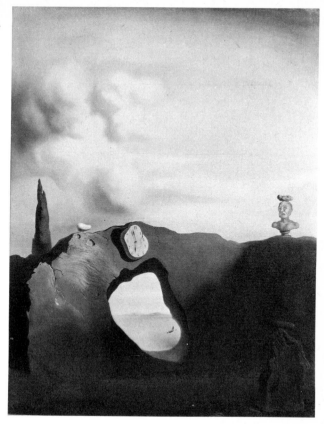

statue, the flaming giraffe being thrown from the window – there are also hints of Dalí's obsessive themes of the period. When the gamekeeper reacts so savagely to his son's innocent attempts to tease him into playing a game that he shoots him, there is an echo of Dalí's sadistic and repressive William Tell/ father. But Buñuel's role in the film is clearly preponderant. The control of cinematic narrative is very different from *Un Chien Andalou* with its individually poetic images, and the film as a whole lies closer in spirit to that serious Surrealist engagement in the undermining of the institutions of Family, State and Religion (it was regularly called 'a Bolshevist film' in the press) from which by the time he came to write *The Secret Life* Dalí had dissociated himself. Yet, it should be remembered, in 1930, when *L'Age d'or* was made, Dalí had given a lecture at the Ateneo in Barcelona which he announced as a contribution to the definitive demolition of 'ideas like family, religion and fatherland'. Buñuel has subsequently paid homage to Surrealism

197

for revealing to him the discipline of a commitment which was what during the thirties helped drive Dalí away from the movement. He said in 1954: 'It is Surrealism which has revealed to me that in life there is a moral code from which man cannot extricate himself. It has enabled me to learn for the first time that man is not free, I believed in the absolute liberty of man, but I have seen in Surrealism a discipline to be exercised.'

Dalí has been involved sporadically throughout his career with the cinema, though never to the extent that might have been predicted in 1929. He has collaborated with other directors, or produced scenarios or ideas for films of his own, most of which were never made.

166 A hitherto unpublished scenario is of particular interest, and must date from the first years of his contact with the Surrealists. It was intended to be a documentary introduction to Surrealism, in an expository form unusual for Dalí, and was to have been made with the effective collaboration of the Surrealist group. Although undated, it can probably be placed, for various reasons, between 1930 and 1932. He discusses, for example, the double image in the scenario, and gives as example a series of schematic drawings based on his first finished painting using this technique, *Invisible Sleeper, Horse, Lion* of 1930, and he uses the term 'paranoiac' to describe this procedure rather than the 'paranoiac–critical' which he invariably used after 1933.

The scenario takes, on the whole, an orthodox view of Surrealism, explaining its theories about automatism and the dream in relation to the subconscious, examining Surrealist techniques like collage and the *cadavre exquis*, and proposing the paranoiac method as an additional rather than alternative Surrealist technique. Certain animation 'gags' would have been added had the film been made, but what does seem especially characteristic of Dalí was the sound-track he planned to accompany the spoken commentary and the images. As the film opens, 'very faint music of havana rumbas, blues, etc is audible. . . . This lazy, drawling and excessively softening music will be a background, contrasting with this a certain number of noises which will follow one another as the film progresses and will be destined to create an ambiance of "surrealist disorientation".' Among these additional sounds was a steadily increasing wind, the whistle and roar of the Metro, an alarm clock, and 'simultaneous and very violent sounds of laughter, and the cry of a chicken whose throat is being cut, at which the laughter redoubles'. The use of a sound-track to intensify and dramatize emotion recalls the use of Wagner's *Tristan und Isolde* intercut with tango music to accompany *Un Chien Andalou*; in *L'Age d'or* (a talking film) the orchestra plays the 'surging music' of the Liebestod of *Tristan und Isolde* to an impassive and unmoved audience, while in the background the girl passionately sucks the marble toe. Dalí's interest in jazz, of course, goes back to his adolescent days in Madrid, and it is most likely that he and Buñuel were in agreement about the use of music; this, in fact, runs

166 Page from an unpublished film scenario, early 1930s

directly counter to the Surrealists' general indifference or active hostility to music, which Breton described as the most deeply confusing of all art forms.

Dalí was, incidentally, also responsible for the unusual introduction of a dancer at the opening of the 1938 International Exhibition of Surrealism: 'The big event of the evening was Hélène Vanel's spectral appearance dancing dressed as a doll or a witch out of *Macbeth*. I had personally arranged her entrance and the Surrealist choreography. As Breton understood nothing about music or the dance it had taken some doing to get him to agree to the scene that the ballerina . . . was so masterfully to bring to life with her Dionysiac fervor.'

In 1932 Dalí published a 'Short Critical History of the Cinema', preceding the scenario of *Babaouo*, 'a Surrealist film'. This critical text opens with a refutation of the ideas he had expressed in several of the Catalan texts of 1927–9 on the innate power of film and photography, exceeding that of painting. 'Contrary to current opinion,' Dalí wrote in 1932, 'the cinema is

infinitely poorer and more limited for the expression of the true functioning of thought than writing, painting, sculpture and architecture.' And he went on, 'The rapid and continuous succession of images in the cinema, whose implicit neologism is in direct proportion to a particularly generalizing visual culture, prevents any attempt to reduce to the concrete and most often annuls its intentional, affective and lyrical character. . .'. Five years earlier, in 'Film-art, fil antiartistique', Dalí had argued that the unique possibilities of the film lay in its power to reveal the marvellous in banal factuality, and compares the kind of film he has in mind with the 'art films' which rely on the grandiose and the subjective emotion of the artist–director. The anti-artistic film, by contrast, 'far from any concept of grandiose sublimity, shows us, not the illustrative emotion of artistic deliria, but the quite new poetic emotion of all the humblest and instantaneous facts, impossible to imagine or to foresee before the cinema, born from the miraculous spirit of the capture of the bird–film.' The idea that the camera had opened up a whole new world of unexpected or poetic fact invisible to the naked eye was one of the most exciting visual discoveries for artists in the early years of the twentieth century and one that was shared by the late twenties not only by the Surrealists but by the Constructivist photographers like Moholy-Nagy and Rodchenko, and the *Neue Sachlichkeit* photographers in Germany – Blossfeldt's magnified close-ups of natural forms, for example, fascinated Dalí. In 'Film-art, fil antiartistique' Dalí had argued that film directors on the whole had failed to take advantage of the camera's capacity to open up a different nature from that available to the naked eye. As Walter Benjamin put it in 'The Work of Art in the Age of Mechanical Reproduction' (1936): 'Our taverns and our metropolitan streets, our offices and furnished rooms, our railroad stations and our factories appeared to have us locked up hopelessly. Then came the film and burst this prison-world asunder by the dynamite of the tenth of a second, so that now, in the midst of its far-flung ruins and debris, we calmly and adventurously go travelling.' This is not the place to speculate in more detail on the differences between Benjamin's 'freed reality' and Dalí's 'fantasy born of things themselves'; it is interesting, though, that it was Benjamin who wrote: 'The camera introduces us to unconscious optics as does psycho-analysis to unconscious impulses.'

Dalí does still hold the opinion, in 1932, that art films, in starting from abstract or invented forms, like those of Léger or Man Ray, are fundamentally in error, although he expresses it more murkily. Poetry in the cinema, he now argues, resides only in its capacity for the 'concrete irrational', which alone will lead to genuine 'lyrical fact'. It is only, in his view, in comic films that this is achieved within the production of the contemporary cinema. Only 'comic films with an irrational tendency mark the road of poetry' – like those of Mack Sennett, Harry Langdon or the Marx Brothers (whose *Animal Crackers* aroused for Dalí the same kind of 'lyrical consternation as certain passages of

Raymond Roussel'). Dalí's love of American comic films goes back to his pre-Surrealist days, and was shared by Buñuel, who said in his interview with Dalí in 1929 that Pollard, Adolphe Menjou and Ben Turpin were much closer to themselves and to Surrealism than Man Ray was. The unexpected element of farce that enters the passionate atmosphere of *L'Age d'or* – as when the jealous lover springs to his feet to avenge himself on the old conductor and hits his head hard against a hanging flower basket – has a source here. As far as the commercial cinema is concerned, Dalí went on, 'B' adventure films could sometimes have an unintentionally comic and irrational effect.

The scenario *Babaouo*, which was never realized, lacks the graphic horror and desire of *Un Chien Andalou*, resorting instead to a more gothic poetry, its horrors hidden or enacted off-screen. In the opening sequence a page boy hurries with a message to a hotel room, from behind the locked door of which is heard 'a veritable concert of strident hysterical laughter, mixed with violent bangs, which seem caused by the projection of very heavy objects against the walls and furniture'. All we see of what might have been going on is the body of a headless chicken flung into the corridor. Later, at the Chateau of Portugal, Babaouo sees on the bed in Matilda's room 'something infinitely larger than a corpse covered by a white sheet'. What exactly this is is never revealed, though it is obscurely hinted that it is Matilda's father, and at one point the wrapped object is thrown at her mother. This image relates to a number of paintings of the period: *Le Cœur volé* (1932), for example, where a huge form is draped in a cloth, or the *Old Age of William Tell* (1931). These veiled scenes or figures are closely related to the William Tell/father theme; *Babaouo* ends with a 'Portuguese Ballet', William Tell. This contained the scene with numerous cyclists slowly inter-crossing, eyes bandaged and with a loaf balanced on their heads, which Dalí reproduced painted on glass panels set in a wooden lighted box in the work also called *Babaouo*, 1932.

167

167 *Babaouo*, 1932. Lit box with glass panels

Dalí does make a dramatic use of sound in *Babaouo*, and in one sequence creates what amounts to an auditive paranoiac–critical image. Babaouo is approaching the Chateau of Portugal where his mistress Matilda is awaiting him, and he hears a rhythmical noise which grows stronger and stronger, and sounds like monstrous and weary breathing. It gets nearer and becomes deafening and threatening as Babaouo, terrified, passes behind a long wall in semi-darkness. The scene then cuts to reveal the source of the noise, huge waves breaking on the beach whose sound resembles the hissing of breath.

Dalí sent Raymond Roussel a copy of *Babaouo*, who replied: 'A thousand thanks, my dear colleague, for your kind gift and dedication which seem to me to prove that you already know my *New Impressions of Africa*, which makes me very proud. . .'. Dalí certainly did know Roussel's book: one might say that *Babaouo* is born of a curious marriage of Roussel and the Marx Brothers.

Exactly what kind of film or spectacle Dalí intended *Babaouo* to be is not entirely clear. He wrote to the Vicomte de Noailles in 1932: 'There has been a little adventure with Leonide Massine, who wanted me to do a ballet for him, I told him naturally that nothing was further from my mind than that kind of spectacle and that I conceived only theatrical representations that were beyond the limits of ballet . . . whose irrational tendency would be closer to things by the Marx Brothers. I read him *Babaouo* (the Portuguese Ballet) and against my belief that this would thoroughly discourage him he was *thrilled* and in principle wants to concoct the said spectacle(!) . . .'

Dalí was here echoing the Surrealists' dislike of the ballet, and at that time avoided any entanglement with Massine. It does suggest, though, that Dalí had ambitious plans for a 'film-spectacle' for *Babaouo*. He was, moreover, while in the USA just before and during the war, to plan and/or design several ballets. *Bacchanale* (1939), *Labyrinth* (1941) and *Mad Tristan*, 'The first paranoiac ballet based on the eternal myth of love in death' (1944), were all scripted by Dalí, who also designed the sets and costumes, and choreographed by Massine. He also did the sets and costumes for *El Cafe de Chinitas* (1944), *Sentimental Colloquy* (1944), based on a poem by Verlaine and with music by Paul Bowles, and, in 1949, for Strauss' *Salome* in Peter Brook's Covent Garden production.

Of the Marx Brothers, Dalí most admired the 'curly-haired one, whose face is that of triumphant and persuasive madness, as much at the end of the film as during the too short moment when he interminably plays the harp. . .'. In 1937 Dalí went to Hollywood to draw Harpo's portrait, and while there, in the intervals of the making of *A Day at the Races*, Dalí and Harpo worked together on a scenario for a film to be called *Giraffes on Horseback Salad*. Only a few drawings and notes survive, unfortunately, of this unique project of collaboration between a Surrealist and a screen comedian.

Dalí immediately recognized the 'Surrealist' potential of Hollywood's unconsciously 'hallucinatory' celluloid, but no new cinema project of Dalí's

168

168 *Portrait of Harpo Marx*, 1937

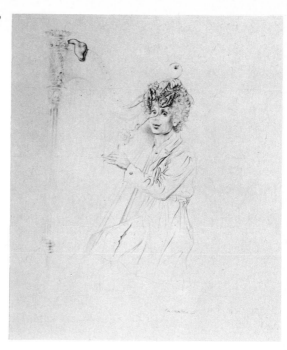

came to fruition until he was invited to collaborate with Alfred Hitchcock on the dream sequence in *Spellbound*. This was the first Hollywood film to take psycho-analysis seriously as its subject, and great emphasis is laid on the interpretive value of dreams. For this reason Hitchcock wanted to present them in the film with the maximum realism and immediacy: 'When we arrived at the dream sequences, I wanted absolutely to break with the tradition of cinema dreams which are usually misty and confused, with a shaking screen, etc. I asked Selznick to make sure of the collaboration of Salvador Dalí because of the publicity that would give us. The only reason was my desire to obtain very visual dreams with sharp, clear features. . . . I wanted Dalí because of the sharpness of his architecture – Chirico is very similar – the long shadows, the infinite distances, the lines that converge in perspective . . . the formless faces. . .'. In fact, the film, with screenplay by Ben Hecht suggested by Francis Beeding's novel *The House of Dr Edwards*, had a classic view of the healing property of psycho-analysis, and had a text preface: 'once the complexes that have been disturbing the patient are uncovered and interpreted, the illness and confusion disappear . . . and the devils of unreason are driven from the live soul . . .' with which Dalí can have had little sympathy, though he collaborated with Hitchcock enthusiastically.

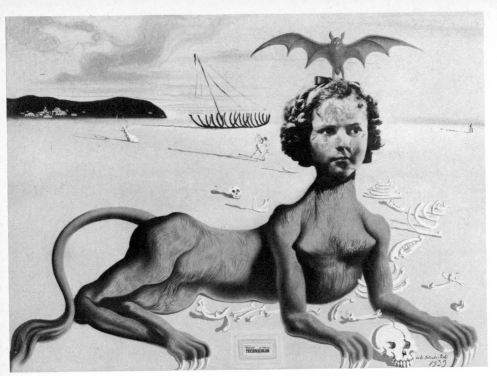

169 *Shirley Temple, the Youngest Sacred Monster of the Cinema,* 1939

He made one hundred drawings and five paintings in black and white for the dream sequence, but also planned other extravagant sequences not used in the final version. For part of the nightmare, for example, Dalí wanted fifteen heavy grand pianos weighted down with sculpture suspended over the heads of dancing couples, who, 'immobilized in exalted poses, will be only silhouettes narrowing according to a speeded up perspective, disappearing into an infinite darkness.' When he arrived at the studio for filming he found prepared for him by the Hollywood specialists precisely the reverse effect of what he had conceived: several reduced models of pianos rather than real ones, and forty or so real dwarfs instead of cut-out silhouettes, which would, claimed the experts, give exactly the perspective effect Dalí wanted. Although Dalí appreciated the bizarre interpretations of the props experts, the scene was scrapped. Dalí's contribution in the end seems to have been limited to the actual painted sequence, the transition within the dream taking place as a real eye turns into a painted eye on a curtain; each image, with a few exceptions like the giant pincers, is finally given a detailed interpretation by the psychoanalyst, and therefore was determined largely by the scenario, not Dalí.

170

170 Dalí standing before his set of painted eyes for the dream sequence in Hitchcock's *Spellbound*, 1945

In 1946 Dalí worked with Walt Disney on an animated sequence lasting about six minutes, which was to have been part of a full-length cartoon of the *Fantasia* genre, called *Destino*. This project reached a fairly advanced state, and contained some very exactly realized cinematic examples of the paranoiac double image. One has been described by one of the artists working with Dalí, which involved an image similar to one Dalí had used in 1932, when he altered a post-card of skiers by the addition of drawing and collage so that the figures turn into the eyes of a boxful of puppies. In *Destino* a scene of skiers shifts to a snowy hillock, on which the camera rests then tracks back to reveal that the image on the screen was a detail of a nude. An earlier substitution of nude flesh for snow passes unnoticed.

Ten years later he planned another film with Disney, *Don Quixote*, which was never realized. In 1949 he prepared the scenario for a film to be called *History of a Wheelbarrow*, later renamed *The Flesh Wheelbarrow*, which was to recount the fetishistic love of a woman for her wheelbarrow, and is obviously related to the wheelbarrow imagery discussed in *The Tragic Myth of Millet's Angelus*.

From 1954 Dalí has been working with Robert Descharnes and the cameraman Gérard Thomas D'Hoste on *The Prodigious Adventure of the Lacemaker and the Rhinoceros*, which has been shot and is in the process of being cut. It turns, apparently, on a remarkable morphological link between Vermeer's *Lacemaker* and a rhinoceros (discussed above), and the shooting of some of the sequences involved the kind of bizarre scenes which for Dalí are a natural sequel to his first idea but which so often seem like a publicity stunt: Dalí was filmed seated on a wheelbarrow facing his easel, protected by a barrier of granite boulders from the rhinoceros, which is charging a large reproduction of *The Lacemaker* lowered into the enclosure by the keepers, on ropes.

A rare completely realized film was Dalí's *Voyage in Upper Mongolia*, made in 1974 for West German television. In this film the camera, starting from the tip of a pen, explores whole landscapes evolving from it, thus returning in some ways to Dalí's original ideas concerning the mystery and magic of ordinary objects, and the way a camera can reveal, distort and metamorphose these objects.

Dalí has consistently denied that his films belong in any sense to the avant-garde. 'My next film', he commented of the proposed *Flesh Wheelbarrow*, 'will be exactly the opposite of an experimental *avante-garde* film, and especially of what is nowadays called "creative", which means nothing but a servile subordination to all the commonplaces of our wretched modern art.' Dalí's reaction against the post-war art cinema led him to propose a film-making method not so distant, ironically, from more recent experimental cinema. In 'Mes Secrets cinématographiques' (My Cinematographic Secrets), published in 1954 and based on his diary for 1953, Dalí describes how he would set about making a film that would be marvellous to its audience. To be marvellous, the marvels that happen in a film must be believable. 'One must therefore abandon, first of all, today's repulsive cinematographic rhythm, that conventional and boring rhetoric of camera movements. How can one believe for a second in even the most banal melodrama when the camera follows the murderer everywhere, travelling even into the washroom where he goes to wash the blood off his hands? That is why Salvador Dalí, before he so much as begins his film, will take care to immobilize his camera, to nail it to the floor like Christ to the cross. Too bad if the action moves out of the visual field! The public will wait – distressed, exasperated, breathing heavily, stamping their feet, in ecstasy, or better still, bored to death – for the action to come back into the visual field. . .'. If Dalí's cinematic projects remained so often unrealized it was perhaps because he came to see film as a 'secondary' form, involving the intervention of too many people in its creation. The best belong to his period of collaboration with Buñuel and the Surrealists when his faith in the medium was still strong.

Select Bibliography

Many of Dalí's original Catalan texts are available in Ilie, *Documents of the Spanish Vanguard* (see below).

An asterisk denotes that all or part of the text can be found in French translation in *Salvador Dalí: Retrospective 1920–1980*, Paris 1979–80.

1. A SELECTIVE LIST OF EXHIBITION CATALOGUES, CRITICAL BOOKS ON DALÍ AND OTHER SOURCES CONSULTED AND QUOTED FROM.

See *Salvador Dalí: Retrospective 1920–1980*, Paris 1979–80 for the most comprehensive bibliography to date of writings by and about Dalí, listings of one-man and group exhibitions, book illustrations, collaborations on films, ballets, operas and other spectacles, radio and television programmes, and a full chronology.

Œuvres anciennes de Salvador Dalí, Galerie A.-F. Petit, Paris 1970
Dalí, Museum Boymans–van Beuningen, Rotterdam 1970–71
Dada and Surrealism Reviewed, Arts Council, Hayward Gallery, London 1978
Salvador Dalí: Retrospective 1920–1980, Centre Georges Pompidou, Musée Nationale d'Art Moderne, Paris 1979–80

Bataille, Georges 'Dictionnaire critique: œil', *Documents* (Paris), 1929, no. 4
—— 'Le Jeu lugubre', *Documents*, 1929, no. 7
Bosquet, Alain *Conversations with Dalí*, New York 1969 (Fr. edn Paris 1966)
Breton, André *Clair de terre*, Paris 1923
—— *Manifeste du surréalisme*, Paris 1924
—— 'Introduction au discours sur le peu de réalité', *Commerce* (Paris), 1924 (Eng. trans. in *What is Surrealism?* ed. Franklin Rosemont, London 1978)
—— *Le Surréalisme et la peinture* (Paris), 1928 (Eng. trans. by Simon Watson Taylor, London and New York 1972, also contains *Artistic Genesis and Perspective of Surrealism*, 1941, and 'The Dalí Case', 1936)
—— *Nadja*, 1928
—— *Second manifeste du surréalisme*, *La Révolution Surréaliste* (Paris), 1929, no. 12
—— Catalogue preface to Dalí Exhibition, Goemans Gallery, Paris 1929
—— *Entretiens 1913–1952*, 1952
—— with Paul Eluard *L'Immaculée Conception*, Paris 1930
Buñuel, Luis *L'Age d'or and Un Chien Andalou* (film scripts), London 1968
Chadwick, Whitney *Myth in Surrealist Painting 1929–1939*, UMI Research Press 1980
Crevel, René *Dalí, ou, L'anti-obscurantisme*, Paris 1931
Dalí, Ana María *Salvador Dalí visto por su hermana*, Barcelona 1949 (Fr. trans. *Salvador Dalí vu par sa soeur*, Paris 1960)
Descharnes, Robert *Salvador Dali*, New York 1976
Freud, Sigmund *The Interpretation of Dreams*, London 1953 (1st Ger. edn 1900)
—— *Introductory Lectures on Psycho-analysis*, London 1963 (1st Ger. edn 1916–17)
Gómez de la Serna, Ramón *Dalí*, New York 1979
Hammond, Paul (ed.) *The Shadow and its Shadow: Surrealist Writings on the Cinema*, London 1978
Ilie, Paul (ed.) *Documents of the Spanish Vanguard*, University of North Carolina 1969
Kraepelin, Emil *Lectures on Clinical Psychiatry*, London and New York 1906
Krafft-Ebing, Richard von *Psychopathia Sexualis, With Special Reference to Antipathic Sexual Instinct: a Medico-forensic Study*, London 1899, Chicago 1901
Lacan, Jacques *De la psychose paranoïaque dans ses rapports avec la personnalité (1932) suivi de Premiers écrits sur la paranoïa*, Paris 1975
Levy, Julien *Surrealism*, New York 1936
—— *Memoirs of an Art Gallery*, New York 1977
★Lorca, Federico García 'Oda a Salvador Dalí', *Revista de Occidente*, April 1926
Mellen, Joan (ed.) *The World of Luis Buñuel* (includes Buñuel's 'Notes on the making of *Un Chien Andalou*'), New York 1978
Morris, C.B. *Surrealism and Spain 1920–1936*, Cambridge University Press 1972
Morse, A. Reynolds *Salvador Dalí: a Panorama of his Art*, Cleveland, Ohio 1974
Naville, Pierre *Le Temps du*

surréel, vol. 1, Paris 1977
Orwell, George 'Benefit of
Clergy; Some Notes on
Salvador Dalí' (1944) in
Dickens, Dalí and Others, New
York 1963
Romero, Luis *Salvador Dalí*,
Secaucus, New Jersey 1975
Rubin, William *Dada and
Surrealist Art*, London 1969
Soby, James Thrall *Salvador Dalí*,
New York 1946

2. WRITINGS BY DALI (only those
referred to directly or indirectly
in the text are listed).

Articles on Velázquez, Goya, El
Greco, Michelangelo, Dürer,
Leonardo, in *Studium*
(Figueras), 1919
'Sant Sebastià', *L'Amic de les Arts*
(Sitges), ii (1927), no. 16
★'Reflexions', *L'Amic de les Arts*,
ii (1927), no. 17
'La fotografia, pura creació de
l'esperit', *L'Amic de les Arts*, ii
(1927), no. 18
★'Els meus quadros del Saló de
Tardor', *L'Amic de les Arts*, ii
(1927), no. 19
★'Dues proses' (★'La meva amiga
i la platja' and 'Nadal a
Bruselles'), *L'Amic de les Arts*, ii
(1927), no. 20
★'Film-art, fil antiartistico',
Gaceta Literaria (Madrid), 15
December 1927, no. 24
★'Nous limits de la pintura',
L'Amic de les Arts,
February–May 1928
'Poesia de l'útil standarditzat',
L'Amic de les Arts, iii (1928),
no. 23
(with L. Montanyà and S. Gasch)
'El manifiesto antiartistico
Catalán', *Gallo* (Granada),
1928, no. 2
'Joan Miró', *L'Amic de les Arts*, iii
(1928), no. 26
'Realidad y sobrerrealidad',
Gaceta Literaria, 15 October
1928
'La Dada fotogràfica', *Gaseta de
les Arts* (Barcelona), ii (1929),
no. 6

★'. . . L'alliberament dels dits
. . .', *L'Amic de les Arts*, iv
(1929), no. 31
★'Luis Buñuel', *L'Amic de les
Arts*, iv (1929), no. 31
'. . . Sempre, per damunt de la
música, Harry Langdon',
L'Amic de les Arts, iv (1929),
no. 31
'Documentaire – Paris – 1929',
La Publicitat (Barcelona),
April–June 1929
(with Luis Buñuel) 'Un Chien
Andalou', *La Révolution
Surréaliste* (Paris), 1929, no. 12
'Posició moral del surrealisme',
Hélix (Vilafranca del Penedes),
1930, no. 10
'L'Ane pourri', *Le Surréalisme au
Service de la Révolution* (Paris),
1930, no. 1
La Femme visible, Paris 1930
'. . . Surtout, l'art ornemental
. . .', catalogue to Dalí
exhibition, Pierre Colle
Gallery, Paris, 1931
(with Aragon, Breton, Eluard,
Péret and others) *Manifesto* in
programme of *L'Age d'or* 1930
(with Luis Buñuel) *L'Age d'or*,
scenario, see bibliography
entry under Buñuel
L'Amour et la mémoire, Paris 1931
'Objets surréalistes, *SASDLR*,
1931, no. 3
'Communication, visage
paranoïaque', *SASDLR*, 1931,
no. 3
Unpublished notes for the
interpretation of the painting
The Persistence of Memory,
Museum of Modern Art, New
York, 1931
'Rêverie', *SASDLR*, 1931, no. 4
'The Object as Revealed in
Surrealist Experiment', *This
Quarter* (Paris), v (1932), no. 1
*Babaouo: scénario inédit précédé
d'un abrégé d'une histoire critique
du cinéma et suivi de Guillaume
Tell, ballet portugais*, Paris 1932
'Objets psycho-atmosphériques-
anamorphiques', *SASDLR*,
1933, no. 5
'Réponse à l'enquête "Recherches
expérimentales, sur la
connaissance irrationelle de

l'objet", *Boule de cristal des
voyantes*', *SASDLR*, 1933,
no. 6
'Interprétation
paranoïaque–critique de
l'image obsédante *L'Angélus* de
Millet', *Minotaure* (Paris), 1933,
no. 1
'De la beauté terrifiante et
comestible de l'architecture
Modern'style', *Minotaure*,
1933, nos. 3–4
'Le Phénomène de l'extase',
Minotaure, 1933, nos. 3–4
'Derniers modes d'excitation
intellectuelle pour l'été 1934',
Documents 34, special number
'Intervention Surréaliste'
(Paris), 1934, new ser. no. 1
'Les Nouvelles Couleurs du sex
appeal spectral', *Minotaure*,
1934, no. 5
La Conquête de l'irrationel, Paris
1935 (Eng. trans. New York
1935)
'Apparitions aérodynamiques des
"Êtres-Objets"', *Minotaure*,
1934–5, no. 6
'Honneur à l'objet', *Cahiers
d'Art*, Paris 1936
'Le Surréalisme spectral de
l'eternel féminin préraphaélite',
Minotaure, 1936, no. 8
'I Defy Aragon', *Art Front*, iii
(1937), no. 2
Métamorphose de Narcisse, Paris
1937 (Eng. trans. New York
1937)
*Declaration of the Independence of
the Imagination and the Rights of
Man to His Own Madness*,
pamphlet, New York 1939
'Les Idées lumineuses "Nous ne
mangeons pas de cette lumière-
là"', *L'Usage de la Parole*
(Paris), i (1940), no. 2
The Secret Life of Salvador Dalí,
New York 1942
Hidden Faces, New York 1944
*Dalí News, Monarch of the
Dailies*, New York, no. 1
(1945), no. 2 (1947)
*Fifty Secrets of Magic
Craftsmanship*, New York 1948
Manifeste mystique, Paris 1951
'Mes Secrets
cinématographiques', *La*

Parisienne (Paris), February 1954
Les Cocus du vieil art moderne, Paris 1956 (Eng. trans. Dalí on Modern Art: the Cuckolds of Antiquated Modern Art, New York 1957)
'Anti-matter Manifesto', catalogue of Dalí exhibition, Carstairs Gallery, New York 1958–9
Le Mythe tragique de l'Angélus de Millet, Interprétation

'paranoïaque–critique', Paris 1963
Journal d'un génie, Paris 1964 (Eng. trans. New York 1965)
Lettre ouverte à Salvador Dalí, Paris 1966 (Eng. trans. New York 1967)
'Manifeste en hommage à Meissonier', catalogue of exhibition, Hotel Meurice, Paris 1967
Ma Révolution culturelle, pamphlet, Paris 1968
'De Kooning's 300,000,000th

Birthday', Art News (New York), April 1969
Oui: méthode paranoïaque–critique et autres textes, Paris 1971
'Holos! Holos! Velasquez! Gabor!', Art News, April 1972
Comment on devient Dalí, as told to André Parinaud, Paris 1973 (Eng. trans. The Unspeakable Confessions of Salvador Dalí, London 1976)

List of Illustrations

Oil on canvas, $38\frac{5}{8} \times 51\frac{5}{8}$ (98 × 131). Collection The Museum of Modern Art, New York

27 *Fish and Balcony, Still Life by Moonlight*, 1927. Oil on canvas, $78\frac{1}{4} \times 59$ (199 × 150). Private collection

28 *Self-portrait dedicated to Federico García Lorca*, undated. Ink on paper, $8\frac{5}{8} \times 6\frac{1}{4}$ (22 × 16). Juan Abello Prat-Mollet, Barcelona. Photo Mas

29 Cartoon of Lorca and Dalí from *La Noche*, 1927

30 *Honey is Sweeter than Blood*, c. 1927. Former collection Coco Chanel, present whereabouts unknown. Published in *Documents*, no. 4, September 1929

31 J. Puig Pujades, *L'oncle Vicents*, Barcelona, 1926

32 Rogelio Buendía, *Naufragio en 3 cuerdas de guitarra*, Seville, 1928

33 Artur Carbonell, *Christmas Eve*, 1928. Oil on canvas, Private collection. Photo Mas

34 *Apparatus and Hand*, 1927. Oil on panel, $20\frac{1}{2} \times 18\frac{3}{4}$ (52 × 47·6). The Salvador Dalí Museum, St Petersburg, Florida, USA

35 Yves Tanguy (1900–55), *He Did What He Wanted*, 1927. Oil on canvas, $31\frac{1}{2} \times 25\frac{1}{2}$ (80·64 × 64·77). Richard S. Zeisler Collection, New York

36 Giorgio de Chirico (1888–1978), *Melancholy of an Autumn Afternoon*, 1915. Present whereabouts unknown

37 *Untitled*, 1927. Pen, brush and ink, $9\frac{7}{8} \times 12\frac{7}{8}$ (25 × 32·7). Collection The Museum of Modern Art, New York. Gift of Mrs Alfred R. Stern in honour of Renée d'Harnoncourt

38 André Masson (1896–), *Automatic Drawing* from *La Révolution Surréaliste*, no. 1, 1924

39, 40, 41 Scenes from the film *Un Chien Andalou*, 1929, made in collaboration with Luis Buñuel. Sevil Audivisuel, Paris. Photos courtesy of the National Film Archive, Stills Library

42 *Dream*, 1931. Oil on canvas, $37\frac{3}{4} \times 37\frac{3}{4}$ (96 × 96). Private collection

43 *Senicitas*, 1926–7. Oil on panel, $24\frac{1}{4} \times 18\frac{1}{2}$ (63 × 47). Private collection

44 *Bather*, 1928. Oil and gravel collage on panel, $25 \times 29\frac{1}{2}$ (63·5 × 75). The Salvador Dalí Museum, St Petersburg, Florida, USA

45 *The Wounded Bird*, 1926. Oil and sand on cardboard, $21\frac{5}{8} \times 25\frac{3}{4}$ (55 × 65·5). Mizne-Blumental collection

46 *Torso* (Feminine Nude), 1927. Oil paint and cork, $27\frac{3}{4} \times 23\frac{5}{8}$ (70·5 × 60). Collection François Petit. Photo Robert Descharnes

47 Jean Arp (1886–1966), *Mountain, Table, Anchors, Navel*, 1925. Oil on cardboard with cutouts, $29\frac{5}{8} \times 23\frac{1}{2}$ (75·2 × 59·7). Collection The Museum of Modern Art, New York

48 *Sun*, 1928. Oil on canvas, $57\frac{7}{8} \times 77\frac{1}{8}$ (147 × 196). Private collection

49 *The Putrefied Donkey*, 1928. Oil on panel, $24 \times 19\frac{5}{8}$ (61 × 50). Collection François Petit

50 *Bird*, 1929. Oil on panel with sand and gravel collage, $19\frac{1}{4} \times 23\frac{5}{8}$ (49 × 60). Private collection, London

51 Max Ernst (1891–1976), *La Belle Saison*, 1925. Oil on canvas, $22\frac{3}{4} \times 42\frac{1}{2}$ (58 × 108). Private collection

52 *The Spectral Cow*, 1928. Oil on panel, $19\frac{5}{8} \times 25\frac{1}{3}$ (50 × 64·5). Musée National d'Art Moderne, Centre Georges Pompidou, Paris

53 *Dismal Sport*, 1929. Oil and collage on canvas, $12\frac{1}{4} \times 16\frac{1}{8}$ (31 × 41). Private collection

54 *The First Days of Spring*, 1929. Oil and collage on panel, $19\frac{1}{2} \times 25\frac{1}{8}$ (49·5 × 64). Private collection

55 Frontispiece from *L'Amour et la mémoire*, Éditions Surrèalistes, Paris, 1931

56 Georges Bataille's schematic drawing interpreting Dalí's *Dismal Sport* from *Documents*, no. 7, December 1929

57 Drawing for *Dismal Sport*, 1929. Crayon on paper, $7\frac{5}{8} \times 10\frac{1}{8}$ (19·5 × 25·8), Collection Arturo

Schwarz, Milan

58 *The Great Masturbator*, 1929. Oil on canvas, $43\frac{1}{4} \times 59$ (110 × 150). Private collection

59 Rocks at Cadaqués. The Salvador Dalí Museum, St Petersburg, Florida, USA

60 *The Enigma of Desire*, 1929. Oil on canvas, $43\frac{1}{3} \times 59\frac{1}{3}$ (110 × 150·7). Oskar R. Schlag, Zurich

61 Artist unknown, *The Fountain*, lithograph. Gift from Ana Maria Dalí, The Salvador Dalí Museum, St Petersburg, Florida, USA

62 Max Ernst (1891–1976), *Pieta, or Revolution by Night*, 1923. Oil on canvas, $44\frac{7}{8} \times 34\frac{5}{8}$ (114 × 88). Tate Gallery, London

63 Giorgio de Chirico (1888–1978), *The Child's Brain*, 1914. Oil on canvas, $31\frac{1}{2} \times 25\frac{2}{3}$ (80 × 65). Statens Konstmuseer, Moderna Museet, Stockholm

64 *Portrait of Freud*, 1938. Ink on paper, $11\frac{5}{8} \times 10\frac{1}{2}$ (29·5 × 26·5). The Edward James Foundation, Sussex, on loan to the Boymans–van Beuningen Museum, Rotterdam

65 *Accommodations of Desire*, 1926. Oil on panel, $8\frac{5}{8} \times 13\frac{3}{4}$ (22 × 35). Private collection. Sotheby, Parke, Bernet, New York. AGENT: Editorial Photo

66 *Illumined Pleasures*, 1929. Oil and collage on panel, $9\frac{3}{8} \times 13\frac{3}{4}$ (23·8 × 35). The Sidney and Harriet Janis Collection, Gift to the Museum of Modern Art, New York

67 *Portrait of Paul Eluard*, 1929. Oil on cardboard, $13 \times 9\frac{7}{8}$ (33 × 25). Private collection

68 Frontispiece to the *Second Surrealist Manifesto*, 1930. Pen, ink and watercolour on paper, $12 \times 10\frac{5}{8}$ (30·5 × 27). The Sidney and Harriet Janis Collection, Gift to The Museum of Modern Art, New York

69 *Combinations*, 1931. Gouache on paper, $5\frac{1}{2} \times 3\frac{5}{8}$ (14 × 9·2). Perls Galleries, New York

70 *The Enigma of William Tell*, 1933. Oil on canvas, $79\frac{1}{4} \times 136\frac{1}{2}$ (201·5 × 346·5). Statens Konst-

museer, Moderna Museet, Stockholm

71 *William Tell*, 1930. Oil and collage on canvas, $44\frac{1}{2} \times 34\frac{1}{4}$ (113×87). Private collection

72 *The Old Age of William Tell*, 1931. Oil on canvas, $38\frac{5}{8} \times 55$ (98×140). Private collection

73 Arnold Böcklin (1827–1901), *Island of the Dead*, 1880 version. Oil on canvas, $43\frac{3}{4} \times 61$ (111×155). Öffentliche Kunstsammlung, Basel

74 *Mad Associations Board* or *Fireworks*, 1930–31. Oil on embossed pewter, $15\frac{3}{4} \times 25\frac{5}{8}$ (40×65). Private collection, London

75 *The Birth of Liquid Desires*, 1932. Oil on canvas, 37×44 (94×112). Peggy Guggenheim Foundation, Venice

76 *The Signal of Anguish*, 1936. Oil on panel, $8\frac{3}{4} \times 6\frac{1}{2}$ ($22 \cdot 2 \times 16 \cdot 5$). Private collection

77 Giuseppe Arcimboldo (1527–93), *Winter*, 1563. Oil on panel, $26\frac{3}{8} \times 20\frac{1}{2}$ (67×52). Kunsthistorisches Museum, Vienna

78 *Helena Rubinstein's Head Emerging from a Rocky Cliff*, c. 1942–3. Oil on canvas, 35×26 ($88 \cdot 9 \times 66$). Collection of Helena Rubinstein Foundation Portraits

79 *Portrait of Frau Isabel Styler-Tas*, 1945. Oil on canvas, $25\frac{3}{4} \times 33\frac{7}{8}$ ($65 \cdot 5 \times 86$). Nationalgalerie Staatliche Museen Preussicher Kulturbesitz, Berlin (West). Photo Jörg P. Anders

80 *The Architectonic Angelus of Millet*, 1933. Oil on canvas, $28\frac{3}{4} \times 23\frac{5}{8}$ (73×60). Perls Galleries, New York

81 Plate XVII for Comte de Lautréamont, *Les Chants de Maldoror*, Paris, 1934. Etching, 13×10 ($33 \times 25 \cdot 4$). Collection The Museum of Modern Art, New York. The Louis E. Stern Collection

82 Jean-Louis-Ernest Meissonier (1815–91), *Napoleon I and his Staff*, 1868. Oil on panel, $6 \times 7\frac{1}{8}$ ($15 \cdot 24 \times 18$). Reproduced by permission of the Trustees of the Wallace Collection

83 Antonio Gaudí (1852–1926),

Casa Milá, Barcelona, 1906–10, from *Minotaure*, December, 1933. Photo Man Ray

84 *Le Phénomène de l'extase*, 1933, from *Minotaure*, 1933

85 *Soft Construction with Boiled Beans: Premonition of Civil War*, 1936. Oil on canvas, $43\frac{1}{4} \times 33\frac{1}{8}$ (110×84). Collection Arensberg, Philadelphia Museum of Art

86 *Autumn Cannibalism*, 1936. Oil on canvas, $25\frac{5}{8} \times 25\frac{3}{4}$ ($65 \times 65 \cdot 2$). Tate Gallery, London. Photo courtesy of E.F.W. James Esq. and A. C. Cooper Ltd

87 *The Ampurdán Chemist Seeking Absolutely Nothing*, 1936. Former collection E.F.W. James Esq.

88 Francisco José de Goya (1746–1828), *Why?*, from *The Disasters of War*, 1810–14. Etching, $5\frac{1}{2} \times 7\frac{1}{2}$ (14×19). Prado Museum, Madrid

89 *The Inventions of the Monsters*, 1937. Oil on canvas, $20\frac{1}{8} \times 30\frac{7}{8}$ ($51 \cdot 1 \times 78 \cdot 5$). Joseph Winterbotham Collection. Courtesy of the Art Institute of Chicago

90 *Spain*, 1938. Oil on canvas, $36\frac{1}{4} \times 23\frac{3}{4}$ ($91 \cdot 8 \times 60 \cdot 2$). Boymans–van Beuningen Museum, Rotterdam

91 *The Enigma of Hitler*, 1937. Oil on panel, $37 \times 55\frac{1}{2}$ (94×141). Private collection

92 *The Invisible Man*, 1929–33. Oil on canvas, $56\frac{1}{3} \times 31\frac{7}{8}$ (143×81). Private collection

93 *Paranoiac Face* from *Le Surréalisme au Service de la Révolution*, no. 3, December 1931

94 *Mediumistic–paranoiac Image*, 1935. Oil on panel, $7\frac{1}{2} \times 9$ (19×23). Former collection E.F.W. James Esq. Photo by courtesy of Christie's

95 *Phantom Chariot*, 1933? Oil on panel, $7\frac{1}{2} \times 9\frac{1}{2}$ ($19 \times 24 \cdot 1$). Former collection E.F.W. James Esq. Photo by courtesy of Christie's

96 Page from an unpublished film scenario, early 1930s. Private collection

97 *Invisible Sleeper, Horse and Lion*, 1930. Oil on canvas, $20\frac{1}{2}$

$\times 23\frac{5}{8}$ (52×60). Private collection

98 *Apparition of Face and Fruit Dish on a Beach*, 1938. Oil on canvas, $45\frac{1}{4} \times 56\frac{5}{8}$ ($114 \cdot 8 \times 143 \cdot 8$). Wadsworth Atheneum, Hartford, Conn. The Ella Gallup Sumner and Mary Catlin Sumner Collection

99 Schematic explanation of *The Endless Enigma* from the catalogue of the Dalí exhibition at the Julien Levy Gallery, New York, in 1939

100 *The Endless Enigma*, 1938. Oil on canvas, $45 \times 57\frac{5}{8}$ ($114 \cdot 5 \times 146 \cdot 5$). Private collection

101 *Suburb of the Paranoiac–critical Town; Afternoon on the Outskirts of European History*, 1936. Oil on panel, $18\frac{1}{8} \times 26$ (46×66). Former collection E.F.W. James Esq. Photo by courtesy of Christie's

102 *The Metamorphosis of Narcissus*, 1937. Oil on canvas, $20 \times 30\frac{3}{4}$ ($50 \cdot 8 \times 78 \cdot 2$). Tate Gallery, London

103 *Impressions of Africa*, 1938. Oil on canvas, $36 \times 46\frac{1}{4}$ ($91 \cdot 5 \times 117 \cdot 5$). Boymans–van Beuningen Museum, Rotterdam

104 *White Calm*, 1936. Oil on panel, $16\frac{1}{8} \times 13$ (41×33). Former collection E.F.W. James Esq.

105 *The Great Paranoiac*, 1936. Oil on canvas, $24\frac{1}{4} \times 24\frac{1}{4}$ (62×62). Boymans–van Beuningen Museum, Rotterdam

106 Leonardo da Vinci (1459–1519), *Adoration of the Magi*, begun 1481, unfinished. Oil on panel, $96\frac{7}{8} \times 95\frac{2}{3}$ (246×243). Uffizi, Florence

107 Detail of *Spain*, 1938 (see ill. 90)

108 *The Slave Market with the Disappearing Bust of Voltaire*, 1940. Oil on canvas, $18\frac{1}{3} \times 25\frac{3}{4}$ ($46 \cdot 5 \times 65 \cdot 5$). The Salvador Dalí Museum, St Petersburg, Florida, USA

109 Head of Voltaire from *The Secret Life of Salvador Dalí*, Dial Press, New York, 1942

110 *Beach with Telephone*, 1938. Oil on canvas, $28\frac{3}{4} \times 36\frac{1}{4}$ (73×92). Tate Gallery, London

111 Detail of *Impressions of Africa*, 1938 (see ill. 103)

112 *The Spectre of Sex Appeal*, 1934. Oil on canvas, $7 \times 5\frac{1}{2}$ (18×14). Teatro Museo Dalí, Figueras

113 Jean-François Millet (1814–75), *The Angelus*, 1858–9. Oil on canvas, $21\frac{5}{8} \times 26$ (55×66). Louvre, Paris. Photo Giraudon

114–116 A photograph and two postcards from Salvador Dalí's *The Tragic Myth of Millet's Angelus, a Paranoiac–critical Interpretation*, Jean-Jacques Pauvert, Paris, 1963

117 *Imperial Monument to the Child Woman*, c. 1930. Oil on canvas, $56\frac{1}{8} \times 31\frac{7}{8}$ (142×81). Private collection

118 *Gala and the Angelus of Millet Preceding the Imminent Arrival of the Conic Anamorphoses*, 1933. Oil on canvas, $9\frac{1}{2} \times 7\frac{1}{2}$ (24.2×19.2). National Gallery of Canada, Ottawa

119 *The Atavism of Dusk*, 1933–4. Oil on panel, $5\frac{3}{4} \times 6\frac{3}{4}$ (14.5×17). Private collection

120 *Portrait of Gala*, 1935. Oil on panel, $12\frac{3}{4} \times 10\frac{1}{2}$ (32.4×26.7). Collection The Museum of Modern Art, New York. Gift of Abby Aldrich Rockefeller

121 Plate XIV for Comte de Lautréamont, *Les Chants de Maldoror*, Paris, 1934. Etching, $13\frac{1}{8} \times 10\frac{1}{8}$ (33.3×25.7). Collection The Museum of Modern Art, New York. The Louis E. Stern Collection

122 *Composition – Evocation of Lenin*, 1931. Oil on canvas, $44\frac{7}{8} \times 57\frac{1}{2}$ (114×146). Musée National d'Art Moderne, Centre Georges Pompidou, Paris

123 *The Face of Mae West (Usable as a Surrealist Apartment)*, 1934–5. Gouache on newspaper, $12\frac{1}{4} \times 6\frac{5}{8}$ (31×17). The Art Institute of Chicago. Gift of Mrs Gilbert W. Chapman

124 *Cadavre exquis*, c. 1930. Pencil on paper, $10\frac{1}{2} \times 7\frac{7}{8}$ (26.7×19.5). Private collection

125 Alberto Giacometti, *Suspended Ball*, 1930–31. Wood and metal, height $23\frac{5}{8}$ (60). Private collection. From *Le Surréalisme au Service de la Révolution*, no. 3, December 1931

126 *Aphrodisiac Jacket*, 1936, from *Cahiers d'Art*, 1936

127 Charles Ratton Gallery, Paris, Surrealist Exhibition, May 1936. Photo Charles Ratton collection

128 Valentine Hugo, *Surrealist Object*, 1931, from *Le Surréalisme au Service de la Révolution*, no. 3, December 1931

129 *Surrealist Object*, 1931, from *Le Surréalisme au Service de la Révolution*, no. 3, December 1931

130 *Retrospective Bust of a Woman*, 1933. Painted porcelain, height: $19\frac{1}{4}$ (49). M. Nellens, Knokke-le-Zoute

131 *Lobster Telephone*, 1936. Assemblage, $11\frac{3}{4} \times 5\frac{7}{8} \times 6\frac{5}{8}$ ($30 \times 15 \times 17$). Former collection E.F.W. James Esq. Photo by courtesy of Christie's

132 Photographs of the Paris Metro from *Minotaure*, December 1933

133 *Surrealist Object*, 1936. Assemblage. Collection Charles Ratton, Paris

134 *Mae West's Lips Sofa*, 1936–7. Wooden frame covered with pink satin, $33\frac{7}{8} \times 71\frac{5}{8} \times 31\frac{1}{2}$ ($86 \times 182 \times 80$). Collection E.F.W. James Esq. On loan to the Victoria & Albert Museum, London

135 *Chair with Spoons*, 1970. Bronze, $47\frac{1}{4} \times 13\frac{3}{4} \times 13\frac{3}{4}$ ($120 \times 35 \times 35$). Collection Berrocal, Verona

136 Gala Dalí's maquette for a Surrealist apartment, from *Cahiers d'Art*, 1936

137 *Rainy Taxi* at the International Exhibition of Surrealism at the Galerie des Beaux-Arts, Paris, 1938

138 *The Living Flower*, early 1950s. Eighteen-carat gold, diamonds and malachite. ©1977 The Owen Cheatham Foundation

139 *Michelin Slave*, 1966. Bronze, $11\frac{3}{4} \times 7 \times 7$ ($30 \times 18 \times 18$). Collection Berrocal, Verona

140 *Otorhinologique Head of Venus*, 1964, reconstruction. Painted plaster, $28 \times 19\frac{1}{3} \times 14\frac{1}{8}$ ($71 \times 49 \times 36$). Museum Boymans-van Beuningen, Rotterdam

141 *Dream Caused by the Flight of a Bee Around a Pomegranate One Second Before Awakening*, 1944. Oil on canvas, $20 \times 16\frac{1}{8}$ (51×41). Thyssen-Bornemisza Collection, Castagnola-Lugano, Switzerland

142 *Animated Still Life*, 1956. Oil on canvas, $49\frac{1}{2} \times 63$ (125.7×160). The Salvador Dalí Museum, St Petersburg, Florida, USA

143 *Exploding Raphaelesque Head*, 1951. Oil on canvas, $17\frac{1}{2} \times 13\frac{3}{4}$ (44.5×35). Private collection

144 *Anti-Protonic Assumption*, 1956. Oil on canvas, $27\frac{3}{4} \times 24$ (70.5×70). Collection of Mrs Bruno Pagliai, New York City

145 *The Persistence of Memory*, 1931. Oil on canvas, $9\frac{1}{2} \times 13$ (24×33). Collection The Museum of Modern Art, New York

146 *Velázquez Painting the Infanta Margarita with the Lights and Shadows of his Own Glory*, 1958. Oil on canvas, 60×36 (153×92). The Salvador Dalí Museum, St Petersburg, Florida, USA

147 *Hallucinogenic Toreador*, 1969–70. Oil on canvas, $157\frac{1}{2} \times 118$ (400×300). The Salvador Dalí Museum, St Petersburg, Florida, USA

148 *The Dream of Christopher Columbus*, 1958–9. Oil on canvas, $161\frac{1}{2} \times 122$ (410×310). The Salvador Dalí Museum, St Petersburg, Florida, USA

149 *The Sistine Madonna*, 1958. Oil on canvas, 88×75 (223.5×190.5). Private collection

150 *Portrait of my Dead Brother*, 1963. Oil on canvas, 69×69 (175×175). Private collection

151 First study for *The Madonna of Port Lligat*, 1949. Oil on canvas, $19\frac{1}{4} \times 14\frac{3}{4}$ (48.9×37.5). Marquette University Committee on the Fine Arts, Milwaukee, Wis.

152 *The Chair*, 1975. Oil on canvas, each $157\frac{1}{2} \times 82\frac{5}{8}$ (400×210). Private collection

153 *The Apotheosis of Homer*, 1945. Oil on canvas, $25\frac{3}{4} \times 46$ ($63\cdot5 \times 117$). Staatsgalerie Moderner Kunst, Munich

154 *The Disintegration of the Persistence of Memory*, 1952–4. Oil on canvas, 10×13 ($25\cdot4 \times 33$). The Salvador Dalí Museum, St Petersburg, Florida, USA

155 Drawing of Christ attributed to St John of the Cross from the Convent of the Incarnation, Avila, Spain. Photo Mas

156 *Christ of St John of the Cross*, 1951. Oil on canvas, $80\frac{3}{4} \times 45\frac{2}{3}$ (205×116). Glasgow Art Gallery and Museum

157–164 Stills from the film *L'Age d'or*, made in collaboration with Luis Buñuel, 1930. Contemporary Films Ltd. Photos courtesy of the National Film Archive, Stills Library

165 *The Triangular Hour*, 1933. Oil on canvas, 24×18 (61×46). Private collection

166 Page from an unpublished film scenario, early 1930s. Private collection

167 *Babaouo*, 1932. Lit box with glass panels, $10\frac{1}{4} \times 10\frac{1}{3} \times 12$ ($25\cdot8 \times 26\cdot4 \times 30\cdot5$). Perls Galleries, New York

168 *Portrait of Harpo Marx*, 1937.

Pencil on paper, $18\frac{1}{2} \times 15$ ($47 \times 38\cdot1$). Collection Henry P. McIlhenny, Philadelphia

169 *Shirley Temple, the Youngest Sacred Monster of the Cinema*, 1939. Gouache, pastel and collage on board, $29\frac{1}{2} \times 39\frac{1}{3}$ (75×100). Museum Boymans–van Beuningen, Rotterdam

170 Dalí standing before one of his sets for Alfred Hitchcock's *Spellbound*, 1945. Cinegate Ltd. Photo courtesy of the National Film Archive, Stills Library

Index